TIMELESS RENAISSANCE

Italian Drawings from the Alessandro Maggiori Collection

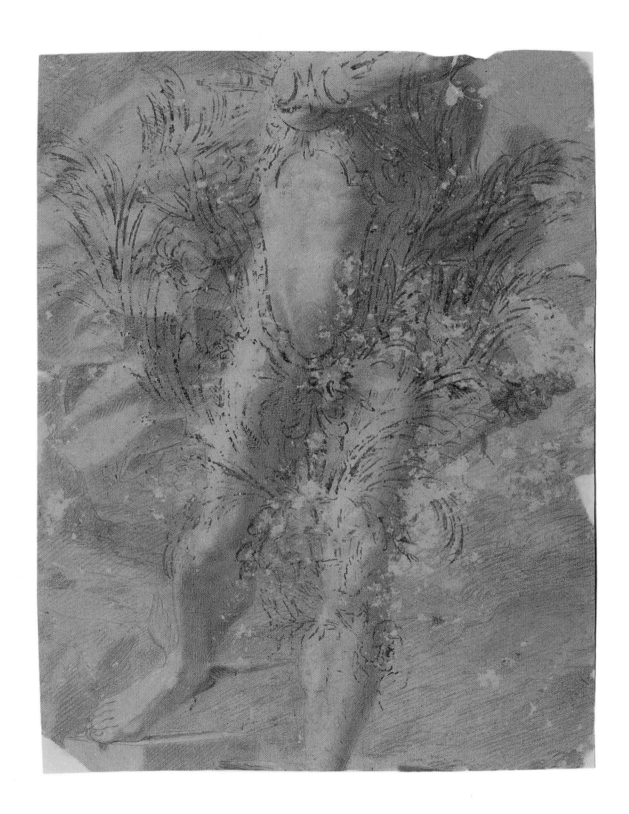

TIMELESS RENAISSANCE

Italian Drawings from the Alessandro Maggiori Collection

by Ricardo De Mambro Santos

HALLIE FORD MUSEUM OF ART
WILLAMETTE UNIVERSITY

DISTRIBUTED BY
UNIVERSITY OF WASHINGTON PRESS
SEATTLE AND LONDON

This book was published in connection with an exhibition arranged by the Hallie Ford Museum of Art at Willamette University entitled *Timeless Renaissance: Italian Drawings from the Alessandro Maggiori Collection*. The dates for the exhibition were August 13 – November 6, 2011.

Designed by Phil Kovacevich

Editorial review by Sigrid Asmus

Printed and bound in the United States

Front cover and Fig. 2, page 80: Anonymous artist (Roman School, 18th century) *Head of a young woman with hair in plaits*, red chalk on light brown paper, 11 x 9 in. Fondo Alessandro Maggiori, Biblioteca Comunale, Monte San Giusto, Italy

Back cover and Fig. 34, page 96: Attributed to Lodovico Carracci (born Bologna, 1555–died Bologna, 1619) *Seated woman looking backward*, red chalk and red charcoal on ivory-colored paper, 4 x 5 in. Fondo Alessandro Maggiori, Biblioteca Comunale, Monte San Giusto, Italy

Frontispiece and Fig. 68, page 113: Anonymous artist (Roman School, 17th century) *Study of Mercury*, black chalk and black charcoal on grey paper, 15.5 x 11.75 in. Fondo Alessandro Maggiori, Biblioteca Comunale, Monte San Giusto, Italy

Page 6: Anton Raphael Mengs (born Aussig, Germany, 1728–died Rome, 1770), *Study of a standing naked man seen from the rear with outstretched hand* (detail), black chalk, slightly heightened with white, on light brown paper, 11.25 x 7.75 in., Fondo Alessandro Maggiori, Biblioteca Comunale, Monte San Giusto, Italy

Page 9: Anonymous artist, *Lowering head of a man*, red chalk on ivory-colored paper, 10.5 x 8.5 in., Fondo Alessandro Maggiori, Biblioteca Comunale, Monte San Giusto, Italy

Library of Congress Control Number 2011933011
ISBN 9781930957657

Distributed by
University of Washington Press
P.O. Box 50096
Seattle, Washington 98145-5096

CONTENTS

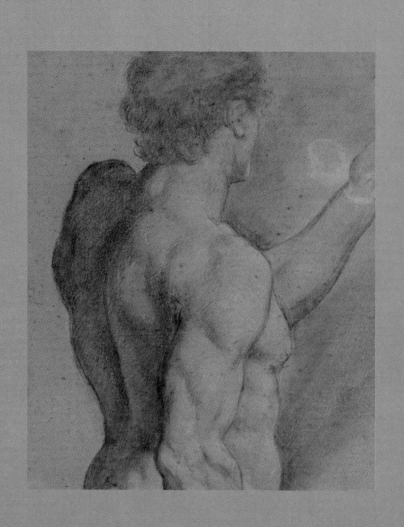

Shortly after he arrived as an assistant professor of art history at Willamette University, Ricardo De Mambro Santos called me on the telephone and said he'd like to have lunch with me. He told me he had an idea for an exhibition of Italian drawings from a collection that had only recently been rediscovered in Monte San Giusto, a small town 108 miles northeast of Rome in the region of Le Marche on the Adriatic Coast. I was intrigued by the idea as I had just finished reading my friend Robert Edsel's riveting book, *The Monuments Men: Allied Heroes, Nazi Thieves, and the Greatest Treasure Hunt in History*, and was fascinated by the Nazi looting of Europe's artistic and cultural patrimony. Could this lost collection of Italian drawings be somehow linked to Hitler's obsession with the visual arts?

Over lunch, Ricardo told me the story of Alessandro Maggiori (1764–1834), an Italian count who had acquired a significant collection of Renaissance and Baroque drawings at the end of the eighteenth and beginning of the nineteenth century during the Napoleonic occupation of Italy. Maggiori, an Italian aristocrat and connoisseur, had amassed a substantial collection of drawings and had argued for the creation of the academic discipline of art history at least a decade before the first chair in art history was established in Germany. When he died in 1834, his collection was divided among his younger brothers and eventually dispersed.

While drawings from the Maggiori collection eventually appeared in such diverse locations as the Metropolitan Museum of Art in New York and the British Museum in London (we know they are from his collection because he signed and dated them whenever he purchased a new drawing), a large portion of the collection appeared in the inventory of the town of Monte San Giusto in the mid-1920s, the gift of a local priest who had donated them some time earlier. During World War II, to protect them from theft or destruction, the drawings were hidden away in a cupboard, only to be rediscovered in the mid-1990s when the city hall was being remodeled. It was a fascinating story that I felt needed to be told.

Timeless Renaissance: Italian Drawings from the Alessandro Maggiori Collection features seventy-four drawings acquired by Count Maggiori during the late eighteenth and early nineteenth centuries, including exquisite drawings by Andrea Sacchi (1599–1661), Elisabetta Sirani (1638–1665), Giorgio Vasari (1511–1574), and Domenico Zampieri, called Il Domenichino (1581–1641). A wide variety of subjects and themes are represented, including male and female heads, anatomical studies, mythological themes, animals, drapery studies, and religious themes. The exhibition represents the first time that the collection has been exhibited outside of Italy and signifies a major coup for the Hallie Ford Museum of Art.

On behalf of the faculty, staff, and students at Willamette University and myself, I want to express my thanks and appreciation to a number of individuals whose help and support brought the exhibition and accompanying

publication to fruition. I would like to express my heartfelt thanks and deep appreciation to Ricardo De Mambro Santos, who curated the exhibition, negotiated the loans with the town of Monte San Giusto, served as our liaison in Italy, and wrote the extensive, scholarly essay on Alessandro Maggiori and his collection. Ricardo is an enthusiastic teacher and brilliant scholar and he has been a joy to work with on the exhibition and book.

I would like to thank graphic designer Phil Kovacevich for his beautiful and spacious design of the book; Sigrid Asmus for her careful and thoughtful editorial review of Ricardo's essay; education curator Elizabeth Garrison for providing further editorial review of the manuscript; and the University of Washington Press for agreeing to distribute the book on a worldwide basis. In particular, I would like to thank Director Pat Soden for his ongoing interest and support of our exhibitions and accompanying books. In addition, Ricardo would like to express his thanks and appreciation to Professor Nicholas Halmi of Oxford University for reading the manuscript and offering insightful comments, and to Patricia Alley of Willamette University for attentively reading the manuscript at various stages in its preparation.

In Italy, I would like to thank Gabriele Barucca, a representative of Soprintendenza per I Beni Storici, Artistici ed Etnoantropologici delle Marche, for his unflagging encouragement and support of the exhibition and publication and for his help in overseeing the packing, shipping, and unpacking of the collection; Mario Lattanzi, mayor of Comune di Monte San Giusto, for approving the loan of the collection (the first time these drawings have been seen outside of Italy) and for facilitating the international loan; and Roberto Spinelli, former Assessore alla cultura del Comune di Monte San Giusto, for initiating the whole process and for introducing Ricardo to Gabriele Barucca.

On the Hallie Ford Museum of Art staff, I would like to thank collection curator Jonathan Bucci, for coordinating the packing and shipping arrangements from Italy; education curator Elizabeth Garrison, for providing further editorial review of the book and didactic material, as well as for writing a teacher's packet to accompany the exhibition; and exhibition designer / chief preparator David Andersen, for his stunning design and layout of the exhibition installation. In addition, I would like to thank administrative assistant Carolyn Harcourt, front desk receptionists Elizabeth Ebeling, Bonnie Schulte, and Linda Horton, safety officer Frank Simons, and custodian Cruz Diaz De Estrada, for their help with various aspects of the project.

Timeless Renaissance: Italian Drawings from the Alessandro Maggiori Collection is the first major exhibition and accompanying publication supported by the late Hallie Ford (1905–2007), who made a significant endowment gift in late 2004 to support the organization of a major art historical exhibition every few years. Hallie was a remarkable woman and a magnanimous benefactor who understood that these types of exhibitions, grounded in quality, scholarship, and pedagogy, could have a profound impact on the lives of students and others; it is to her memory that we dedicate this book.

John Olbrantz
The Maribeth Collins Director
Hallie Ford Museum of Art

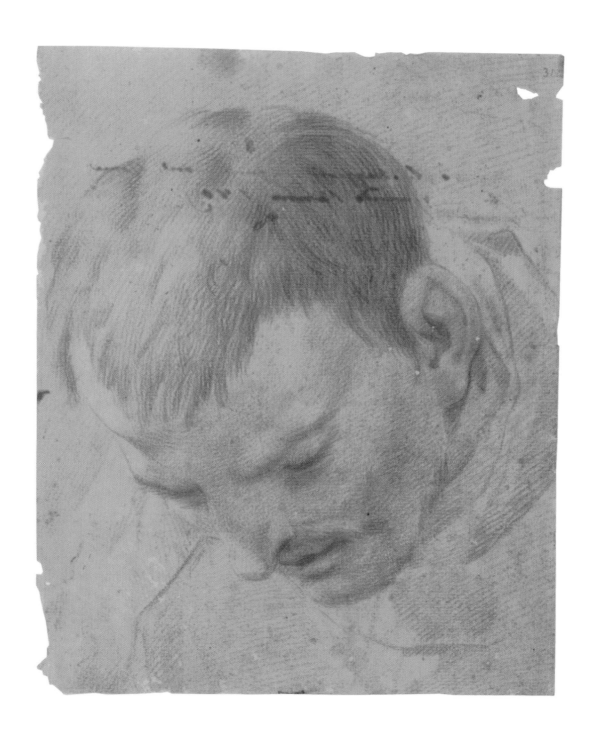

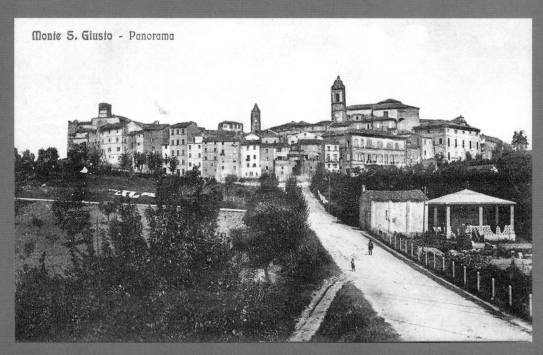

Figure 1. Panoramic view of Monte San Giusto at the beginning of the twentieth century

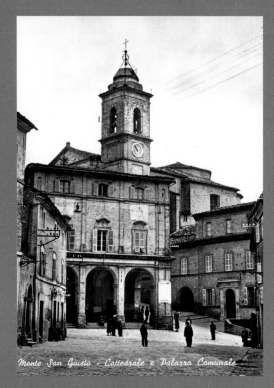

Figure 2. View of City Hall in Monte San Giusto at the beginning of the twentieth century

TIMELESS RENAISSANCE

*Master Drawings from the Alessandro Maggiori Collection
and the Aesthetics of Reappropriation in Eighteenth-Century Italy*

By Ricardo De Mambro Santos

1. The Cultural Paradigms of a Renaissance Nostalgia

Count Alessandro Maggiori (1764–1834) represents a fascinating, yet paradoxical, object of study. Almost completely forgotten by the historiography of art, in spite of his pioneering contributions to this field of

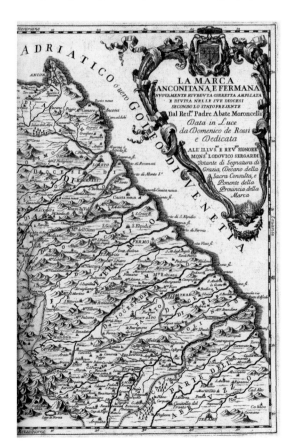

Figure 3. Silvestro Amanzio Moroncelli, *Map of The Marches*, 1711, showing a detail of the territories of Ancona and Fermo, Italy
Cartoteca Storica delle Marche, Serra San Quirico, Italy

research, he is, by contrast, quite well-known among scholars who have devoted their attention to the history of art collecting between the eighteenth and the nineteenth century, thanks to the Count's outstanding collection of drawings and prints, partially preserved today at Monte San Giusto, in the province of Macerata (figs. 1–3), in the Italian region of *Le Marche* (The Marches).[1] A learned and cultivated man with multiple cultural interests, the author not only of detailed guides of Italian cities, such as Ancona and Loreto, but also responsible for the publication of a wide range of volumes— from agronomic studies on maize to compilations of proverbs and folk ways of speech, not to mention a consistent edition of Michelangelo's *Rimes* in 1817—Alessandro Maggiori has never been the object of a scholarly oriented analysis either as a writer or an art collector, nor have his indefatigable undertakings in the different territories of the visual arts been considered in their aesthetic coherence or cultural implications. Highly regarded among his contemporaries, the Count was soon neglected by historians and art historians. His intellectual biography, that of an exquisite connoisseur and a remarkably selective collector, thus still remains to be written. The present essay intends to offer a preliminary study in the attempt to approach this critical gap.

Figure 4. Anonymous artist, *Three studies of an ancient statue*
Fondo Alessandro Maggiori, Biblioteca Comunale, Monte San Giusto, Italy

Alessandro Maggiori's renown in the field of art history is undoubtedly linked to his activity as a very attentive collector of drawings. Among the various masters collected by the Count one can find the names of important protagonists of the Italian Renaissance and Mannerism, such as Perin del Vaga and Giorgio Vasari, along with artists usually associated with seventeenth- and eighteenth-century Roman and Bolognese schools, as recently confirmed by the attributions of some drawings to masters such as Guido Reni, Domenichino, Carlo Bodoni, Giacomo Cavedoni, Andrea Pozzo, Francesco Trevisani, Pompeo Batoni, and Anton Raphael Mengs.[2] From an iconographic point of view, the drawings originally belonging to his collection can be divided into a limited range of categories: these chiefly encompass anatomical studies, with meticulous representations of parts of the human body—such as heads, hands, and legs—as well as depictions of complete figures, either naked or wearing clothes *all'antica*. Other drawings present rapid sketches or accurate studies for mythological and religious compositions, as well as depictions of animals, like the delicate drawing representing a donkey recently attributed to the ambit of Federico Barocci.[3] Absent from the remaining sheets at Monte san Giusto are images representing landscapes, and *vedute*, or still lifes.[4]

The Maggiori collection thus appears to embrace as its guiding aesthetic thread artistic genres and iconographic typologies generally associated with the various steps involved in the making of a historical painting—from the depiction of the human body to rapid compositional plans, without neglecting studies of drapery and other secondary elements, such as ornamental grotesques and intricate festoons. Surprisingly, though, only a very small portion of the collection is made up of images directly borrowed from the vast vocabulary of ancient motifs, such as trophies and classical statues (fig. 4). In spite of these absences, however, the most striking feature of the collection lies in its astonishing coherence with regard to the style of the masters chosen to become part of it. As we shall analyze in detail in the following pages, the vast majority of the drawings are, in fact, related to modes of visual construction associated with the reemergence of a certain Classicism that was especially diffused among the members of the Roman and Bolognese schools between the seventeenth and the eighteenth centuries.

In other words, unlike earlier collections of drawings, such as the famous *Libro de' Disegni* gathered by Giorgio Vasari in the sixteenth century, or the many albums compiled by Padre Sebastiano Resta from the end of the seventeenth to the beginning of the eighteenth century, all characterized by a wide range of works belonging to different Italian schools, the Maggiori collection presents a quite narrow selection of drawings, both from a stylistic and an iconographic point of view.[5] Moreover, despite the different provenance of the various sheets purchased by the Count, they all show an evident preference toward masters linked to the great tradition of Italian Classicism, a tradition that found, according to Alessandro Maggiori, its most promising centers of creation and dissemination in early modern Rome and seventeenth-century Bologna. As the product of this sensibility, the collection gathered by the Count is not a universal display of drawings coming from all Italian schools, but an intentionally limited, local cabinet of exquisite examples of classicist-related artworks. The present study will explore and explain the reasons that lie behind such a programmatic aesthetic orientation by providing a circumstantiated reconstruction of Alessandro Maggiori's historical context and personal inclinations, with the intention of better understanding his cultural as well as artistic preferences. In this way it will be possible to offer a horizon of references and intellectual connections within which to interpret the historical relevance of such a remarkable collection of drawings.

2. Back to the Beginning: The Panorama of the Studies

Known to important art historians of the nineteenth century, such as the Swiss scholar Jacob Burckhardt and, in more recent times, by the Italian professor Roberto Longhi, Alessandro Maggiori has been almost exclusively examined within the ambit of studies concerning graphic works. As a matter of fact, his name is almost always mentioned in relation to specific sheets formerly belonging to his collection. Very little is known, on the other hand, about Maggiori's contributions to what has been called *art literature*, which refers to the field in which the written sources of art are investigated. As a direct consequence of this omission, the several volumes on art-related subjects published by the Count between 1817 and 1832 are still awaiting critically oriented analysis.[6] On the other hand, the recent rediscovery at Monte San Giusto of a distinctive group of drawings belonging to his collection has increasingly favored the appearance of scholarly studies. However, the largest part of these studies is primarily, if not exclusively, focused on attributive questions that are subordinated to essentially author-centered approaches, in the attempt to provide names, to establish stylistic borrowings, and to point out iconographic chains of derivation. Thanks to these contributions it has now become possible to reconstruct, at least in part, times, places, and characteristics of the various purchases undertaken by the Count in the art markets of Bologna, Rome, Naples, Pesaro, and Urbino from 1788 to 1817.

Owing to the fact that more systematic attention to the Maggiori collection began only in the mid-1990s and was mostly concerned with attributive issues, very little has been done thus far to investigate, from a broader intellectual and cultural point of view, the personality of Count Alessandro Maggiori as a collector, writer, and exquisite connoisseur within his own historical, social, and even political context. In this regard, it is worth recalling that Count Maggiori lived at a moment characterized by a vivid crossroads of cultural exchange, not only in Rome and Bologna, but also in smaller but no less flourishing centers like Macerata and Fermo, his native hometown. Furthermore, one should not overlook the fact that a central part of Maggiori's life was spent in a particularly intense period in the history of Europe, with the expansionistic invasions organized by the French Directory, under the guidance, in Italy, of the General, Consul and, subsequently, Emperor Napoleon Bonaparte, from the end of the eighteenth century to the first decades of the nineteenth.

Thanks to the pioneering investigations undertaken by Italian scholars Luigi Dania and Giulio Angelucci in 1992, a little more is now known about the various geographic areas and the different moments in which the Maggiori collection was formed, extending over a period of approximately four decades.[7] For this reason, the present study, instead of focusing on attributive matters and providing new insights on the interpretive history of single drawings formerly belonging to his collection, will instead center its attention on the intellectual agenda of Count Alessandro Maggiori, in order to delineate his character as a very sophisticated—and highly conscious—art lover and connoisseur. To this end, we shall explore aesthetic, cultural, and ideological questions that are potentially associated with the making of this collection, and in addition examine, on a more detailed level, the Count's connections with other protagonists of the world of art in eighteenth-century Italy, such as Luigi Lanzi, Giannandrea Lazzarini, and his friend Amico Ricci, who was not only a dear friend of Maggiori, but also, and more importantly, his first biographer. Through the meticulous investigation of Alessandro Maggiori's cultural context, it will be possible to analyze the material conditions as well as the artistic premises and the historical circumstances that led to the formation of an incomparably rich and unique collection of drawings, a collection that, as I will argue throughout the whole essay, was intended, from its very beginning, to be the tangible witness of a selective paradigm of beauty and could thus be interpreted as a product of the emerging idea of a collective cultural identity in the early nineteenth century, namely the idea of an Italian art rooted on classical and classicist grounds.

By framing this specific phenomenon of taste within a broader context of historical events, this study will allow us to understand the system of converging reasons that may have oriented the Italian collector to purchase, in a rather programmatic way, almost exclusively models of art directly related, on the one hand, to the sixteenth-century Roman school, and in particular to Raphael and his followers; and, on the other, to artists associated with seventeenth-century Bolognese classicism, such as Carracci, Reni, and Domenichino. As we shall see in the next chapters, an attentive reading of the Maggiori collection requires, beyond a generic connection with the long-established phenomenon of Neoclassicism—disseminated all over Europe in the eighteenth century—the adoption of more refined and circumscribed paradigms of critical examination that will ultimately demonstrate the existence of a cultural movement not yet adequately explored by specialists. That is, it is now possible to investigate a Raphael–Carracci genealogical chain of art that should be more appropriately defined, in virtue of its immanent aesthetic nostalgia, as a "Timeless Renaissance" or a "Renaissance Revival." Inaugurated by Raphael's gracious classicism and notably enriched by Annibale Carracci's selective naturalism, such a genealogy was further developed, in the eighteenth century, by the solemn compositions of Carlo Maratti as well as by the calculated rigor of Domenico Corvi, the beloved master of Alessandro Maggiori during the years he spent in Rome.

The main goal of the present essay is, therefore, to provide a scholarly contribution to the history of what has been defined by Genevieve Warwick as "the arts of collecting" in eighteenth-century Italy, thus leaving issues concerning attribution or philological matters in regard to specific single drawings to be addressed on a different occasion. In other words, this introduction will focus on the construction of a hermeneutic context of possibilities within which one could analyze Alessandro Maggiori's peculiar agenda as an art collector as he gathered the works associated with the classicist tradition. Nevertheless, one should not fail to consider as well the theoretical guidelines and cultural directives that may have accompanied and possibly given orientation to the constitution of such a coherently formed collection of drawings.

3. A Brief, yet Veracious, History of a Collection

Historical discourses can start from different beginnings. In the case of the Maggiori collection, it would not be misleading to begin with one of its final chapters or, to put it in a less emphatic tone, from a quite recent episode. By paraphrasing the title of a famous book by Roberto Longhi—namely, *Breve ma veridica storia della pittura italiana*[8]—we could start our "brief, yet veracious history" of the Maggiori collection from a point that has been justly described as "the fabulous retrieval of the sheets."[9] Toward the end of the 1980s, during the restoration of the *Palazzo Comunale*—the City Hall of Monte San Giusto—a group of sheets was found, among several long-neglected documents and papers, that immediately captured the attention of the people involved in the work, owing to their most uncommon features. In the words of art historian Giulio Angelucci:

> Once it was agreed that [the sheets] deserved to be preserved [...] their nature was clarified and tracks and memories of them were thus provided. That was all that remained from what a local priest, Nicola Bellesi, had donated to the City Hall of Monte San Giusto and [that] had become the object of a list published in the third issue of *Rassegna Marchigiana*, a magazine founded and directed by Superintendent Luigi Serra in 1925. (fig. 5)[10]

The retrieved sheets seemed to correspond, and in fact did seem to be the works left by Don Bellesi as a

Figure 5. Cover of the magazine *Rassegna Marchigiana*
Biblioteca Pubblica, Fabriano, Italy

Figure 6. The first page of an inventory of the Alessandro
Maggiori collection from the magazine *Rassegna Marchigiana*
Biblioteca Pubblica, Fabriano, Italy

legacy to the public administration of Monte San Giusto. The works, previously set within eight large frames
that formerly were hung on the walls of the *Palazzo Comunale*, were summarily listed, in 1925, in an article signed
by Filippo Di Pietro (fig. 6).[11] The fact that the drawings were kept framed, instead of being bound in volumes
as in the collection gathered by Padre Sebastiano Resta in Rome, should not be regarded as something out of the
ordinary. Quite the opposite: it is far from being an isolated case. It may suffice to recall only that, many decades
earlier, when the first inventory of the drawings belonging to the Bolognese *Accademia Clementina* was compiled on
July 25, 1798—in an attempt to preserve them from the spoliations caused by the Napoleonic invasions—the sheets
were arranged within one hundred sixty-six frames.[12]

On the other hand, Di Pietro's list is extremely concise and does not provide any information about the back
sides of the sheets, some of which have signs and forms clearly outlined on their surfaces, a fact that leads us to
conclude that, on the occasion of this rough draft of an inventory, the sheets were not removed from the frames.
Perhaps it may be for the same reason that the one hundred forty-nine prints still remaining from the collection
assembled by Alessandro Maggiori were listed by Di Pietro—and dismissively qualified as works "of very scarce
value" (*di scarsissimo valore*)[13]—in the same article that appeared on the *Rassegna Marchigiana*, along with the drawings
currently displayed at Monte San Giusto. Moreover, due to the fact that the drawings were examined by Di Pietro
while within their frames, their *marques de collection* (marks of collection) were not correctly read by the author,
leading him to awkwardly interpret the signature of the owner as "*un tale Alessandro Maggini*" (a certain Alessandro
Maggini).[14] "Another consequence of having missed the removal of the drawings from the frames," Angelucci
suggests, "is the irremediable lack of any information about the other side of the sixty-six sheets that have gone
lost in the years, whereas twenty-three of the one hundred nine surviving sheets have also revealed drawings on their

back sides—drawings that, of course, could not be described in 1925 given that the bottom edges of the frames were hiding them from the eyes of the commentator."[15]

What remained from Don Bellesi's legacy was thus limited to drawings and prints protected within eight gigantic frames. Used as conventional objects of decoration, the artworks were thus kept in the rooms of the *Palazzo Comunale* until World War II, when the whole building was transformed into a provisionary lodging for the victims. Some time after the war, the frames were transferred to a new location, namely *Palazzo Bonafede*, the current seat of the public administration of the town. In the meantime, the drawings were finally removed from the frames. Unfortunately, though, in this process they "lost all idea of their dignity"; as Angelucci puts it, the sheets "were kept in disarray in the bottom of a cupboard and suffered lacerations in the corners on which they had been glued together."[16]

Only at the end of the 1980s did the drawings become the object of more systematic and stylistically oriented investigations, thanks to a series of initiatives organized by the local scholars mentioned above, Luigi Dania and Giulio Angelucci. In these years, the beginnings of a rigorous campaign of restoration were undertaken as well, under the supervision of the then director of the *Istituto Nazionale per la Grafica* in Rome, Michele Cordaro. This operation has brought to light some outstanding results, as noted by the Italian scholar and restorer, Grazia Bernini Pezzini.[17] Ultimately, around 1990, the Center Alessandro Maggiori was founded at Monte San Giusto. On this occasion, the drawings were newly housed in a historic building belonging to the City Hall, where they could be adequately kept and safely displayed. A new era in the history of the Maggiori collection was thus inaugurated.

4. Portrait of the Collector as a Gentleman

It now appears clear that the history of the Maggiori collection has been at the center of many vicissitudes. From the beginning of its formation, toward the end of the eighteenth century, to the various subtractions that occurred until not very long ago, to the important organization of a center in Monte San Giusto devoted to the study and the appropriate conservation of the drawings, this collection is a tangible example of the vitality of works of art through time, and could thus become the exemplary object of further research conducted according to the hermeneutic premises of the *Rezeptionstheorie* (the theory of reception).[18] Compared to the intricate history of the collection, the biography of Alessandro Maggiori emerges, by contrast, as rather uneventful. Without any particularly relevant exterior event, the life of Count Maggiori, who was born in 1794 in Fermo, a little town in The Marches, seems to have been conducted in the serene atmosphere of an aristocratic setting, mostly spent within The Marches or in regions nearby. His earliest education took place at Osimo, where he became a childhood friend of the future Pope Leo XII. His youthful years were spent in Bologna, followed by an important period in Rome at the turn of the century, and, finally, his definitive return to The Marches, where he first lived in his hometown, Fermo, and then in the villa *Il Castellano*, near Sant'Elpidio a Mare.

An indispensable primary source for getting a better sense of the human as well as the intellectual parable of Alessandro Maggiori is the volume entitled *Memorie Storiche delle arti e degli artisti della Marca di Ancona* (Historical Memories of the Art and Artists of the Province of Ancona), published by the Italian art historian and personal friend of Maggiori's, Amico Ricci.[19] At its conclusion, this book—which represents one of the earliest organic studies on the development of the arts in this region of Italy, even now somehow neglected by scholars—the author provides an intimate biographical note regarding the Count. Written in the melancholy mood of someone who has recently lost a dear friend, Ricci's volume was printed in 1834, which is to say in the year of Maggiori's death. This explains the moving words chosen by the author while writing this brief yet touching encomium:

Having established, as a system, that I would not talk about living persons [as usual in the Italian art literature since its very beginning in early modern times], I would have never imagined that in these pages I would have signed your name by using tears instead of ink, and would celebrate you, who have been a witness of my current studies, and responsible for most of them. I still bear in mind your literary exchanges filled with beautiful doctrines, from which I have enriched my soul, thanks also to the sweetness of your loyal friendship, from which I have rejoiced my heart. Alessandro Maggiori has been one of the few men, in our age, who has cultivated the civic virtues in the peaceful leisure of a retired and tranquil life, in the company of Minerva and the Muses.[20]

Despite its brevity, Ricci's note offers some significant data concerning Alessandro Maggiori's education and academic training, in particular with regard to his precocious artistic interests as well as to his mature literary achievements. It is thanks to Ricci's biographical tribute that we know the important dates of Maggiori's life, such as the very date of his birth, in Fermo, on January 30, 1764. We are also informed that Alessandro was the eldest son of Count Annibale Maggiori and the noble lady Rosa Sciarra. "His initial education," as Ricci recalls, had taken place, first in Osimo, and then in Bologna, "where he graduated."[21] Not very keen on the idea of pursuing his studies in law, Alessandro tried to mitigate "the aridity of these studies," as the author claims, through the "practice of the Fine Arts, toward which he was naturally inclined and excited, given the extraordinary monuments of Bologna. He examined carefully the many beauties spread all over the town, and fed his own thoughts with [the company of some] distinguished men, without neglecting to depict the objects by which he had been most strongly affected."[22] It is evident that not only had Maggiori's interest in the arts emerged quite early in his academic life, but also that he tried to further enrich and develop such a personal curiosity by discussing aesthetics-related matters with "distinguished men," among whom we may as well include—symbolically, of course—some great writers of the past, such as Vasari, Baldinucci, Bellori, and Zanotti, with whom the Count seemed to be very well acquainted, given the many quotations from their work in his volumes.[23]

Maggiori's increasing interest in the visual arts and the emergence of a preliminary idea of organizing a collection that could assemble graphic works by paradigmatic masters seems to have first appeared during the Bolognese years, as unarguably confirmed by the collection of approximately 240 letters written by Alessandro and sent to his father, Count Annibale, between 1781 and 1796 (fig. 7).[24] By reading this impressive exchange, currently preserved at the *Biblioteca dell'Archiginnasio* in Bologna and still unpublished, one gets a clear sense of how intelligently and systematically Alessandro Maggiori had conducted his explorations of local monuments.

One can also follow, in detail, his growing passion for the fine arts, in general, and for drawings, in particular. It was not by accident that the earliest purchases of drawings were undertaken precisely in Bologna in 1788, as unequivocally witnessed by an inscription that appears on the back of the delicate *Head of a woman*, probably executed by an artist belonging to the Roman school at the beginning of the eighteenth century. On this work, the sentence "A. Maggiori bought it in Bologna on 1788," written in the Count's promptly

Figure 7. Alessandro Maggiori, *Letter*
Collezione Autografi, XL, c. 10983
Biblioteca dell'Archiginnasio, Bologna, Italy

recognizable calligraphy, seals its provenance as an undisputable *marque de collection*, almost concealing the face of the flying angel represented on the sheet.

Annotations similar to this one—often written in abbreviated forms, such as "Aless. Maggiori bought it in Bologna in 1790," "Aless. Maggiori purchased it in Rome in the year 1809," "It belongs to Aless. Maggiori, who has bought it in Rome in 1806," or "I, A. Maggiori, have purchased it in Rome when the year 1809 was running"—appear on almost all drawings acquired by the Count, as though he wanted to establish the boundaries of a new intellectual as well as legal propriety, and in doing so leaving the tracks of a personal taxonomy of places, dates, and stylistic preferences. This habit of signing his name on every drawing that was about to become part of his "portable museum" would eventually transform such notes; they became precious *marques de collection* thanks to which it is still possible to trace back drawings that once originally belonged to this collection and that are now displayed in various public and private institutions, in Europe as well as in the United States.[25]

With regard to Alessandro Maggiori's life, another significant event is mentioned in Amico Ricci's biography, namely the collector's moving to Rome in the last years of the eighteenth century. In the capital of the State of the Church, Maggiori became an *habitué* within some of the most vivid artistic circles of the town, notably the studio-academy organized by Viterbese master Domenico Corvi.[26] But before analyzing in detail such a fundamental step in Alessandro's career both as a dilettante painter and an exquisite connoisseur—the subject of the next chapter—it is necessary to recall that it was specifically while in Rome that the Count had given the first concrete proof of his literary ambitions, with the publication of the initial part of a novel entitled *Il Capriccio* (The Caprice), a text that,

as Ricci emphasizes, would never have been completed owing to very negative criticisms raised by "a bunch of little literati and artists of no weight," who were responsible for stopping its publication.[27] Under these conflicting circumstances, no wonder that Maggiori decided to leave Rome, turn toward his tranquil native province, and return to Fermo. Most unfortunately, however, while referring to Maggiori's acquaintances, connections, and even unpleasant enemies in Rome, Ricci does not mention any specific name, with the exception of the collector's beloved master, Domenico Corvi.

Upon returning to The Marches, Alessandro Maggiori married Giuseppina Bonafede, the daughter of an influential local family whose ancestor, the bishop Niccolò Bonafede, had in 1525 been responsible for commissioning the monumental altarpiece depicting the *Crucifixion*, painted by the Venetian master Lorenzo Lotto and still displayed in its original setting at S. Maria in Telusiano in Monte San Giusto.[28] Along with his wife, Maggiori moved to *Il Castellano*, the villa near Sant'Elpidio a Mare, where he spent his last years organizing and further enriching his collection of drawings as well as completing his many contributions in

Figure 8. Alessandro Maggiori, *Le Rime di Michelangelo* Private collection, Macerata, Italy

the field of art literature, beginning with the edition of Michelangelo's *Rimes* of 1817 (fig. 8). Between 1817 and 1832, Maggiori in fact published many volumes,[29] most of them associated with the world of local art, such as the historic, artistic, and archaeological guides of Ancona and Loreto, respectively entitled *Le pitture sculture e architetture della città di Ancona* (Paintings, Sculpture, and Architecture of Ancona) (fig. 9), and *Indicazioni al forestiere delle pitture sculture architetture e rarità d'ogni genere che vi veggono oggi dentro la Sagrosanta Basilica di Loreto e in altri luoghi della città* (Notes for

Figure 9. Alessandro Maggiori, *Le pitture sculture e architetture della città d'Ancona* Biblioteca Comunale Benincasa, Ancona, Italy

the Foreign Visitor on Paintings, Sculpture, Architecture, and All Sorts of Rarities that One Can See Inside the Most Sacred Basilica of Loreto as Well as in Other Sites in the Town) (fig. 10). His books also related to what one might today call ethnographical research, as exemplified by the *Raccolta di proverbj e detti sentenziosi* (Compilation of Proverbs and Popular Maxims). Interestingly, beyond the sphere of art, Maggiori was profoundly attracted by questions pertaining to the field of agronomy, as demonstrated by his *Dialogo sopra la cultura del gran turco* (Dialogue on the Cultivation of Maize). By the end of this period at The Marches—only occasionally interrupted by short trips to Rome and Naples—Maggiori published, in 1832, his most ambitious literary project: the volume entitled *Dell'itinerario d'Italia e sue più notabili curiosità d'ogni specie* (Itineraries of Italy and Its Most Noteworthy Curiosities of All Sorts) (fig. 11), a monument of patient erudition and constant bibliographical updating, in which different Italian localities are described for potential visitors on the Grand Tour, traveling from Milan to Venice and from Macerata to Rome.

Figure 10. Alessandro Maggiori, *Indicazione al forestiere delle pitture sculture architetture e rarità d'ogni genere che si veggono oggi dentro la Sagrosanta Basilica di Loreto e in altri luoghi della città* Biblioteca Comunale Benincasa, Ancona, Italy

Quite significantly, Alessandro Maggiori never allowed his publisher or editor to print his name in the front page of any of his books, so that they all appeared as the fruits of an anonymous mind. As a matter of fact, we owe to Amico Ricci's timely comments the knowledge of the titles that should be justly listed among the heterogeneous literary enterprises of the Count. In Ricci's opinion, Maggiori "wanted to be useful to both friends and strangers, but due to his modesty he did not want to have his name [explicitly printed] on his books, preferring instead to stay unknown; however," Ricci justifies, "now that he is part of the venerable and arcane eternity and has paid for such a virtue, I shall finally reveal his name without shame."[30]

The somehow aristocratic decision to keep secret his own identity and not sign any of his textual works could be associated with another idiosyncrasy of Alessandro Maggiori's biography: the complete absence—so far not contradicted by any retrieval—of a portrait, or any representation of the collector's physical aspect. In spite of the expanding interest in Maggiori's intellectual physiognomy and the critical knowledge of his achievements both as an art collector and a writer, the actual appearance of his face still remains a mystery.

Figure 11. Alessandro Maggiori, *Dell'Itinerario d'Italia e sue più notabili curiosità d'ogni specie* National Art Library, London

5. Inside Domenico Corvi's Studio-Academy in Rome

As Ricci mentions, the years spent in Rome were of vital importance in the development of Alessandro Maggiori's intellectual proclivities, chiefly by virtue of his becoming a mature student within the studio-academy organized by Domenico Corvi.[31] Born in Viterbo in 1721, Corvi became one of the leading figures in the artistic circles of the capital in the second half of the eighteenth century, at a time when different styles were gradually emerging and detaching themselves from Baroque and Rococo formulas to assume a more classically oriented system of formal references, thus defining tendencies usually referred to as Neoclassical. As we shall see in this chapter, Maggiori's relationship with Corvi played a central role in the artistic education of the former. Thanks to this most promising encounter, in fact, the Count was introduced to a richer panorama of aesthetic ideas and artistic ideals. One could even argue that Alessandro's predominant taste in matters of art, which first emerged during the Bolognese period, was significantly enriched and brought to a complete maturation in the years spent in contact with Domenico Corvi in Rome.

We do not know, however, the precise dates of Maggiori's stay in Rome. It is nevertheless possible to hypothesize, on the basis of notes written on some drawings purchased by the Count, that he may have been living in the capital rather regularly between 1801 and 1803, the year of Corvi's death. No concrete evidence exists, however, regarding his presence in that city—or elsewhere for that matter—in the years between 1797 and 1800. Most unfortunately, the epistolary exchange with his father stops in 1796, whereas the earliest purchase of drawings in Rome begins with the date of 1801. What happened to Alessandro Maggiori in these particularly turbulent years in the history of Italy?

According to Luigi Dania,[32] Maggiori would have moved to Rome in 1798, a date that, it is important to emphasize, was quite significant to the city, for it had become, from February 15 until September 1799, the capital of the brief and troubled Roman Republic, as a consequence of the unstoppable advance of Napoleon's *Armée d'Italie* over the peninsula. It is possible, therefore, if not probable, that Alessandro Maggiori was already in Rome in those years of tormented political readjustment.

With regard to his relationship with Domenico Corvi, it is essential to bear in mind, first of all, the profound aesthetic affinity that tied Alessandro to Corvi. Corvi had begun his career as a painter, in his contacts with another master born in The Marches, Francesco Mancini, in whose studio his presence is documented in 1736.[33] Some years later, in 1750, when Mancini was elected Prince of the Academy of S. Luke in Rome—the most prestigious institution of the town in the field of the Fine Arts—Corvi would win, *ex equo* with the French painter Jean-François Vignal, the first prize in a contest sponsored by Pope Clemens XI, presenting a drawing depicting an episode from Joseph's life. The drawing, now lost, is recorded in written sources.[34]

Two years later, in 1752, Corvi was already able to organize, in his own house, a private academy of art, as confirmed by Stella Rudolph's recent investigations.[35] In this academy it was possible to study anatomy directly from natural models as well as through the copying of ancient statues or Renaissance prints, as Corvi himself clarifies in a letter written on December 22, 1752, addressed to his friend, the painter, architect, and art theoretician Giannandrea Lazzarini from the town of Pesaro, a name that also frequently appears in Alessandro Maggiori's books.[36] To quote Corvi's own words: "I assure you [Lazzarini] that here, in my academy, we work as everyone should, since we are a gentlemen's gathering, among whom is the Count Antonelli. [...] We have as a model a most beautiful ancient statue, similar to the Gladiator."[37]

Evidently, the anatomical studies played an essentially instructional role within the academies of art, for they provided exemplary models for the aspiring artists. Along with ancient prototypes, however, the young students

were expected to dedicate themselves to the study of modern examples belonging to the classicist tradition, such as Raphael, Carracci, and Maratti, without forgetting to pay attention to the most promising artistic solutions offered by contemporary masters, like Marco Benefial and Francesco Mancini. Without establishing any distinction between past and present canons, but implicitly proposing, on the contrary, a concept of beauty that appears as an immanent ideal of perfection or a transhistorical paradigm of artistic excellence, Corvi promoted, in his works as well as in his pedagogical schemes, a suggestive balance between classically oriented visual codes that were borrowed from ancient statues, as well as more dynamic and naturalistic approaches, partly due to the direct observation of living models.

Furthermore, the fact that Corvi was able to organize a private academy in his own house around 1752 clearly confirms that he had by that time reached a quite privileged social position within the artistic community of Rome. It is important to remember that, in that same period, other highly regarded masters working in the capital, such as Pompeo Batoni and Anton Raphael Mengs, had also opened their own studio-academies. As noted by the Italian scholar Stefano Susinno in his research on Domenico Corvi, "around the 1780s and 1790s, a young student could have chosen among at least a dozen schools, from the famous ones, such as those organized by Batoni, Mengs, and Corvi, just to mention some of the most authoritative names, to the studios of Tommaso Conca and Stefano Tofanelli."[38]

Unlike other training academies in mid-eighteenth-century Rome, however, the stylistic vocabulary promoted by Corvi's studio was much more indebted to the lessons of classicist masters, such as Carlo Maratti, than to the intensive examination of ancient prototypes. Maratti, a painter originally from The Marches, had become, between the last decades of the seventeenth century and the beginning of the following century, one of the most prominent figures of the Roman artistic panorama.[39] His pictorial creations, which tended to bridge a conscious continuation of the reform efforts inaugurated by the Carracci and the present, offered a solid connection between the heroic classicist climate of the Renaissance and its multiple subsequent developments, especially throughout the seventeenth century in Rome and Bologna. In these settings, the classical legacy seemed to be the consequence of a ceaseless examination of the formal lexicon established by masters such as Raphael and the Carracci, rather than the result of a continual distillation of forms and motifs directly borrowed from ancient fragments. It might be more appropriate, therefore, to refer to this specific kind of Renaissance-oriented art as a Neo-Raphaelism, a Renaissance Nostalgia, or even a Renaissance Revival, instead of simply adopting Neoclassicism—the recurrent and yet perhaps dismayingly generic expression.

Such a shift of attention toward Renaissance paradigms is, in fact, the most striking difference between the methods and models adopted by Corvi in his academy and the ones used, for instance, in Mengs's studio.[40] Whereas Mengs would most certainly have chosen his models from among the various examples offered by antiquity as canons of artistic achievement, owing to their *"edle Einfalt und stille Grösse,"* that "noble simplicity and serene grandeur" so programmatically decanted by his friend, the German theoretician Johann Joachim Winckelmann[41] in reference to Greek prototypes, Corvi would instead have privileged more Renaissance-centered solutions, largely borrowed from the creative patterns of Raphael and his school, without denying, however, the didactic relevance of those ancient parameters of beauty. Corvi had also demonstrated an avid interest in the styles of Annibale, Agostino, and Ludovico Carracci, as well as in the artistic solutions elaborated by their many Bolognese pupils, including Guido Reni, Domenichino, and Guercino, masters—one should not forget—whose paintings were eagerly observed and whose drawings were avidly collected by Alessandro Maggiori during and after his stay in Bologna.

Moreover, it is also important to emphasize the fact that the Roman academy organized by Corvi occupied a particularly central place in the education of artists coming from The Marches, the homeland of Raphael, Maratti, and Maggiori, a circumstance facilitating their introduction into the most exclusive artistic circles of Rome. This is

Figure 12. Anonymous artist, *Study of standing anatomical model*
Fondo Alessandro Maggiori, Biblioteca Comunale, Monte San Giusto, Italy

clearly attested in the letters exchanged between Corvi and Lazzarini, in which the colleague from Pesaro frequently reminds his reader of the reasons why he had preferred to send his own protégés to the Roman academy of his friend Corvi, instead of addressing them to any other local celebrities.

Such a privileged relationship between artists born at The Marches and the Roman academy of Domenico Corvi is emblematically clarified by a letter, dated 1774, sent by the Viterbese master to Lazzarini. In this missive, Corvi informs his friend that a certain Signor Giuseppe "has started to come to my academy and I have written a letter of recommendation on his behalf to the Capitol Academy. I have done the same thing for Signor Tomaso in order to make it possible for him to go to such an academy. Moreover, in the next days, I will introduce him to the best practitioners of architecture that we have here."[42] When Corvi uses the expression "Capitol Academy" in this letter he is evidently referring to the so-called "School of the Nude" inaugurated in 1754 on the Capitol Hill, under the protection of Pope Benedict XIV.[43] Therefore, this letter not only confirms the friendship that bound the two masters—one, a famous member of the Roman academy of S. Luke; the other, a leading exponent of the Academy of Pesaro—but also reasserts the preeminently pedagogical nature of their exchanges. One could even argue that such a friendship ended up by transforming the Roman studio of Domenico Corvi into an indispensable point of reference for any young artist originally from The Marches who wanted to successfully start his creative enterprises in the capital. This was, for instance, what happened to Alessandro Maggiori himself.

Maggiori's unconditional admiration for Corvi is well documented by drawings belonging to his collection that recall, stylistically as well as formally, the master's studies in anatomy (fig. 12). In fact, as Corvi's letters to Lazzarini amply indicate, the study of anatomy used to constitute one of the most important practices that a young artist was expected to pursue during his initial path of education and, for this very reason, it was strongly promoted within Corvi's own studio as a central part of the training process. As the Italian writer Pellegrino Orlandi stated in his *Abecedario Pittorico* (Manual of Painting)—another source mentioned several times by Alessandro Maggiori[44]—such a practice could be done "after the ancient, as well as from the natural," that is to say, either imitating actual living models or emulating the forms of ancient casts.

From a pedagogical perspective, in inviting his students to depict models "from life"—which could have meant representing a human body either on the basis of observation of nudes or by the copying of statues—Corvi was following a didactic practice already well-established by that time, and one diffused among other institutions. This practice implied a systematic reversibility between living models and the casts of statues, since the poses of the models were often chosen in a way that could allow students, to explore the natural mechanics

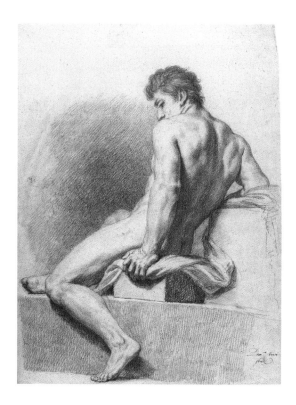

Figure 13. Domenico Corvi, *Anatomy*
Pinacoteca di Brera, Milan, Italy

of the bodies while also recalling ancient as well as Renaissance prototypes, thus establishing an indissoluble symmetry between the perception of reality and the projection of classicist canons of beauty.

A good example of this practice of "meta-poses" is represented by a drawing elaborated by Domenico Corvi and now preserved at the Pinacoteca di Brera, in Milan (fig. 13). Although the drawing is most certainly the result of the direct observation of an actual living model, the pose of the figure belongs to a rather significant formal lineage, for it reminds the viewer unequivocally, in a backward process of intervisual connections, of images depicted by Carracci (fig. 14) and Michelangelo (fig. 15), respectively, in the Farnese Gallery and in the Sistine Chapel, which were in turn programmatically inspired by the *Belvedere Torso* (fig. 16). As the consequence of such a culturally oriented practice of studying anatomy, in which the poses are both an exploration of nature and a journey in the vocabulary of art, the resulting drawing is a visual construction that should be praised for its high degree of naturalism as well as for its incisive reappropriation of past models. In other words, the work produced is worthy of collecting not only for its mimetic qualities, but also—and maybe above all—for its metalinguistic implications.

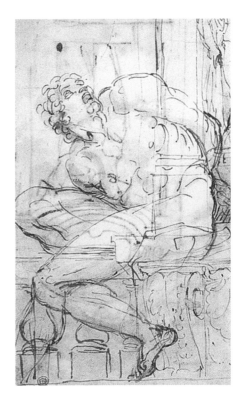

Figure 14. Annibale Carracci, *Study for nude figures in the Farnese Frieze* École Nationale Supérieure des Beaux-Arts, Paris

In the case of Corvi's anatomy studies, the process of representation from life seems to stimulate an implicit comparison between art and nature, past and present. Simultaneously, the meticulous study of the human figure had become a double-sided moment of investigation, for it required an attentive analysis of natural forms as well as a selective recreation of classical principles of perfection. By observing

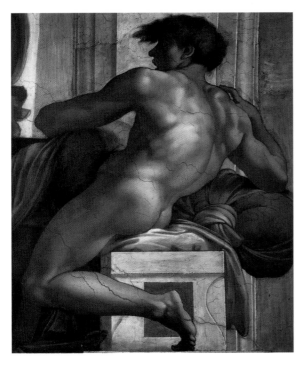

Figure 15. Michelangelo, *God separates the waters from the heavens* (detail) Sistine Chapel, The Vatican, Rome

Figure 16. *Belvedere Torso*, 1st century CE Museo Pio-Clementino, The Vatican, Rome

some of the anatomical drawings made by Domenico Corvi, one can notice an important shift that has occurred in the master's schemes of representation. Here, in some of these drawings now at Brera, Corvi has consistently turned from a rigidly classically oriented lexicon to a much more descriptive and naturalistic style in order to render the shapes of the human body in strict accordance with their actual models, instead of rebuilding them according to a more idealized set of forms and formulas borrowed from ancient examples.[45]

The Brera drawings thus document the flourishing of a special instance of study. This study was marked by a didactic method already established by previous masters and quite diffused among sixteenth-century Italian academies, whose pedagogical roots in turn were grounded on the assumption that every artist needed to go through the various steps of a progressive learning process before becoming a truly accomplished master. Consequently, young artists were invited to start their apprenticeship by depicting, at first, only simple forms, usually anatomical details, such as eyes, arms, or hands, whose taxonomical forms are not at all dissimilar to some of the drawings collected by Alessandro Maggiori (fig. 17). Then the aspiring artists would gradually begin to represent increasingly more complex visual constructions, such as human emotions or figures in action. Once he had learned what the sixteenth-century master Federico Zuccari used to call "the alphabet of the art," that is to say, the depiction of anatomical parts such as noses, feet, and legs, the student would finally dedicate himself to the representation of entire bodies, thus overcoming the initial "visual metonymies" and ultimately elaborating complete "figurative sentences." The demanding practice of studying from life generally constituted one of the final steps within this articulated path of education, for it definitely allowed the young artists to learn not only how to conceive their own compositions but also how to respect, on the one hand, the variegated shapes of nature and, on the other, the ordering rules of art.

Figure 17. Anonymous artist, *Study of an arm, leg, hands, and feet*
Fondo Alessandro Maggiori, Biblioteca Comunale, Monte San Giusto, Italy

Such a working method, based upon the study of anatomical models, whether real or ideal, had become a widely diffused practice among Florentine masters ever since the second half of the fifteenth century. However, it was only during the eighteenth century that it became an institutionalized *modus operandi* in other cultural contexts, such as Rome and Bologna, especially after the inauguration, in 1754, of the School of the Nude on Capitol Hill, soon known as *Schola Pictorum Capitolina* (the Pictorial School of the Capitol).[46] This academy became the point from which a rather ambitious project of didactic reform originated, one directly associated with the foundation, two decades earlier, of the Museum of Antiquity, in 1734, also located on the famous Roman hill. This was an explicit attempt to provide models for contemporary artists that could guarantee the development of the "beautiful arts of drawing" in accordance with classicist canons. Among the various professors who taught at the School of the Nude, it is worth recalling at least two leading protagonists of that art who were active in Rome between the eighteenth and the early nineteenth century, namely Anton Raphael Mengs, in 1755, and Antonio Canova, from 1802 to 1812.[47]

Affiliated with the Roman Academy of S. Luke, the School of the Nude provided two terms of study, summer and winter, during which it was possible to study the human figure from life. As written sources confirm, each professor directed the course for a month, during which he was responsible for choosing the weekly pose

of the model. In addition, both the poses and attitudes were chosen in order to stimulate the artists to explore the structure of the human body in relation to its potential expressions, according to the humanistic-related belief in a direct correspondence between physical motions and inner emotions. Such a training practice could be appropriately called a "metonymic method," for it tended to establish a clear path of progression from the depiction of isolated details to the advanced capacity to create more intricate compositions—from head and hands to whole figures, so to speak. During this process of observation-emulation, the artists were expected to investigate any element that could help them to conveniently prepare their own compositions, taking care not to neglect any component that could be taken from the classical as well as classicist tradition. For this reason, students were required to carefully learn how to represent not only human bodies, but also draperies and ornaments.

Not by accident, one can find among the drawings formerly belonging to the Alessandro Maggiori collection excellent examples related to these different stages of representation. It seems clear that a particular didactic concern, associated with the metonymic method, seems to have conditioned, at least partly, the organization of this collection, since among the many drawings gathered by the Count a quite consistent number of images represent anatomical fragments, sometimes meticulously rendered, along with others done in a quicker way (fig. 18). These works unmistakably recall the kind of anatomical depictions elaborated by artists during the practice of drawing from life, as promoted within Roman studio-academies such as Corvi's. Furthermore, the presence of several studies of drapery along with the many depictions of delicate ornaments, like *grottesche* (grotesques), reinforce the hypothesis that, behind the establishment of the Alessandro Maggiori collection, there may have been a precise, academically oriented intent.

Figure 18. Anonymous artist, *Study of crossed arms*
Fondo Alessandro Maggiori, Biblioteca Comunale, Monte San Giusto, Italy

The circulation and dissemination of this training method during the eighteenth century—in a revealing continuity between the academic experience of such pioneers as the Carracci, and the more recent institutionalization of this pedagogical trend in the Roman School of the Nude, not to mention the studies from life conducted at Corvi's workshop—constitutes an important precedent for Alessandro Maggiori's interest in collecting drawings. It can be seen even in small fragments of certain drawings in which the human body, as well as draperies and decorative schemes, is depicted. The role played by the metonymic method in the education of young artists seems to have informed the very constitution of the Maggiori collection and could be considered, therefore, as a fundamental point of reference for its historical comprehension.

Moreover, the evident necessity for an artist to demonstrate his own dexterity in the field of anatomy is loudly and proudly proclaimed by Domenico Corvi himself in his monumental *Self-portrait* (fig. 19). Executed in 1785 for the Grand Duke of Tuscany, Pietro Leopoldo dei Medici, this portrait was intended to be included in the prestigious gallery of illustrious men gathered at Gli Uffizi.[48] Significantly, two years later, in 1787, both Mengs and Batoni received a similar commission.[49]

Corvi's *Self-portrait* presents the master comfortably seated in his studio, with reflective eyes looking upward; he is wearing, with aristocratic nonchalance, a domestic dressing gown, while a brush held in his right hand firmly touches the canvas on which a standing Hercules is represented, a figure which, despite its sinuously naturalistic

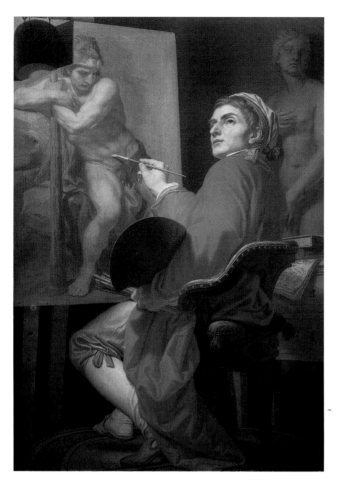

Figure 19. Domenico Corvi, *Self-portrait*
Galleria degli Uffizi, Florence, Italy

forms, brings immediately to mind a precise ancient model—the *Farnese Hercules*—as well as the anatomical exercises practiced in academic settings such as Corvi's studio in Rome or the *Accademia Clementina* in Bologna, as unmistakably confirmed on the cover of Zanotti's volume on the history of the Bolognese institution. From a morphological standpoint, the soft rendering of Hercules's body echoes visual codes and formal models that belong to the Bolognese classicist school and, more specifically, to the circle of Annibale Carracci. In the background, the image of the *Medici Venus* recalls, as a visual metonymy, the collection of ancient art gathered by the patron's family, while simultaneously underlining the educative validity of copying antiques. The statue, however, does not appear isolated in its didactic claims. Next to it, in fact, some volumes (one of which shows the inscription "Prosp," that is to say, *prospettiva*, or perspective) are posed directly on the ground, along with some sheets on which appears the master's signature, *D. Corvi*, with a series of geometrical and anatomical schemes accompanied by an unreadable text.

It is evident that the artist's intention here, as it would be for anyone who was willing to achieve a successful process of artistic education, must be to show the decisive function exercised by the study of ancient statues, as well as the need to know the art theories of the past. Moreover, the drawing depicted within the painting further confirms its didactic aims, for the schematic face represented on the sheet—in an extraordinary *mis-en-abîme* in which Corvi *represents* a *representation*—repeats the standard formula already adopted by Renaissance artists in the attempt to build up a human face, as illustrated, among other masters, by Albrecht Dürer in the plates and diagrams of stereometric heads printed in his treatise on the measurements of the human body, entitled *Underweysung der Messung* (The Painter's Manual), a method widely diffused in eighteenth-century academic settings even outside Italy, as demonstrated by the plates engraved by Nicholas Dorigny for the volume *The School of Raphael*.[50] In the case of Corvi, the artist emphasizes, by means of a metalinguistic device, the intellectual, rational, and therefore measurable roots of the pictorial construction of any form, including the parts of the human body. In other words, if a painter wishes to represent a figure as harmoniously and vividly as Corvi did in his *Hercules*, it is first of all necessary to undertake a long training process, during which the observation of nature, the assimilation of ideal parameters of beauty, and the apprehension of theoretical premises are expected to play equally important roles.

Theory and practice are thus united in the creation of natural, beautiful, and selective images, such as the ones elaborated by Raphael and the Carracci in the past, whose ideas in the realm of art theory were promptly examined by the Roman writer Giovan Pietro Bellori in his *Vite dei Pittori, Scultori et Architetti Moderni* (The Lives of Modern Painters, Sculptors, and Architects), published in 1672, a book greatly admired by both Corvi and Maggiori.[51] According to Bellori's influential theory, ideal forms are always superior to the chaotic confusion of merely natural

elements; consequently, artists are called to render the forms of nature more beautifully and perfectly than any mirror could by following their "learned" hands as well as their "judicious" minds, instead of simply providing a mimetic reproduction of the surrounding world. Such a classicist alliance between theory and practice, nature and culture, was praised by Bellori as the highest task of art; this achievement it is also singled out quite eloquently by the eighteenth-century art historian Luigi Lanzi as Corvi's most distinguishing characteristic. In his *Storia Pittorica d'Italia* (Pictorial History of Italy), first published in 1793, Lanzi in fact remarks: "He [Domenico Corvi] was a truly learned painter, one who could be compared to few others in anatomy, perspective, drawings. He got from his master [Francesco] Mancini a certain idea of the Carraccesque taste and has always kept it."[52] Given the centrality of Luigi Lanzi's *Pictorial History* as a source for Alessandro Maggiori's critiques on art and statements as a connoisseur, we will dedicate a whole chapter to this important art historian from The Marches.

To conclude, the "metonymical method" diffused among eighteenth-century Roman academies of art, in general, and in Corvi's studio, in particular, not only oriented the technical habits and the stylistic tendencies of classicist-based artists, but also conditioned the aesthetic preferences and critical categories adopted by connoisseurs, *dilettanti*, and art collectors, thus extending the boundaries of academic influence beyond the walls of any private or public school. The didactic model diffused within and institutionalized by the practice of art undertaken in these academies became the tangible sign of a sense of cultural belonging in eighteenth-century Rome, one that presupposed the sharing of common technical, aesthetic, and theoretical premises among the members of a specific cultural setting. Put another way, by the end of the eighteenth century academies assumed a relevant social dimension in towns like Rome and Bologna, a status held by virtue of their capacity to offer a transmissible grid of critical as well as creative coordinates to the various exponents of the "imagined community" gravitating around the world of Neoclassical or Neo-Renaissance oriented art.[53]

It seems legitimate, therefore, to ask what could have been the effect of the role played by Domenico Corvi's academy on the artistic education of Alessandro Maggiori in order to better understand whether, how, and to what extent such a sphere of influence could have guided the establishment of his remarkable collection of drawings. Before answering this question, however, it is necessary to take a step backward and examine, however briefly, the historical development of some important Italian academies of art between the sixteenth and the eighteenth century, from the pioneering *Accademia del Disegno*, founded in Florence in 1563, to the *Accademia Clementina* inaugurated in Bologna in 1710. In doing so, it will be possible to more fully comprehend, this time from the perspective of academic training, Alessandro Maggiori's profound and self-conscious debt with to past.

6. *The Naked History of Italian Academies of Art*

The year 1563 represents a crucial moment in the history of academies of art, for that date marked the moment at which the prototype of many future institutions dedicated to the teaching of art was founded in Florence: the *Accademia del Disegno* (the Academy of Drawing), supported financially by the Grand Duke of Tuscany, Francesco de' Medici, and relentlessly promoted by the painter, architect, and writer Giorgio Vasari.[54] From its very start, the academy has attempted to guarantee a correct path of education for artists by perpetuating, as an immanent patrimony, forms, styles, and working methods belonging to the classicist tradition. Along with the teaching of principles consensually regarded as indispensable to achieve the manual as well as the intellectual development of an artist, the academy was also intent on offering to young students a rich repertoire of models that could help reinforce their innate abilities.

Within this path, as set down in its formation, the study of human anatomy occupied a central position. From the representation of emotions to the accurate depiction of muscles and bones, the study of anatomy became, as early as in the fifteenth century, a fundamental field of practice in Italy. In the sixteenth century, the adoption of casts and fragments of ancient models, combined with the use of prints and drawings created by great Renaissance masters, became another common means through which the artists could exercise their own creative skills. To this end, different instruments and diverse didactic materials were offered to students, from the so-called *scorticati* (little statues), usually made of wax or terra-cotta, representing the human body in various attitudes, to illustrations borrowed from treatises on anatomy, such as Vesalius's monumental volume, published in 1543.[55]

Throughout this learning process the young artist was not only expected to create anatomically correct bodies, but was also asked to depict figures that could bring together the prerequisites of natural forms with the paradigms of an ideal concept of beauty, thus overcoming the merely mimetic basis of visual representation. For this reason, along with the study of anatomy from life, generally based on copies or ancient casts, the student was also required to assimilate the different manners and styles of those masters who were considered particularly exemplary, such as Raphael and the Carracci, in the attempt to develop, by the end of this long path of education, a personal vocabulary of forms. Given that the process of representation was regarded, from a classicist perspective, as a selective activity of emulation in which the direct experience of natural phenomena was transformed into the assimilation of aesthetic codes, the young artist was also expected to learn how to follow the laws of nature and, at the same time, how to respect the parameters of artistic decorum.

In order to achieve such a goal, students would copy either models from antiquity or the works created by paradigmatic artists from past and present days. Making drawings thus became the core of any didactic agenda, not only for young apprentices but also for accomplished masters. The exercise of the hand, supported by a continual theoretical reflection, began to occupy a central position in academic life, as clearly documented in a 1531 print executed by Agostino Veneziano, after a composition by Baccio Bandinelli, representing what is usually referred to as the *Academy of Baccio Bandinelli in Rome* (fig. 20),[56] in which the practice of drawing and the empirical observation of models appear as the real protagonists of the training process.

In another print, executed by Enea Vico and depicting the *Studio of Baccio Bandinelli* approximately twenty years later (fig. 21), the protagonists of the scene appear to be, once again, engaged in the making of drawings, but the typology of the exemplary models is now significantly enlarged and includes, among ancient casts, skeletons as well as portions of the human body.[57] Moreover, the very act of drawing seems to be separated from the effective observation of the exemplary models, which literally lie on the ground or are dismissively placed on unreachable

Figure 20. Agostino Veneziano, *The Academy of Baccio Bandinelli*
Fine Arts Museums of San Francisco, California, anonymous gift through the Patrons of Art and Music, 1959.132.1

shelves. The act of drawing clearly emerges, in this print, as an essentially mental issue, as Leonardo had firmly declared. Detached from any empirical observation, the creation of drawings seems to be the result of an intellectual act of introspection more than the record of actual forms.

A few years after the foundation of the Florentine *Accademia del Disegno*, the hegemonic position of the concept of drawing as the Father of the Arts, as Vasari had claimed, was consistently confirmed by the publication of several pedagogically oriented art treatises

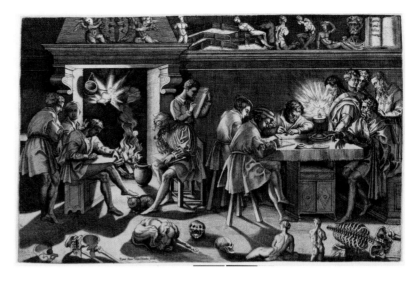

Figure 21. Enea Vico, *The Studio of Baccio Bandinelli, after Baccio Bandinelli*
Fine Arts Museums of San Francisco, California, Mr. and Mrs. Marcus Sopher Collection, 1986.1.310

and academic discourses, such as Alessandro Allori's *Dialogo sopra l'arte di disegnare le figure* (Dialogue on the Art of Drawing Figures) (fig. 22), printed in 1565, or Vincenzo Danti's *Primo libro del trattato delle perfette proporzioni* (First Book of the Treatise on Perfect Proportions), published in 1567.[58] Moreover, at about this time drawings began to be regarded not simply as limited to a specific medium or technique, but in addition as documents of manners and styles adopted by different masters, thus increasing immeasurably their value as objects worth preserving, protecting, and collecting. From this moment on, drawings would be seen, in fact, as faithful carriers of the

Figure 22. Alessandro Allori, *Dialogo sopra l'arte di disegnare le figure* (Fol. 7, verso)
Biblioteca Nazionale Centrale, Florence, Italy

legacy of "the most illustrious artists" so diligently described by Vasari in the sixteenth century and by Bellori in the seventeenth. No wonder, then, that the author of the *Lives* would become himself an indefatigable researcher and collector of drawings. Conscientiously kept in frames carefully designed by Vasari, the drawings, thus united, composed what became universally known as the *Libro dei disegni* (Book of Drawing).[59] It is also no surprise that Bellori too possessed a quite astonishing body of drawings.[60]

A similar correspondence between academic training and collecting drawings took place in Bologna, but many years earlier, around the end of the sixteenth century, when Ludovico, Annibale, and Agostino Carracci founded what was at first called the *Accademia dei Desiderosi* and later renamed the *Accademia degli Incamminati*.[61] According to seventeenth-century sources, Agostino inaugurated in this academy a quite innovative teaching method by making several drawings in which anatomical details such as eyes, hands, and legs were represented from different sides in a highly repetitive way (fig. 23). In fact, the obsessive repetition of these elements, depicted over and over on the same sheet, ended up by transforming those forms into lucid, almost clinical figurative formulas that were easily studied and, consequently, could be adopted by any apprentice, no matter how inexperienced he may

have been. The constant and diligent copying of these schemes, with the crystallization of their morphologies into clear patterns, was believed to facilitate the fruitful development of students' manual and mnemonic skills. At the conclusion of such a mechanical, almost mnemonic, process of (meta)imitation—with its divisions between observation and repetition, record and memorization—the young artist would eventually become able to draw any form or figure from life as well as from his own imagination. The systematic imitation of anatomical details, transformed into authentic visual patterns, was believed to increase the artist's mimetic as well as inventive dexterity.

Figure 23. Agostino Carracci, *Features and figure*
The Royal Collection © 2011 Her Majesty Queen Elizabeth II

The Carraccis' teaching methods most certainly stimulated the appearance of the pedagogical volumes known as "drawing books," which were widely distributed throughout Bologna in the seventeenth century, as previously suggested by other scholars.[62] Particularly famous among those volumes was the compilation of graphic schemes published by Odoardo Fialetti in 1608, under the emphatic title *Il vero modo et ordine per dissegnare tutte le parti et membra del corpo humano* (The True Mode and Rule for Drawing All Parts and Members of the Human Body) (fig. 24).[63] Another renowned example of handbooks of this kind was the volume, published at an unknown date but certainly in the Bolognese area in the first half of the seventeenth century, entitled *Scuola perfetta per imparare a disegnare tutto il corpo humano cavata dallo studio, e disegni de Carracci* (The Perfect School for Learning How to Draw the Human Body, Based upon Studies and Drawings by Carracci).[64] Finally, a most sophisticated example of these didactic publications can be found in Giuseppe Maria Mitelli's exquisite volume, printed in Bologna

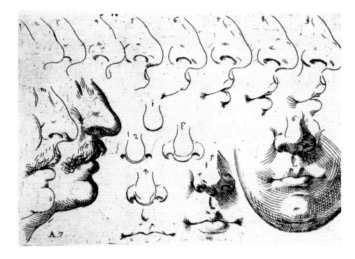

Figure 24. Odoardo Fialetti, *Features* from *Il vero modo et ordine per dissegnare tutte le parti et membra del corpo humano*
Biblioteca dell'Archiginnasio, Bologna, Italy

in 1683, and poetically entitled *Alfabeto in sogno: Esemplare per disegnare* (An Alphabet in Dream: Drawing Examples) (fig. 25), in which the letters of the alphabet appear intricately inserted alongside details of the human body, creating a rather hybrid articulation of visual forms and verbal signs.[65] A hilarious visual comment on the academic goals to be achieved through the careful study of bodies from life is the object of a caricature designed by Pietro de Rossi and engraved by Mitelli in 1686, with the eloquent caption *Accademia degli Scontornati*, or the Academy of the Contourless.

Within this context of pedagogically oriented depictions of the human body, another good example is the text written and illustrated by Carlo Cesio, with the title *Cognitione de muscoli del corpo humano per il disegno. Opera di Carlo Cesio* (Understanding the Muscles of the Human Body for Drawing, by Carlo Cesio), published in Rome in 1697.[66]

In their ambitious taxonomic agenda, all these volumes document the paradoxical confidence of seventeenth-century pedagogy, which held that most aspects pertinent to the artistic sphere could be taught. Nevertheless, the debate about the transmissibility—or not—of Prometheus's fire to the future professors of drawing was a recurrent

Figure 25. Giuseppe Maria Mitelli, first page from *Alfabeto in sogno: Esemplare per disegnare* Biblioteca dell'Archiginnasio, Bologna, Italy

one in art literature between the sixteenth and the eighteenth century. On one hand there would be the promoters of an absolute belief in the powers of a proper artistic education, especially through the training practices organized by or undertaken within the academies; on the other, there were those patrons and artists who drastically limited and reconsidered the effective didactic potential of these methods, to the point of criticizing the very efficiency of the academies as pedagogically relevant institutions.

With regard to this topic, the position of the Italian painter Carlo Maratti is very revealing. A master whose creations were deeply admired by Domenico Corvi and eagerly collected by Alessandro Maggiori, Maratti was eloquently praised by Giovan Pietro Bellori, in his *Lives*, as a "new Raphael."[67] It is possible to reconstruct the artist's ideas about the extent to which art could be taught thanks to the analysis of a print depicting an academy of art (figs. 26–27), engraved by the French master Nicholas Dorigny after a preparatory drawing made by Maratti.[68] The print is significantly dedicated: *A Giovani Studiosi del Disegno* (To Young Students of Drawing), and constitutes an important visual document for an understanding of the pedagogical directives pursued by the master born in The Marches, whose workshop and methods strongly influenced eighteenth-century academies, such as Domenico Corvi's in Rome, due to their sharing a common stylistic agenda, which originated in their attempt to unite the placid classicism of Raphael with the selective naturalism of seventeenth-century Bolognese masters. More importantly, such a

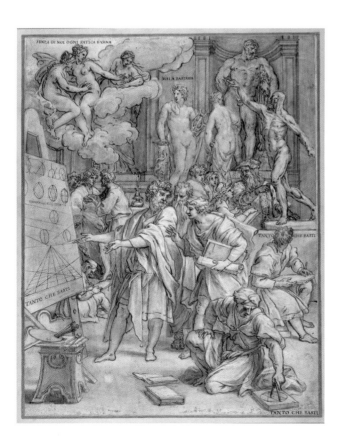

Figure 26. Carlo Maratti (1625–1713), *The School of Design (Accademia della Pittura)*
© Devonshire Collection, Chatsworth.
Reproduced by permission of Chatsworth Settlement Trustees.

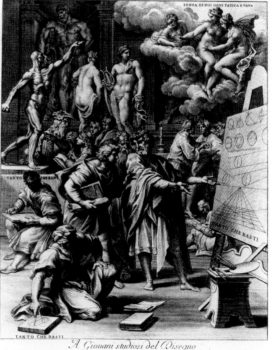

Figure 27. Nicholas Dorigny (after Carlo Maratti), *The School of Design*
Istituto Nazionale per la Grafica, Rome

programmatic stylistic agenda seems also to have constituted the guiding aesthetic grid upon which the Maggiori collection was formed.

By borrowing forms, poses, and motifs from Raphael's *School of Athens*, the print celebrates the Renaissance master as the supreme example of artistic perfection. According to Bellori—author of the first detailed biography of Carlo Maratti—the seventeenth-century master had always professed an unconditional admiration of Raphael, and defined him as a "guide above anybody else."[69] In the foreground of the print, a man is represented in the act of drawing, with the help of a compass, a geometrical figure similar to those depicted on the panel set on the easel. This figure seems to attract, in turn, the attention of two other men engaged in a quite vivid conversation. In the background, at the left side of the composition, the unmistakable physiognomy of Leonardo da Vinci is portrayed, as he indicates to a group of young people the statue of a *scorticato*, the cast of a naked figure. Below the statue is carved the Italian inscription *tanto che basti* (as much as necessary), significantly repeated three times within the same composition. This expression recalls a statement made by Maratti himself. According to Bellori, in fact, the master would have endlessly repeated to his pupils that anyone willing to become an artist should constantly devote himself to the correlated fields of geometry, perspective, and proportions—provided, however, that he should not lose too much time in these territories of study, only exploring them "as much as necessary," without any aesthetic obsession.

The print seems to assert, therefore, that once an apprentice had learned the basic rules and tools of art he should definitely try to go beyond them, instead of slavishly following geometrical or mathematical devices. At the same time, he should not forget to seriously pursue the analysis of ancient models, represented in the print under the metaphorical forms of Hercules, Venus, and Apollo. Not by accident, beneath Apollo's head another lapidary sentence is written in Italian: *mai abbastanza* (never enough). In other words, only by means of constant practice (as represented by the seated figure behind the easel) and the promising exchange of ideas among learned artists, *dilettanti*, and patrons (as suggested by the three men in discussion next to the easel), can a young artist finally reach the supreme ideal of beauty. This supreme ideal is one that is not determined by any fixed geometrical grammar, nor by any mathematically-based formulas, but guided instead by a much more subtle and flexible paradigm: "grace" (represented in the print through the figures of the Three Graces.) As the motto above the three divinities clearly indicates in Italian, *senza di noi ogni fatica è vana*: "without us [the Graces] all effort is in vain."

Clearly, Maratti's image focuses on the prominent role played by this concept of grace within the process of artistic creation, simultaneously stressing the need to first acquire the basic rules of art in order to later on become able to go beyond such a horizon of prescriptive norms, by then elaborating works truly touched by the ungraspable principle of grace, or *grazia d'arte*, a grace that, without ceasing to be personal, is nonetheless capable of uniting itself with the great tradition of the past. To put this another way, according to Maratti some elements pertaining to the realm of the arts cannot be taught, given that an important part of artistic activity lies precisely in its variable quotient of uncertainty, and in that ungraspable unpredictability that marks decisively yet subtly the difference between the power of grace and the effects of beauty. If beauty, in its measurable components, can be transmitted and objectively evaluated, in accordance with such Renaissance-related standards as measure and proportion, then grace should be considered differently, as the result of more personal declinations of the visual vocabularies consensually disseminated within a certain tradition.

This being the case, the primary task of an academy should be to guide and instruct, to stimulate and facilitate the development of any young talents by providing efficient methods and samples of perfection, but without attempting to establish overly rigid limitations, whether from a technical, stylistic, or canonical point of view. According to this didactic premise, an academy should promote methods and models clearly in consonance with a specific horizon of artistic references—namely, the sphere of classical or classicist forms—but should

not impose any aesthetic axioms within these boundaries. As is implied in the visual discourse of Maratti's composition, there is no such a thing as a unique prototype of beauty, not even among classically oriented masters, but rather a plurality of "tempers" and "geniuses" able to create, out of their own individuality, "perfect" works of art that could resume a productive conversation with their multilayered tradition. It is for this reason that, since the second half of the sixteenth century, it became so important to collect as many "examples of perfection" as possible, especially among prints and drawings, for these media were believed to document with particular immediacy the cohesion, and also the vastness, of this classical–classicist repertoire of references. As a direct consequence of such an aesthetic agenda, the production of art became a process of meta-artistic exploration. To see what Maratti's work meant, from this hermeneutic perspective, was to understand how the master was able to engage himself in a visual exchange with Raphael, as well as antiquity and nature.

It is thus no mere coincidence that Carlo Maratti became one of the greatest collectors of graphic works in Rome between the seventeenth and the eighteenth century. In 1703, when the artist was still alive, part of his impressive collection was acquired by Pope Clemens XI Albani—whose family was originally from The Marches and, more precisely, from Urbino—as documented by the publication of a solemn *Avviso* on April 3:

> The pope having heard that the celebrated painter Carlo Maratti, a master of venerable age, had sold for five thousand *scudi* his studio of painting [that is to say, his collection of artworks] to an Englishman, he [the Pope] called the gentleman and said that these precious studies and collection of rare things should not leave the city, in order to further promote the arts.[70]

The extraordinary collection of drawings gathered by Maratti constitutes—along with Giorgio Vasari's *Libro dei Disegni*, Cassiano dal Pozzo's *Museum Chartaceum*, and Padre Sebastiano Resta's *Portable Gallery*[71]—one of the most important precedents of Maggiori's enterprise, both from an historical as well as an aesthetic point of view. Significantly, Maratti's collection was also primarily focused, in a way that appears to be the result of a rather conscious choice, on the purchase of artworks deeply related to the Roman classical as well as classicist heritage, articulated in its ancient, Raphaelesque, and—above all—Carraccesque components. It is thus not surprising that among the masterpieces assembled by Maratti one could find cartoons made by Annibale Carracci and Domenichino as well as many drawings executed by prominent artists who had worked in seventeenth-century Bologna. The stylistic coherence of Maratti's collection appears, therefore, as the perfect visual equivalent of the pedagogical program illustrated in the previously examined print engraved by Dorigny.

On the basis of this dense territory of historical references, it is possible to argue that the drawings originally belonging to the Maggiori collection should be examined in the light of the dialectical relation between artistic creation and the academic teaching methods discussed earlier. As a matter of fact, not only was Alessandro Maggiori familiar with the didactic strategies adopted by Roman academies such as Corvi's, but he was also a grand admirer of Maratti's style and working methods. Furthermore, Maggiori most certainly must have known the typology of the introductory volumes so common among Bolognese institutions, such as Fialetti's and Mitelli's books, and may have used books such as these during his own artistic training, before going to Rome. This hypothesis is further supported by the fact that, even later, in the years spent in the capital, Alessandro Maggiori consistently purchased drawings in which only anatomical metonymies appeared, images quite similar to the ones used among academicians or described in those books for practical, training-oriented reasons. It appears truly revealing, moreover, that among the remaining prints gathered by Alessandro Maggiori one can find a series of fragments depicting small details of the human body, like those that presently make up part of the collection currently preserved at Monte San Giusto.

Also revealing, from this point of view, is a letter written by the Count in 1785, a date that precedes his first documented purchase among the drawings still preserved at Monte San Giusto. In this missive, Maggiori notifies his father about having received from a certain Vittorino some books, including a volume of Giorgio Vasari, along with a printed edition of the *Rimes* by Vittoria Colonna, and also a volume of poems by Veronica Gambara. Then, Maggiori claims to have additional material, gathered *in due fagottini di carta* (in two bundles of paper): in the first, he kept "some drawings and, in the other, some well-known pages on the Fine Arts" (*uno dei quail avvolsi de Disegni, in un altro de' noti fogli sulle bell'arti*). With regard to these drawings, the Count asserts:

> In those drawings I have mainly set all the remaining part of my examples of hands, feet, arms, etc. I have put also some figures made in black chalk, two hands and one head, all designed with black pen on dark paper, heightened with white chalk. Among the hands, two were depicted after Palma's very old model. [...] Among the feet, the two [inspired] by Reni and the other two by Milanese were executed after drawings by these masters that I had bought from the beginning. The other two [inspired] by the Great Carracci were copies from an ancient example by the same author, engraved and very rare [to find] at the present. The two last hands, depicted on blue-gray paper and heightened with chalk, were portrayed by me after an example of hands and feet gathered long ago, after the purchase of some sketches and drawings that had arrived to my hands. The first figure is by Rolli. The color is Caccioli's, and Canusti's. The [...] last is by Ludovico [Carracci]. As for the figures made in black charcoal, the first represents a philosopher that I copied from a beautiful drawing in my possession by Contarini, aka Simon from Pesaro, disciple of Guido Reno, his brave pupil at first and, then, a rebel. The second was copied from an example engraved by Mattioli, representing the Elder Man [probably from the iconography of Susanna and the Elder Men] by the grand Guercino.[72]

This letter seems to indicate that the Maggiori collection may have performed some kind of didactic function, for it provided—to an audience that still needs to be investigated—a compendium of models and styles very useful to any eighteenth-century artist, dilettante, connoisseur, or art collector. As the letter makes very clear, Alessandro Maggiori himself had realized copies from the original drawings made by famous Bolognese masters that had previously come to be part of his collection. Therefore, the Maggiori collection could be seen as a "portable museum" of exemplary artistic achievements, thus responding to specific pedagogical expectations, for it provided a set of models that could be used as visual tropes by the beholder. All he needed to do was to observe, imitate and, ultimately, assimilate such a coherent group of models throughout the training process, in order to become an expert master, a learned connoisseur, or both, as Alessandro's biography extensively confirms.

The fact that the drawings chosen by Maggiori were attentively selected among artworks largely—if not exclusively—produced by classicist-oriented masters is an interpretive clue that no one should minimize. Such a stylistic cohesion leads us, in fact, to consider the Maggiori collection in its multiple facets. It was a project clearly designed to fulfill different but intertwined didactic as well as aesthetic functions, thus characterizing itself as a specific type of collection in the vast eighteenth-century panorama in which a circumscribed range of styles, techniques, and subjects was purposefully united to define the boundaries of a Neo-Renaissance paradigm of art. But it was also an early example of the necessity of protecting the artistic identity of masters considered worth preserving; and, finally, it could be used as a "library-academy" or a "portable instructional gallery" of art, to paraphrase the expression coined by Padre Resta, in which one could find samples from the great masters of both past and present times.

In summary, the collection of drawings gathered by Alessandro Maggiori was profoundly linked, from its very beginning, to a classicist-oriented academic mentality. His stylistic preferences show unmistakable connections with Carlo Maratti's conception of art as well as with Domenico Corvi's methods of study. Furthermore, another important element that associates these two artists, clearly placing them in the role of enlightening predecessors of Alessandro's aesthetic agenda, lies in their common attempt to establish the boundaries of the classicist vocabulary within a genuinely Bolognese context. Despite the continual recall to the exemplary position occupied by Raphael's grace in the development of the "modern" arts, the authentic stylistic thread that links Maratti to Corvi, ultimately reaching Maggiori, is the deep admiration that all these protagonists felt toward such seventeenth-century Bolognese masters as Carracci, Reni, Guercino, and Domenichino—the last given the friendly nickname "Menichino" by the Count in his letters—and many other artists, who were equally praised for having inaugurated a promising creative season in which had been achieved a "renaissance" of the Renaissance, or a "Renaissance Revival" based upon a sense of cultural nostalgia. Thanks to these seventeenth-century masters, a new balance between classicist ideals and natural forms was reached, one in which the Roman grace of Raphael was further enriched by the Bolognese sense of naturalism.

One should not forget, however, that after the arrival in Bologna of his *S. Cecilia* in 1514, the Renaissance master himself had sealed the close connection between these two artistic centers. To Alessandro Maggiori's eyes, such a balance may have appeared the perfect antidote needed to prevent the decadence of the arts around the end of the eighteenth century, and to bring them back to their past greatness and glory, thus opening a path of artistic renewal that was, as I have argued, the reemergence of a devoutly Renaissance-related aesthetics. Moreover, this attempt to establish an artistic renewal also helped to promote, from an ideological perspective, creative traditions that, in spite of their clearly delineated regionalism (the "Bolognese School," the "Roman School," etc.), were also now beginning to be felt as specifically "Italian."

7. *Grace and The Bolognese Identity*

The critical acknowledgment of a distinctively classicist line of beauty—in which the ancient canons of perfection, retrieved by Raphael and corrected by the Carracci, had finally become the object of systematic exploration throughout the eighteenth century—found its most vital centers in Rome and, above all, in Bologna. For Bologna, an area politically subordinated to Rome and to the State of the Church until the institution of the Cispadane Republic in 1796[73]—is not by accident the town in which an important episode concerning the dissemination of classicist tendencies took place at the beginning of the eighteenth century, or more precisely in 1710, the date of the foundation of the *Accademia Clementina*.[74]

Housed in the elegant rooms of the Palazzo Marsilli, the Bolognese Academy found, in the pages of the *Storia dell'Accademia Clementina* (The History of the Clementina Academy), written by its secretary Giampietro Zanotti and published in 1739, a most accurate description of its aesthetic goals and ideological premises.[75] In pages that are clearly intended to relate to a famous literary source in the history of Bolognese art—Cesare Malvasia's *Felsina Pittrice*[76]—Zanotti reasserts the vivid authority exercised by the Carracci tradition in the development of the local visual arts. As suggested by art historian Anton Boschloo, in the years between the end of the eighteenth and the beginning of the nineteenth century, the Carracci were "named regularly, as if they were the artists who the young generation should mirror."[77] The past was significantly remembered not only as if it were still alive, but indeed more effective and influential than ever in its role of model for artists belonging to the youngest generations.

Thanks to the teaching program pursued at the *Accademia Clementina* and its programmatic attempt to consolidate what one may justly call Bolognese taste, throughout the eighteenth century, a recurrent tendency to rely on formulas and rules previously established by the Carracci can clearly be seen, particularly among local professors of drawing. For a large audience of artists, as well as patrons and art collectors, the Carracci had become timeless models of perfection, worth being admired, followed, and, more importantly for the sake of our discourse, purchased and collected. As the decades passed by, the force of such admiration ended up assuming the proportions of an authentic collective obsession, as Boschloo has acutely suggested: "instead of a fertile relationship with the past, it became a *preoccupation* about the past."[78] Given its immanent status as exemplarity, the tradition seemed to provide irreplaceable prescriptions for any and every artistic matter. This led to the Carracci—considered as the most brilliant promoters of a return to Raphael, who was in turn praised as the greatest heir of the ancient idea of beauty—being regarded, by the beginning of the eighteenth century, as the only artists who could effectively guarantee a promising continuation of local art as well as a clearer definition of its own identity.

Furthermore, as we shall see in a more detailed way in the next chapter, Italian patrons and artists had witnessed, around the end of that century, a series of traumatic events that led to the massive dispersion, loss, and destruction of many artworks. Among these events it will suffice to mention the episodes connected with Napoleon's politics of the *rappatriament* and the creation of the *Musée Nationale* in Paris, with the subsequent removal of thousands of works of Italian art from their original settings, including those in Rome, Bologna, and various towns from The Marches.[79] As a consequence of these dramatic readjustments, Bolognese artists tended to concentrate themselves even more radically on the maintenance of their own cultural roots, focusing, as Boschloo claims, "on the conservation of their great pictorial past and on the principles upon which it was founded," and thus isolating themselves from artistic tendencies that had begun to characterize different centers of cultural production in those years, such as the more classically grounded phenomenon of Neoclassicism then emerging in Rome, no doubt also thanks to the presence there of Johann Joachim Winckelmann.[80]

By the end of the eighteenth century Bologna seemed to have definitely closed its frontiers to any artistic sphere of influence beyond the range of local masters, building up a sort of transhistorical artistic community that regarded the more archaeologically oriented ferments that were spreading in Rome at the time as essentially foreign. In their eloquent way, the Bolognese cultural elite opposed the prevailing Neoclassicism—or Neo-Hellenism—then developing in Rome by formulating an aesthetic agenda that tended, by contrast, to retrieve the threads of its specific past, rather than promoting a vague passion for antiquity. For this reason, it is my strong conviction that it could well be critically much more incisive and historically appropriate, in place of adopting the generic term Neoclassicism, to refer to such a cultural phenomenon as a "Neo-Renaissance," particularly because of the central role played by Raphael and the Carracci and their schools in the process of self-definition of a regional paradigm of artistic perfection.

Historically, such a quest to define a local concept of ideal beauty grounded in the Raphaelesque and Carraccesque tradition would eloquently find its more emblematic achievement in the organization of a museum in Bologna primarily devoted to the "great Bolognese art," a dream that would finally come true in 1804, when the National Academy of Fine Arts of Bologna would replace the former *Accademia Clementina*.[81] Interestingly, the ideal of a specifically "Bolognese grace"—inaugurated by the arrival in the town of Raphael's painting, *S. Cecilia* in 1514, and then coherently developed by the Carracci and their followers in the seventeenth century—was felt as well in such peripheral areas as The Marches, a region that was then, culturally as well as geographically, located between Rome and Bologna, at a point of intersection in which the genealogical line of artistic perfection represented by the axis Raphael–Carracci–Maratti–Corvi could stimulate vivid intervisual exchanges. To overlook a consideration of this

point would mean a failure to acknowledge the specific historical relevance of the collection of drawings gathered by Count Alessandro Maggiori, for it represents a singular conjunction of these two, deeply mingled, schools.

In fact, the remarkable collection of Count Maggiori summarizes, in its calculated selectivity of styles and iconographies, not only the aesthetic but also the pedagogical aims promoted by the *Accademia Clementina* in Bologna, which were very similar to the ones strenuously pursued by Domenico Corvi in his studio-academy in Rome. One could even claim that the Maggiori collection offers a paradigmatic synthesis of the Roman–Bolognese circuit of art as it was developed, on a private dimension, within Corvi's workshop and, publicly, at the *Accademia Clementina*. Moreover, the fact that Alessandro Maggiori had acquired such an impressively coherent group of works, works so clearly preferring certain stylistic tendencies over others, was most surely the result of his consciously established aesthetic choices, in part due to his long stay in Bologna, and in part representing the debt to his productive sojourn in Rome that brought him into contact with the Maratti–Corvi tradition. Corvi's adoption of a tempered naturalism in his own works, so evidently reminiscent of the Carraccesque lesson, unequivocally anticipates Maggiori's stylistic proclivities as an art collector. It is not surprising, then, to find that many of the drawings purchased by the Count appear quite strictly connected to this Roman–Bolognese cultural background, in which the study of anatomy—conducted, however, in accordance with a less rigid canon of idealization than the one adopted, for example, in works by Mengs—constituted the very core of the classicist pedagogy of art that characterizes the line linking Raphael–Carracci–Maratti–Corvi.

This is paradigmatically confirmed, for instance, by an anatomical study, attributable to the ambit of Domenico Corvi, that was purchased by Alessandro Maggiori in Rome, in 1809 (fig. 12), in which the left leg of a standing male figure is quickly outlined by means of a system of parallel hatchings that create, in a deceptively simple yet efficient manner, a delicate sense of relief. In another sheet, the leg of a seated figure, carefully depicted in a soft red charcoal, shows the same proximity to the academic practice of copying from life, as it was undertaken in the School of the Nude ruled by Corvi. On a purely hypothetical basis it is thus quite tempting to attribute the execution of this drawing to Alessandro Maggiori himself, in the years in which he frequented Corvi's studio-academy in Rome. In an analogous frame of hypothetical attributions, it is likewise tempting to recognize Maggiori's autography in another drawing belonging to his collection, in which the detail of a foot is depicted with great skill. Drawings representing small details of the human body seem to have been made quite often by Maggiori as a training practice.

These attributions, not supported by any documentary evidence, nevertheless appear relatively plausible thanks to the absence, in both cases, of the usual inscriptions made by the collector indicating the places and dates of his purchases. Moreover, the formal characteristics of both drawings, in which one can notice the awkward yet gracious uncertainty of an artist not yet mature or not particularly gifted, reinforce the hypothesis that these sheets were not bought by the Count, but instead made by him. Their (actually not very) exemplary qualities could be seen, therefore, as the direct result of his period of artistic apprenticeship under the guidance of Domenico Corvi, thus documenting Maggiori's aspiration, soon abandoned, to become a distinguished professor of drawing. For all the above-mentioned reasons, it seems reasonable to conclude that these drawings did not "enter" into the collection of the Count, but were rather "kept" in it, since the owner was, as suggested here, their author, the collector as a dilettante.[82]

In addition to their problematic attribution, these drawings also provide a concrete record of Corvi's teaching strategies and reinforce the important role played by the Viterbese master in the shaping of Alessandro Maggiori's taste and aesthetic preferences. By further pursuing this reasoning, one could argue that Maggiori's personal "system of taste" was in fact primarily formed during his Bolognese days, when he was consistently exposed to the

Carraccis' legacy; even so, it was definitely consolidated in the Roman years thanks to his attending Corvi's academy and promptly assimilating its lessons. In other words, the Raphael–Carracci–Maratti–Corvi lineage constitutes the main frame of stylistic references for Maggiori, informing both his decisions as a dilettante artist as well as his orientation as a selective art collector.

The inner coherence of the Maggiori collection thus does not depend upon the fact that most of the purchases were made in Bologna, as suggested by Giulio Angelucci,[83] for Maggiori could well have found in Bologna drawings ascribable to masters belonging to different schools, such as Titian and Correggio for instance. Yet his choices were not mainly dictated by contingent matters but reveal instead the signs of a consciously driven plan of acquisition, and a coherent aesthetic agenda.

Moreover, it is also important to note the way that Maggiori's profound admiration for seventeenth-century Bolognese masters, seen as the heirs of Raphael's "perfect naturalness," offers, from a stylistic standpoint, an alternative to what was then the prevailing Greek ideal of beauty, promoted in Rome by the protagonists of Neoclassicism, especially Johann Joachim Winckelmann.[84] In Maggiori's view, Raphael's highly selective working method was enlarged by the Carracci, who had transformed individual inclinations into a transmissible creative practice that could, at least in part, be taught through an appropriate academic curriculum. Accordingly, Raphael and the Carracci, especially Annibale Carracci, were considered by Maggiori, via Corvi, as the authentic exponents of that classicist tendency theoretically codified by Bellori in the second half of the seventeenth century, namely a tendency with the capacity to unite the ancient paradigm of perfection with the superlative achievements of Renaissance art. For this reason, such a tradition was felt as an artistic legacy worth preserving, pursuing, and protecting. Maggiori's (as well as Corvi's) constant appeals to Raphael and the Carracci do not thus appear as isolated acts of recovery or late discovery of past ideals, but rather the conscious acknowledgment of a still-vivid cultural identity. This was in fact a Renaissance nostalgia that had its deepest roots in the immanent "Italianness" associated with the Roman–Bolognese tradition, in which the paradigm of grace constituted the main pillar of all artistic construction.

Within the collection of drawings gathered by Count Maggiori, the selective choice of models from the past was based upon two specific prototypes of beauty. First, works in the style of sixteenth-century Roman masters, and, second, works whose modes of representation had been established by seventeenth-century exponents of the Bolognese school. Within such a hermeneutic circle, Raphael and the Carracci became the founders of a "Timeless Renaissance" fervently praised by Alessandro Maggiori as the utmost model for eighteenth-century artists as well, owing to their continuing transhistorical value as aesthetic objects. It is also the case that some of the most accomplished syntheses of these two models had, not by chance, been provided by masters like Anton Raphael Mengs and Pompeo Batoni, whose drawings are significantly present in the Maggiori collection, in sheets representing, respectively, a female head rendered with sober grace, and a study of drapery executed with stunning naturalness. While referring to works such as these, adjectives like "grace" and "naturalness" indicate implicitly their connection with the orbit of visual codes related to Raphael and the Carracci, regarded as masters of incomparable grace.

Interestingly, the concept of grace came to assume, throughout the eighteenth century, a peculiar ideological connotation, as it was pressed into use to distinguish the idealized yet naturalistic creations of contemporary Italian masters from the more taxonomic results achieved by French artists of the time.[85] According to eighteenth-century literary sources, such as Giannandrea Lazzarini among others, the qualities that distinguish the presence of grace were the fruit of innate intuition and, as a consequence, could not be taught, not even by the best teachers in the best academies. In his *Dissertazioni sulla Pittura* (Dissertations on Painting), Lazzarini clearly underlines the "indefinable" essence of "grace," and subtly suggests its Italian origins.[86]

Remarks such as Lazzarini's indicate the difference between the didactic aspirations of the Italian academies and the severe "discipline of Beauty" promoted by the French *Académie Royale de Peinture et Sculpture*, founded in Paris in 1648 and reinforced, in 1666, through the institution of its Roman seat.[87] As for the concept of grace and its decisive role in the making of an artwork, the term is frequently mentioned as a distinguishing characteristic belonging to Italian masters, and, it was suggested, lacking in any creation made by French painters or draftsmen.

The position of the French Academy is, indeed, quite peculiar. Associated directly with the state, the *Académie Royale* tended to enforce a rigid control over the quality of the artistic productions of its members. Despite the common pedagogical goals pursued by analogous Italian institutions—focused on the adequate education of young artists through the study of excellent models of the past—the programs, methods, and results obtained by late seventeenth- and eighteenth-century Roman academies were remarkably different from the ones achieved by their French alternative, especially with regard to the way in which past canons were expected to be adopted. If, in the case of Italian academies, the models of perfection were used as general points of reference, in the case of the French *Académie* the strict link between pedagogic plans and state interests tended to transform the set of exemplary styles into fixed rules and formulaic norms. In other words, the stylistic references employed by Italian artists were translated by their French colleagues into a much more inflexible visual vocabulary, whose elements were accordingly expected to be followed and venerated with all the respect required by an aesthetic dogma. This is, at least, the way in which French academic methodologies were perceived and described by Italian sources.

It may go without saying, but should be noted that in Rome the vicinity of the Holy Seat had inevitably imposed the employment of a certain system of taste with its own rules and expectations.[88] However, when compared to the rigid control exercised by the French state through the *Académie*, the sphere of influence represented by the Vatican assumes a much more modest proportion, at least in the eighteenth century, while what was achieved in France, in terms of formal results, came close to becoming a phenomenon of homologous similarity.[89] The *Académie Royale*, from the time of its foundation, had been organized in order to support the ideological schemes of the French government, headed at first by its Minister Jean-Baptiste Colbert. Consequently, its program of studies was conceived, from the beginning, as a highly hierarchical set of progressive steps. Moreover, the belief that every aspect of the arts could be ruled by a precise set of norms—established once and for all—and that these could therefore be transmitted to any student, was developed and expanded throughout the eighteenth century. It was didactic intransigence of this kind that ultimately led to the emergence of an irreconcilable gap between the Roman academies, with their strong emphasis on individuality, and the severe theories of idealized beauty promoted by the French institution.

The pedagogical dogmatism of the French institution is well documented by André Félibien's lessons, in 1667, and by Charles Le Brun's *Conférences*, which had been printed from 1696 to 1718.[90] As one can easily see from the theories of art embraced by these two authors, the French Academy was inclined to discourage any form of expression that was not conceived as a reiteration of models from the past, with these largely derived from ancient examples of beauty. For this reason, a subtle component like grace, which could not be framed within a rigid scheme of specifications, but depended instead on an individual's capacity to articulate the tradition, was often singled out, by Italian artists as well as theoreticians such as Lazzarini, as an element generally absent from the images created by French masters. The educational function performed by the *Académie Royale* tended to distill a concept of art that, in spite of certain apparent similarities, was in reality radically different from the one diffused among the founders of private academies in Rome, such as Mengs, Batoni, and Corvi. As suggestively argued by scholar Laura Olmstead Tonelli, "The Italians were critical of the French academicians' disregard for the *grazia d'arte*, that indefinable quality appealing to the heart more than to the intellect."[91] Most interestingly, and not by accident, the production of copies from ancient models—undertaken on a serial scale—once constituted one of the major

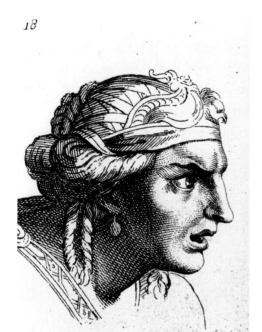

Figure 28. Charles Le Brun, *Fear*
Bibliothèque National, Paris

Raph.Vrb.pin .

Figure 29. Nicholas Dorigny, *Raphaelesque head*,
from *The School of Raphael*, or *The Student's Guide
to Expression in Historical Painting* (Plate 10.1),
©The Trustees of the British Museum.

activities that the members of the *Académie Royale* were expected to perform during their sojourn in Italy. For this reason, "the Roman branch of the French academy," as Tonelli correctly states, "had as its chief goal the reproduction of the most famous sculptures of Rome for export to Paris."[92]

Even the courses dedicated to anatomical studies made from life were quite different from the exercises conducted within the Roman academies. In the case of the French institution, "the rigorous and lengthy training [...] began in the *Salle de Dessin*, where the students copied models for as long as three years. For the first time," Tonelli concludes, "an order of progression with set time limits was imposed on the students with an even stronger focus on mastering the human form";[93] as a consequence, "unlike the Carracci academy where landscape and animals were also studied, the French academy concentrated on the production of history painters."[94]

The excessive rigidity of the methods promoted by the *Académie* is well exemplified by the visual taxonomies of human expression formulated by Le Brun in his discourse on physiognomy and the depiction of different emotional states (fig. 28). The distance that separates the schematic French practices, as superbly condensed in Le Brun's crystallized formulas of pathos, from the more flexible, variegated, and expansive Italian methods, could not be better understood than by means of a *paragone*. This can be seen by comparing some drawings belonging to the Maggiori collection—in which both bodies and faces are represented—with those falling under the arid classification of *affetti* illustrated by Nicholas Dorigny in his images, clinically borrowed from Raphael (fig. 29).[95] Whereas the examples taken from the Maggiori collection provide unmistakably Renaissance-oriented solutions, capable of uniting the prerequisites of an ideal beauty with the actual forms of nature, Dorigny's illustrations instead present an exasperatingly clear rendering of human expressions, even to the point of transforming them into types, almost caricatures, as if they were frozen maps of a paralyzed land of emotions. If, in the case of Dorigny's visual schematics, the images subscribe to a norm too drastically respected, in the drawings collected by Maggiori, the forms instead brought forward are the fruit of the aesthetic potentials of several past paradigms, thus enlarging their frame of reference, from Raphael to Mengs, from Maratti to Sacchi, from Domenichino to Corvi.

In conclusion, one could assert that in the fixed taxonomy of *affetti* promulgated by Dorigny—and, more generally, by the masters of the French Academy—there was a formal law that could not be dismissed or overcome, a law that did not take into account Carlo Maratti's advice to study the models of the past only "as much as

necessary" (*tanto che basti*), without any excessive faithfulness, with his sense that otherwise any artistic creativity would be sentenced to death, destined only to disappear into the realm of pointless tautologies. By contrast, the drawings collected by Alessandro Maggiori tended to present themselves not as mere repetitions of previously established forms of perfection, as in the case of Dorigny's rather ungracious physiognomies, but as further explorations of a tradition that could and should be kept alive through the attentive, yet not dogmatic, study of its "most clear examples," examples like those that Giannandrea Lazzarini, a source very well known by Alessandro Maggiori, had systematically examined in his *Dissertations*, presented at the Academy of Pesaro in 1753. His theories on art and its connection with the Maggiori collection will be the subject of the next chapter.

8. Past as Present: Giannandrea Lazzarini's "Most Clear Examples"

The historical link that connects the classical revival of the Renaissance to the classicist vocabulary adopted by eighteenth-century artists was felt by Alessandro Maggiori to be the definitive guarantee of a profound cultural identity. Examined from this perspective, the Italian *Settecento*—and in particular the eighteenth century at The Marches—appears to be conscientiously developed under the aegis of a creative nostalgia that brought together masters like Raphael and the Carracci along with later artists such as Maratti, Mengs, and Corvi. It is this development that demands not only the study but also the attentive preservation of the artworks generated by the most significant protagonists of this rich, and still enriching, tradition. It is interesting to note that the conservation of this artistic heritage—a legacy that could well be metaphorically defined as a Timeless Renaissance, rather than being reductively designated as a Neoclassical tendency—was concretely promoted, in the region of The Marches, first by means of the collection of drawings assembled by Count Maggiori, and, second, by the theoretical discussions promoted by the painter, architect, and academician Giannandrea Lazzarini, a name often mentioned by the Count in his books.[96] As the present chapter will argue, a strong link exists between Maggiori's agenda as an art collector and the theory of art addressed by Lazzarini in his texts and academic discourses, for both authors deliberately chose to ground their aesthetic preferences on the solid territories of what can be called a Neo-Raphaelesque and Neo-Carraccesque tradition, while not paying as much attention to the study of examples taken directly from antiquity. Thus it is crucial to examine in detail the potential connections between these two protagonists of the intellectual life of The Marches in the eighteenth century from critical, conceptual, and historical points of view.

Born in Pesaro in 1710, Giannandrea Lazzarini is documented as being in Rome in 1732, in the studio of Francesco Mancini, the same master with whom Domenico Corvi had trained. Not by accident, Lazzarini and Corvi became warm, lifelong friends, as demonstrated by their correspondence, which is preserved at the Biblioteca Oliveriani in Pesaro.[97] With regard to Lazzarini, after a few years in Rome, spent without having obtained any particularly relevant commission, he decided to return to his homeland, Pesaro, where in 1777 he was named the canonical of the cathedral, a position that he would hold until the day of his death in 1796.

Both as an artist and a classicist-oriented theoretician, Lazzarini was invited to deliver a series of *Dissertations on Painting* in 1753 at the Academy of Pesaro, beginning with a lecture on the concept of "invention." The records of these conferences were eventually published, in 1806, along with other texts by the same author, by Niccolò Gavelli from Pesaro.[98] Lazzarini's *Dissertations* are here regarded as a fundamental source on which to base an understanding of Alessandro Maggiori's cultural context, for they provide a clear, theoretically engaging panorama of statements and precepts most certainly shared by the Count, as one can hypothesize after having read his letters and books.

Figure 30. Giannandrea Lazzarini, *Trinity with Madonna, Angels, and Scene of the Original Sin*
Musei Civici, Pesaro, Italy

Not surprisingly, Lazzarini's career as a painter was pursued under the shadow of Raphael and the Carracci. Furthermore, the pedagogical program promoted by the master in his studio in Pesaro presented several affinities with the one adopted by his friend and correspondent Corvi in Rome. According to the notes published anonymously as the introduction to the 1806 edition of Lazzarini's *Works*, "with regard to drawing, one can find but few defects in Lazzarini's [pictorial and architectural] works. He knew that [making drawings] was the basis and the foundation of painting, and he has always exercised himself in this field; he wanted his students to use colors only after having practiced the making of drawings for many years."[99]

As for the selection of models worth studying, the anonymous biographer affirms that, in Lazzarini's paintings, "he is all in the taste of Raphael."[100] A sacred figure painted by him is, in fact, highly praised by the same biographer for the mature adoption of classicist solutions ("No one could imagine a more beautiful and gracious physiognomy than the one of this saint"), whereas in other paragraphs his works are described as "definitely Raphaelesque" (fig. 30).[101] Moreover, Lazzarini's admiration for Raphael must have been so profound that it led him to execute many replicas of works originally created by the Renaissance master: one painting, for instance, representing the "Holy Father while Creating the Sun and the Moon" is deeply admired for "its idea is Raphaelesque and very well rendered."[102]

Another "excellent painting by Lazzarini is the copy of a famous picture by Raphael, once preserved in Pesaro, in which the Holy Family was depicted," a copy that, as the anonymous biographer enthusiastically recalls, all "people who understand art judged very similar to the original, and even more accomplished [than it]."[103] In other words, Lazzarini's copy was so extraordinary that it should be considered superior even to the very original! "More accomplished" than Raphael himself, Lazzarini becomes, in this almost hagiographical narrative, the major protagonist of a second Renaissance: a Timeless Renaissance, thanks to which an eighteenth-century master was still praised for his wisdom in developing sixteenth-century parameters of harmony, beauty, compositional balance, and more.

No wonder, then, that Maggiori, for his part, will programmatically collect drawings realized after Raphael's compositions or conceived as a sort of virtual mirroring of Raphaelesque ideas. To mention but one example, one need only recall the delicate red charcoal in which a face emulating one of the female characters of Raphael's *Transfiguration* is precisely portrayed (figs. 31–33).

Lazzarini's erudition was surely another factor that might have attracted Alessandro Maggiori's attention as a source of aesthetic reflection. According to the anonymous biographer, "no one knew the history of the painters, and their qualities, and the variety of the different schools, better than Lazzarini; he used to talk about it in the most precise way, without ever being precipitate in his judgment, for he was a most discreet gentleman."[104]

Figure 31. Raphael, *Transfiguration*
Pinacoteca, The Vatican, Rome

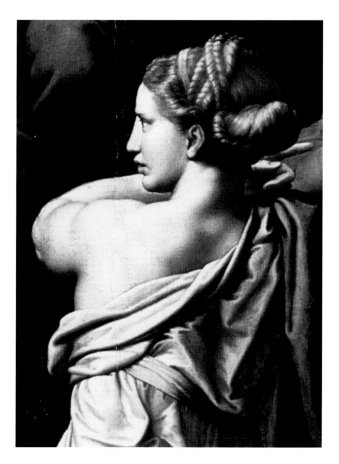

Figure 32. Raphael, *Transfiguration* (detail)
Pinacoteca, The Vatican, Rome

Like Maggiori, Lazzarini seems to have possessed a rather multifaceted personality and had dedicated himself to different activities:

> Lazzarini was not only a good painter, and architect, and maybe the Prince of those who are
> knowledgeable in matters of painting and architecture;
> he was also a distinguished writer and, even more
> importantly, was able to transform the Fine Arts into
> a literary science. This is clearly demonstrated by his
> *Dissertations on Painting*, in which one can find new ideas
> and reasoned principles written in a fluid, expressive, and
> elegant style.[105]

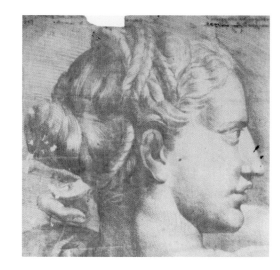

Figure 33. Anonymous artist (Roman School, 18th century), *Head and shoulders of a woman after Raphael's* Transfiguration
Fondo Alessandro Maggiori, Biblioteca Comunale, Monte San Giusto, Italy

What may have ignited Maggiori's interest in Lazzarini's discourse on art was almost certainly the possibility of finding in it "new ideas and reasoned principles." For both Maggiori and Lazzarini, Raphael was the epitome of artistic perfection, while the Carracci were similarly considered to be the authentic promoters of the rebirth of the arts after their decadence during the period of Mannerism. As Lazzarini emphatically states, in a paragraph that echoes a thought diffused throughout the

seventeenth century and most eloquently addressed by Bellori and Malvasia: "Due to this vice of stylizing nature, the art of painting was almost ruined after the end of Raphael's school [...] until the day that came into this world the not sufficiently praised [Annibale] Carracci, who, by taking away these false manners, restored painting to its original dignity."[106]

However, in Lazzarini's pages, the pressing risk of falling again into "mannerist corruption" assumes the status of an imminent danger to eighteenth-century art, given the absence of worthy contemporary heirs of the classicist tradition:

> Could it please the Heaven that, also in our day, for reasons that I shall not be explaining now, such a beautiful art might not be again infected by a similar illness [that is to say, the over-stylization of forms], and that the simple desire to see the triumph of pretty colors and the noisy sounds of drastic *contrapposti* would not make the world refrain from complaining about the ruin of the arts! It would be desirable that some great genius could rise and, by exploring again the lost paths of a Raphael, of a Titian, of a Correggio, of the Carracci, and of other great masters, could clean up the road and take away any falsehood, and at length bring back simple, pure, natural beauty.[107]

The urgent necessity of recalling the past as an indispensable remedy to save the arts and make them rise again is clearly expressed in the list of "illustrious masters" mentioned by Lazzarini: namely, Raphael, Titian, and Correggio, artists who were usually considered, among theoreticians of Neoclassicism such as Mengs, to constitute the Golden Triad of the Renaissance tradition. Significantly, however, Lazzarini adds to Mengs's scale of excellence a fourth important pillar: the Carracci. Similarly, Alessandro Maggiori's project of collecting drawings, or even fragments of drawings, that were ascribable to these great masters of the past could be interpreted as a programmatic attempt to stimulate eighteenth-century artists to further pursue the road of ideal beauty associated with Roman–Bolognese classicism and notably with the Raphael–Carracci lineage. It is thus possible to argue that the collection of drawings assembled by the Count was intended to fulfill, at least partially, a desire not dissimilar to Lazzarini's, namely to provide a set of exemplary models of that "Timeless Renaissance" so deeply admired by both authors for itself and as the only efficient remedy against the dangerous decadence of the arts in a new Mannerism.

For both Lazzarini and Maggiori, the preservation of valid samples of such a creative universe was taken as a most serious task, for the study of exemplary works of the past could be a tremendous help to contemporary artists in solving the aesthetic problems of the present. Since "the immortal Raphael" seems to have "come to the World to become the first and the most perfect example in all parts of the painting,"[108] in Lazzarini's words, eighteenth-century masters, or even early nineteenth-century artists, should definitely be guided by the timelessly powerful style of the Raphaelesque tradition. Moreover, in addition to Raphael, another model to bear in mind was Annibale Carracci, in virtue of his "inexpressible diligence, and accomplishment," qualities that had made him "one of the first masters of art."[109] Significantly, Lazzarini develops his own concepts by means of concrete examples and provides, in his pages, quite detailed descriptions of works considered particularly effective in resolving specific aesthetic problems that might be causing trouble among eighteenth-century artists. He firmly believes, for instance, that only through the observation of *chiarissimi esempi*, or "most clear examples" borrowed from the past, could contemporary masters once more create memorably beautiful *istorie*, as they had in the Renaissance:

> [O]bserve all these excellent paintings [preserved] in our churches [in Pesaro], and also those by Guercino in Cento, by Paolo Veronese, by Cignani, by our Berettoni [*sic*], by Sordo, Pomarancio, Savoldo, Palma, Mola, and by the Zuccheri in other places, by our Niccolò da Pesaro as well as by Simone Cantarini, who

is the honor of our homeland and one of the most delicate and clever minds that have ever practiced this art; not to mention many other rare artists who have enriched our homeland with their works; you shall see in these art pieces the most clear examples of the precepts I am talking about.[110]

Such a group of "most clear examples"—as Lazzarini puts it, *chiarissimi esempi*—offers eighteenth-century artists the most promising solutions to problems that they may have been facing while elaborating their own works. If Simone Cantarini, for example, was indicated as a useful model for studying the correct way of disposing figures within the pictorial composition, Domenichino and Maratti were mentioned, both for their perfect manner of rendering human emotions and for their stunning ability to create images in strict accordance with the rules of convenience, or *decorum*, a branch of art in which Raphael is once again referred to as the "first light and example."[111] However, in spite of Raphael's indisputable supremacy, both Maratti and Domenichino are praised as masters who can provide even more accomplished solutions within this specific field of the visual arts, especially "in times closer to us," as Lazzarini writes. Thus, the author implicitly establishes a connection between the aesthetic directives of the Renaissance and the ones pursued by seventeenth- and eighteenth-century Italian classicist masters.

Such a trans-temporal liaison is particularly relevant in the field of historical representations, in which the depiction of human emotions as well as the correct rendering of the body occupied a central position and so demanded to be carefully taught in any academic setting. It is no surprise to find that this branch of art appears as the most recurrent subject in the drawings belonging to the Maggiori collection. Moreover, the profound relation that unites the representation of emotions with the concrete practice of the drawing is explicitly established by Lazzarini himself in one paragraph of his *Dissertations*, in which he states:

> The great men [of the past] knew how to portray in the face as well as in the actions of the figures what they say, what they love, what they fear, what they feel, and even what they pretend. How and with what art the painter does so by using lines shall be the subject of another dissertation, focused on the drawing.[112]

After having meticulously investigated problems related to the depiction of the different parts of the human body, in order to conveniently convey the figures' feelings, Lazzarini explores other means that should be used by an artist in the attempt to capture the spectator's attention. Surely, one could adopt the formal strategies of *contrapposto*, being careful not to render the figures with "that defective uniformity" of gestures, poses, and attitudes that destroys, in Lazzarini's opinion, the harmony of many works of art. To that purpose, the author advises that the artist should "imitate Nature," which is "various, and accidental in every aspect."[113] In Lazzarini's own words: "It derives from this observation that those who appreciate the true beauty of things quite understandably prefer to see a certain negligence, based upon the model of nature, instead of that affected correctness that seems contrary to it."[114] For Lazzarini, the "true beauty of things" lies in the delicate balance between idealistic aspirations and naturalistic descriptions. Unlike the rigid, ancient-based Neo-Hellenism promoted by Winckelmann in Rome or by the artists belonging to the *Académie Royale* in Paris, Lazzarini's Neo-Renaissance aesthetics find the most effective paradigms of perfection in art in the Bolognese notion of grace, as well as in the Roman sense of beauty.

For Lazzarini, drawings are significantly regarded as the best carriers of such a well-balanced dynamism between grace and beauty, idealization and naturalness. This explains why drawings are so highly regarded by academicians, in general, and by Lazzarini (and Maggiori), in particular, and why they are elevated to the rank of foundational pillars of the world of visual arts. Because of their ability to imitate the multiple forms of nature and at the same time give shape to any concept or idea, drawings are considered indispensable vehicles for the dissemination of a master's particular style. In following a tradition that goes back to Cennini, Alberti, Leonardo,

and Vasari, Lazzarini devotes a whole section of his *Dissertations* to the concept of drawing, writing pages in which themes frequently addressed by Renaissance Italian art literature, such as the doctrine of *ut pictura poësis* or the notion of *decorum*, are analyzed with unexpectedly fresh eyes. On the other hand, Lazzarini's statements on art seem to reflect quite closely Alessandro Maggiori's ideas, as they emerge (explicitly) from his letters and characterize (implicitly) his collection.

In the session of the *Dissertations* dedicated to the notion of drawing, Lazzarini clarifies, first of all, the fact that the concrete practice of drawing is not "a mere mechanism which consists in making lines and adding relief," but one that requires a "power of the mind" that he does not hesitate to call "sublime."[115] In other words, the work or experience of drawing cannot be reduced to a mere "material practice," for its principles are codified "with the foundation of reason," as the author states in a sentence that resonates with ideas borrowed from the philosophers of the Enlightenment.[116]

As a mental operation, argues Lazzarini, the act of drawing means to give to "any element that is depicted its own shape and figure, which can be achieved by means of two things, namely, contour and chiaroscuro."[117] However, the territory in which drawings can most fully express their creative potentials lies in the representation of the human body, "the most beautiful of all visible things and, for that very reason, the most difficult [form] to imitate,"[118] as Lazzarini claims in an eloquent Vasarian echo:

> The body's machine is various in its parts, and these parts are so flexible in their motions, so different
> in their views, and so easily altered by the different passions of the soul, that every movement, every
> aspect, every expression can impress upon them an infinity of accidents, each one of which is worthy of
> [becoming the object of] a separate investigation.[119]

The practice of drawing is thus intimately tied to the representation of the body. Lazzarini's attention to the functional, precise, and yet gracious depiction of the human figure seems to materialize itself in the Maggiori collection, in which, among the sheets originally gathered by the Count, the largest part undoubtedly consisted of drawings depicting the whole body or its multiple parts, as well as other elements directly associated with the creation of a history, such as draperies, animals, and ornaments. Furthermore, several drawings representing human heads—of children, elderly people, men and women—are also massively present in Alessandro's collection, along with studies of other parts of the human figure, such as hands, legs, and feet. What this makes evident is that these studies might have been assembled and thus evaluated as the *chiarissimi esempi* of an exquisitely classicist vocabulary, thanks to which a historical painting could be successfully elaborated. For such subjects alone they were worth collecting. And as Lazzarini underlines in different paragraphs of his *Dissertations*, any artist must be endlessly engaged in the study of the various parts of the body in order to create images that could both deceive and attract the eyes of the spectator by their illusionistic naturalness and artistic perfection. Once again, Raphael's everlasting example is recalled as a supreme paradigm:

> To persuade anyone about Raphael's diligence in the study of his anatomies, it suffices to observe some
> of the original sketches that he made in ink while working on the painting representing the Burial of
> Christ, commissioned by Atalanta Baglioni, and now considered one of the most precious ornaments
> of the famous Galleria Borghese in Rome. In one of these sketches one can see the fainting figure of the
> Virgin, held up by three women, one of whom holds the Virgin by the arms and stands right behind her;
> in another drawing, both the Virgin and the woman who holds her appear undressed, unlike the previous
> sketch, and are only outlined with utmost mastery, thus showing the contours of their bones.[120]

As Lazzarini makes clear, it is thanks to a private collection—specifically, Cardinal Borghese's outstanding gallery of art in Rome—that one can not only admire Raphael's exquisite masterpiece, the *Deposition of Christ*, but also observe the different stages of the artist's creative process, owing to the preservation of various preparatory sketches. By undertaking a comparative analysis of these drawings—"original" drawings, as Lazzarini clearly emphasizes—one can follow, step by step, the different moments of the creation of this prodigious work. Privileged carriers of a most exemplary stylistic idiom, these drawings are then contemplated by Lazzarini as irreplaceable documents marking a complex path of visual construction, a path that, due to the perfect state of conservation of these graphic jewels, can be examined in its very making. This explains why the author stresses the fact that these drawings were all "originals," and not mere copies or secondhand replicas, for it guarantees their unique value as witnesses of Raphael's body and intellect at work.

In this way, from a classicist as well as an academic point of view, drawings became the vessels of stylistic lessons worth studying, transmitting, and, consequently, preserving within the protective walls of a collection. This is precisely what Count Alessandro Maggiori may have had in his mind when organizing in his villa *Il Castellano* a collection of artworks in which Roman–Bolognese classicism was paradigmatically embodied: a tradition that, inaugurated by Raphael in the sixteenth century and vigorously reinforced by the Carracci in the *Seicento*, was then kept alive in the eighteenth century thanks to the measured dexterity of masters such as Maratti and Corvi and the aesthetic agenda of *literati* and connoisseurs such as Giannandrea Lazzarini and Alessandro Maggiori. In a context of calculated encouragement of academic tendencies, it is quite understandable that Maggiori too decided to protect, by means of a stunning collection of "most clear examples," the timeless validity of Renaissance paradigms of perfection.

9. Luigi Lanzi's "Radial Method" in the Pictorial History of Italy

One essential aspect of the Maggiori collection lies, therefore, in the fact that it conscientiously and almost exclusively unites artworks that are associated with the classicist tendencies developed within the Roman and Bolognese schools, as demonstrated by the massive presence of masters working in areas culturally as well as geographically subordinated to these centers, such as The Marches in the eighteenth-century. The concept of regional schools of art, however, although commonly in use since the sixteenth century, had by the eighteenth century taken on new critical connotations.[121] In order to understand this new set of meanings and associations, especially in relation to Alessandro Maggiori's aesthetic agenda, it is useful to begin with an examination of the range of implications generally carried by this term in the Italian art literature of the time, and to devote particular attention to the analysis of its potential meaning in the pages of the *Storia Pittorica d'Italia* (Pictorial History of Italy) written by Luigi Lanzi, a scholar indefatigably praised by Maggiori and also frequently mentioned by Lazzarini.[122] As we shall see, both Lanzi and Lazzarini played decisive roles in the dissemination of artistic principles that were profoundly related to the ideal of a Timeless Renaissance in areas such as The Marches, where the creative traditions of Rome and Bologna stimulated the phenomenon of an eighteenth-century rebirth—or "Second Renaissance"—of the arts.

The concept of the "school"—mentioned in Domenichino's letter to Francesco Angeloni at the beginning of the seventeenth century[123]—had become, in the Italian *Settecento*, the object of a more sophisticated definition. It is thanks to the intellectual efforts of authors like Lanzi that this notion was definitely established as a critical parameter of classification, as part of the attempt to verify the underlining unity of the arts in the different regions

of Italy. In the pioneering chapters of the *Pictorial History*, first published in 1793, and then reprinted in 1809 with significant additions and modifications after the Napoleonic spoliations, Lanzi challenged the previously established historiographical habit of writing "lives" or "biographies," and thus inaugurated a broader method of investigation based primarily on the distinctions characterizing the different "schools" of art as aesthetically autonomous and geographically identifiable entities—followed by more specific definitions. By examining the wide spectrum of artistic events in the various areas of the peninsula with a focus on their predominant features, Lanzi was able to formulate a system of analysis that led to the identification of a "transregional," although not yet "national," dimension: the history of art *in* Italy.

In abandoning the biography as the main genre with which to elaborate a historical discourse on the visual arts, the volume written by Abbot Lanzi was free to describe the gradual emergence of regional schools from the fifteenth to the eighteenth century, while also investigating the many interregional connections among these various entities. In this way, Lanzi used his capacious knowledge of the local schools to provide a more articulated interpretation of the development of the pictorial modes of representation that extended all over Italy. Such an innovative method, suspended between micro-historical investigations and general conclusions, constitutes one of the most relevant contributions of Abbot Luigi Lanzi to art historiography. A new concept of the geography of style emerges from his pages, and a highly contextualizing reading of the artworks becomes, thanks to his book, a methodological imperative. Significantly, the focus of his analysis shifts from *external* definitions of the various schools to more detailed investigations that explore the *internal* plurality of each one of these creative settings, thus establishing a dynamic "system of schools," a system whose unity depended largely upon the recognizable plurality of tendencies that could be found within the boundaries of individual schools.[124] In fact, as Lanzi emphatically states, the styles varied not only from school to school but also with respect to the story of a single artist:

> Beyond the manners of the headmaster of every school, there were within each one [of these schools] infinite other masters who were mixed with this and that [school] to such an extent that it is not easy to decide whether they belong to this or to that group. Moreover, the painters themselves have often adopted, in different times and in different works, styles that are so various that, if yesterday they could be pointed to as Titian's pupils, today they would be better classified among Raphael's or Correggio's followers. Therefore, one cannot imitate the scholars from the Natural Sciences who, once having distinguished the plants in different classes, according to Tournefort's or Linnaeus' systems, can easily classify any other plant growing in the same place by simply adding to each one of them precise names and labels describing their permanent characteristics. In order to produce a complete history of painting, it is more convenient to find a way to include all styles, no matter how different they may appear; I have not found any better method than writing separately the history of each school. In doing so, I have followed the example of [Johann Joachim] Winckelmann, excellent scholar of the history of drawing in Antiquity.[125]

In this paragraph—one essential, as we shall see, for a better understanding of the aesthetic agenda that lies behind the organization of the Maggiori collection—Lanzi postulates the existence of a methodological gap between the aims of art-historical research and the goals of a scientific investigation. Whereas the latter is based upon objective parameters of examination and adopts fixed systems of classification, the former requires a more flexible set of hermeneutic principles and interpretive tools, owing to the indefinable nature of its own objects of analysis, namely, the different manifestations of art, and, in particular, of the various forms of painting. Unlike the "system of plants" mentioned by Lanzi, within which scholars were able to establish once and for all

precise distinctions separating the different species, in the world of art, as examined through the lens of Lanzi's new "system of schools," the boundaries among styles, manners, and techniques appear much more difficult to determine with certainty, in virtue of the constitutive polysemy and the problematic definition of the very concept of "work of art" in eighteenth century Europe. The high degree of variability that characterizes the different contexts of production and circulation of art, even within the boundaries of a single school, makes it difficult for any art historian to adopt taxonomic lines of delimitation, much less those as rigidly and clearly defined as the ones applied in the field of the natural sciences.

In Lanzi's view, the "system of schools" should be regarded, in fact, as a rather flexible method of classification, for it requires, on the scholar's side, not only an acknowledgment of the differences among the various regional traditions, but also an assessment of the differences that exist within each one of these traditions. As the author does not refrain from stating, it is essential to keep in mind as well the metamorphic nature of the style that characterizes any artist during the different moments of their careers. To provide an example directly associated with the Maggiori collection, it will be sufficient to mention the case of Guido Reni. While attentively observing his creations over time, any learned connoisseur would notice, at first, strong similarities with the style of Caravaggio; then, the adoption of working methods much closer to Annibale Carracci's, and, finally, the invention of a formal vocabulary that stands uniquely on its own ground, characterized by the ethereal, almost invisible shapes elaborated by the master in his latest years.

Owing to the frequency with which these stylistic metamorphoses occur, Lanzi appears to be understandably hesitant in describing the most predominant features of particular schools. Since one cannot fix the visual components of a school as one would a monolithic wall of stones, the author tends to point out the most frequent elements that are *expected* to be found in a geographically as well as historically circumscribed community of artists as the main characteristics of a school. In other words, for Lanzi the concept of "school" is one that should only be only used on a macro-historical level, for the term itself represents a critical oversimplification and consequently should be applied as a hermeneutic premise only in the attempt to provide a general framework of reference for the interpreter.[126]

In a similar way, Lanzi focused not so much on the definition of recurrent features of a school as on the diversity of styles that appear throughout the accomplishments of a single master. Lanzi's interpretive model could be usefully defined, therefore, as a *radial method* of examination, one that tends to explore the artistic production of a master from an ideal center represented by the data pertaining to his biography—such as dates and places—outward to the various directions opened up by his multiple stylistic achievements. According to such a radial method, after having located the personal story of an artist within its own cultural setting (the school), another important task to be undertaken by the art historian consists in the critical explanation of the changes in style that accompany an artist's career. In fact, as Lanzi intelligently claimed, the same artist could be classified within and connected to different schools. To once again bring in the example of Guido Reni, it is revealing to note how the master could be interpreted both from a Roman aspect (as an enthusiastic promoter of a new Caravaggesque manner at the beginning of the seventeenth century) and a Bolognese frame of associations (as the follower of a more selective, idealized naturalism based on the Carraccesque lesson). One point, however, remains invariable: according to Lanzi, any art-historical research should start from a philologically grounded critique of concrete artworks and, hence, the process of interpretation should be conducted as a patient game of morphological deciphering and destructuring of particular paintings or drawings. By the end of such a process of formal analysis, all the visual components of an image should have been exhaustively described and connected with their specific genealogical chains. As a consequence of this new approach, the art historian emerges as a rigorous philologist and a most meticulous connoisseur.

It is my strong belief, therefore, that Lanzi's radial method constituted an important point of reference for Alessandro Maggiori as he assembled his collection. Maggiori's knowledge of Lanzi's *Pictorial History of Italy* is well documented by the several quotations that appear in the Count's letters and volumes. In the "guide" of Ancona, for instance, Lanzi's name is mentioned as an authority in attributive matters. Further, it is not superfluous to state that Abbot Lanzi was, like Maggiori, born at The Marches, and more precisely in 1732, in a little town then called Treia and now known as Corridonia. This origin may explain to a certain extent why the Abbot has dedicated so much attention to the study of the artistic life of his homeland.

It is unquestionable that, thanks to Lanzi's profound knowledge of the monuments, artworks, and literary sources originating in and pertaining to The Marches that we know, for example, certain important facts regarding the art collection possessed by the Maggiori family even before Alessandro had begun his own acquisitions. In a paragraph of the *Pictorial History* referring to a book written by Abbot Morcelli in 1781, entitled *De Stylo Inscriptionum Latinorum*, Lanzi recalls that "in the house of a gentleman from Fermo, Annibale Maggiori" [i.e., Alessandro's father] one could find "a Madonna who is holding, with both hands, a transparent veil that covers the Divine Child, sleeping in a cradle; next to Him is S. Joseph, on whose stick the aforementioned author [that is to say, Abbot Morcelli] has discovered and read an inscription written in very small letters: '*R. S. V. A. A. XVII P. Raphael Sanctius Urbinas an. Aetatis 17 pinxit.*'"[127] From this sentence one learns that a painting, then attributed to "the supreme master" Raphael, was displayed in the private collection of Alessandro Maggiori's father in Fermo, thus suggesting an instructive case of genealogical transmission of taste, from father to son!

Lanzi and Maggiori (not to mention Alessandro's father as well) held a great admiration for Raphael. Both authors and connoisseurs believed, in fact, that the visual arts had reached their highest climax in sixteenth-century Rome, when the master from Urbino was working in the company of Giulio Romano, Perin del Vaga, Polidoro da Caravaggio, and many other artists. Thanks to Raphael's achievements, the art of painting "arrived in not many years at a degree [of perfection] never touched before nor afterward, except in the case of artists who had imitated those forerunners or united in a single work the qualities that one can find in different pieces made by those masters," as Lanzi comments.[128] By adopting an interpersonal method of creation, in which a highly selective principle of beauty played an important role, Raphael was able to "establish a system; and search only for examples that could multiply his ideas and further stimulate their exercise."[129] The success of Raphael's "system," as Lanzi writes in a quite modern language, depended only partly on the study of "anatomy, history, and poetry," because "his greatest object of study in Rome were the Greek models."[130] By endlessly examining these models, Raphael had eventually become "the first painter of the world,"[131] thus creating a universe of forms and figures unquestionably worth preserving and transmitting throughout the ages, and as influential among artists of the sixteenth century as well as those of the eighteenth century. Interestingly, Raphael's adroitness and mastery are particularly evident, in Lanzi's critical opinion, in the field of drawings:

> Raphael's drawings, as one can see in the many sheets that are now ennobling the cabinets of private patrons, were made without any color and yet they depicted, purely and immediately, as one may say, the portrait of his imagination; what a precision of contours! What grace! What cleanness! What diligence! What force![132]

Accordingly, Raphael's artistic experiences were to become, in Lanzi's interpretation, the foundational stones of the modern "Roman school" of painting, as the author proudly states:

Upon these fine principles [carried out by Raphael] was founded the school that we call Roman. [...] [A]lthough the population of that town has many mixed languages and persons, among whom Romulus' nephews are but a few; in fact, the pictorial school [of Rome] has been populated and always supplied by foreigners, who were received and welcomed in its Academy of S. Luke as if they were born in this town or had enjoyed the ancient rights of the *Quiriti*. Thus derive the many different manners that we shall find there. Some artists, like Caravaggio, have learned nothing from the marbles or other elements that one can find all over the town; and these [artists] are in the Roman school, but do not belong to this school. Some others have mostly adapted themselves to the lesson offered by Raphael's disciples; their method was generally to study the master's works as well as the ancient marbles and, from the imitation of both, unless I am not wrong, derived the general character and the specific accent, so to speak, of the Roman school.[133]

In this paragraph, Lanzi establishes some important distinctions. First of all, the term "school" does not refer to any specific geographic reality but rather describes a quite articulated cultural entity, usually larger than the territorial borders of its place of origin. Furthermore, the author here employs his particular "radial method" to emphasize the fact that, due to the profound differences that one can find among the many styles, manners, and techniques present in Rome, it is essential to distinguish among the masters who have worked *in* this school from those who truly belong *to* it.

In the specific case of the Roman school, what defines its artistic boundaries is the way in which the various masters have engaged themselves with the fragments of antiquity disseminated all over the town, metonymically indicated through the expression "ancient marbles." According to this aesthetic differentiation, Caravaggio should not be considered a member of this school, for his style had nothing to share with the classical legacy and was "essentially based upon nature." Annibale Carracci, on the other hand, should be justly listed as one of its most brilliant exponents and considered as exemplary as Raphael himself, in virtue of his ability to teach "the way to imitate nature and ennoble it with the idea."[134] In evaluating the historical function performed by Annibale Carracci in the process of the rebirth of the arts, after the decadence of Mannerism, Lanzi does not hesitate to point out the crucial contribution provided by the Bolognese master, and eloquently states, paralleling Lazzarini's ideas, that "to write the story of the Carracci and that of their followers means in a certain sense to write the pictorial history of all Italy in the last two centuries."[135] Such a remark would have received Count Maggiori's unconditional approval.

Within Lanzi's historical narrative, Annibale Carracci is highly praised for having introduced a "new ferment" in the Roman school. His disciples, especially Guido Reni and Domenichino, have further developed the master's aims, "stopping the followers of Mannerism as well as the pupils of Caravaggio, and thus bringing back to the Roman school the best method" of creation.[136] Thanks to the many accomplishments achieved by these masters and to the massive presence of other Bolognese artists in town, a new road was opened for the development of the arts. Significantly, in Lanzi's critique the boundaries of the Roman and the Bolognese school have become indissolubly intertwined.

Quite understandably such a fusion must have attracted Alessandro Maggiori. Moreover, as we have already noted, Lanzi and Maggiori were further linked by their common regional origins, being both born in The Marches, a territory that was then culturally, geographically, and politically related to the artistic epicenter represented by the axis Rome–Bologna. It is thus no coincidence that Lanzi analyzes, in the chapters of the *Pictorial History* dedicated to the Roman school, the careers of many artists who were born in this in-between region, such as Federico Barocci, Simone Cantarini, and Carlo Maratti. With excellent critical insight, Lanzi defined the geographic extension of the

Roman school on the basis of its "creative" boundaries, rather than placing the focus exclusively on its territorial borderlines, and in doing so was able to include The Marches in its ray of stylistic dissemination:

> I do not confine the boundaries of this [Roman] school within those of the State of the Church, for I shall include in it Bologna, Ferrara, and the region named Romagna […] Here, I shall consider, along with the capital, only its nearest provinces, Latium, Sabine, Umbria, Piceno, and the State of Urbino [that is to say, places nowadays belonging to The Marches], whose painters were, for the most part, either trained in Rome or by masters who were originally from there.[137]

In other words, Lanzi's distinction between schools is not grounded on differences that are merely spatial; the differentiation is the result of a much more complex interaction of factors. Nevertheless, he quite clearly has in mind the critical implications of adopting such an apparently geographically centered terminology, since it is, in reality, a way to circumscribe much more dynamic phenomena. In fact, the concept of "school" is not used, in Lanzi's pages, to indicate the presence of a closed cultural manifestation, but to refer to still open horizons of artistic possibilities. A "school" is consequently described as a living network of creative connections, artistic associations, and collecting practices, and not as a fixed set of easily recognizable forms and styles.

Yet Lanzi also acknowledges the importance of framing and interpreting the facts of art within their specific historical settings. For this reason, he often recalls the historiographical background that precedes his own research, and systematically mentions the names of his predecessors. Referring to the notion of "school," for instance, he justly observes that "Vasari did not divide the schools," and correctly notes that Monsignor Giovan Battista Agucchi was, instead, "among the earliest writers who have divided Italian painting into the Lombard, Venetian, Tuscan, and Roman."[138]

A similar use of the notion of "school" can also be seen in Alessandro Maggiori's contributions in the field of art historiography. Like Lanzi's—and perhaps *thanks* to Lanzi's—publications, Maggiori's writings are characterized by a rigorous process of cross-examination of the preceding literary sources concerning the areas described by the Count, such as Ancona, Macerata, and Loreto. Moreover, from a methodological standpoint, one can also recognize a revealing correspondence between Lanzi's interpretive tools and Maggiori's critical procedures. Both scholars show an analogous predisposition to explore philological issues related to the problematic attribution of certain artworks, as well as a recurrent habit of destructuring the images they present to readers in minute detail, as if trying to evocatively set them before the eyes of potential spectators by means of accurate, almost poetical descriptions. Similarly, they share the habit of analyzing the formal components of an image, and frequently adopt it as the most appropriate way to begin a historically based explanation of an artwork.

In the "guide" of Ancona, for example, Alessandro Maggiori demonstrates a remarkable ability to provide meticulous comments on the style of the different paintings and drawings he examines. In a paragraph in which he underlines Guercino's stylistic versatility, for instance, he recalls a certain "panel of this same artist (but of his last manner) possessed by the counts of Camerata, in whose gallery it occupies, perhaps, the first place."[139] In another paragraph, in which he analyzes a "Marriage of the Virgin" executed by Giovan Battista Caccianiga, Maggiori cannot refrain from stating, in a footnote, that the painter "after having studied in Bologna, went to Rome, where he has gradually changed his working methods, getting closer to Maratti's."[140] Like Lanzi, Maggiori does not simply examine the protagonists of a certain school according to the prominent characteristics of such an artistic community but, on the contrary, tends to specify, in a very cautious process of stylistic excavation, the various metamorphoses through which a specific master has moved throughout his entire career, ultimately compiling a list of possible formal references that the artist may have seen or adopted while elaborating a certain work.

To both Lanzi and Maggiori, therefore, the most secure ground upon which one should attempt to build up any aesthetic explanation of an artwork lies in the intertwined territories of historical investigation and formal analysis. One excellent example of this critical method can be found in the pages that Alessandro Maggiori dedicated to the description of works created by Domenico Peruzzini, at that time displayed in the churches of Ancona. In Maggiori's pages the very name of the artist becomes an object of historical reconstruction:

> [Pellegrino] Orlandi, according to Lanzi, calls him Giovanni; and Giovanni Peruzzini is, in fact, the name that I have read in the book, *Paintings of Bologna*. [...] However, according to other sources, Giovanni was the brother of Domenico. Other writers state, on the contrary, that there has been only one Peruzzini with this last name. Should we consider, then, that all works usually placed under the name of Knight Peruzzini were created by the same hand? Some works seem to have been painted by quite different brushstrokes, thus confirming the possibility that there have been at least two [different] artists named Peruzzini. As a matter of fact, a *Memorial* published in Pesaro claims that there have actually been three [artists], since Domenico had a son who "lived and worked in Rome" around 1680; given that, as one reads in the aforementioned *Memorial*, he [is described as having] "had the reputation of being a good, and accomplished painter," it seems impossible therefore to attribute to him works as poorly made as the ones described above.[141]

In order to restore the historical identity of an artist, Maggiori employs a cross-examination of various textual sources, putting together data borrowed not only from very well-known books, such as Luigi Lanzi's and Pellegrino Orlandi's, but also from completely neglected volumes, like the *Catalogue of Paintings Preserved in the Churches of Pesaro*, published by Antonio Becci in 1783, a work within which—it is worth mentioning—was also printed, for the first time, a fragment of Lazzarini's *Dissertations*.[142] His rigorous use of textual sources allowed Maggiori to further enrich his formal analysis of specific artworks by setting them within a precise net of historiographical references, thus providing a pioneering model of metacriticism.

In another paragraph of the "guide" of Ancona, for example, Maggiori, referring to a painting done by Peruzzini previously preserved in the Church of the Carmelitani in Ancona, argues, on the basis of a critical statement expressed by Lanzi, that this work "has been made by Peruzzini, imitating however the style of Barocci."[143] On the other hand, talking about a different painting, then located in the Church of Stella in Ancona, Maggiori attributes it, once again, to Peruzzini, on the ground of his personal visual experience, tentatively suggesting that "the central altarpiece representing the Apostle S. Andrea *seems like* a work by Peruzzini."[144] In another paragraph, while describing a small painting then preserved in the Church of St. Augustine at Ancona and investigating its potential stylistic roots, Maggiori claims that the figure of S. Luke "partly shows the manner of Simone [Cantarini] and partly that of the Carracci, but it is, in fact, a work by Domenico Peruzzini from Ancona."[145] In other words, the same artist—as we have seen earlier in the example of Guido Reni—could be equally associated with different formal roots, namely, Barocci (from Urbino), Cantarini (from Pesaro) and Carracci (from Bologna).

Every work of art is the result of a complex process of intervisual exchanges. Every image is, then, the fruit of a multilayered path of accumulations, variations, and derivations. Choices and misunderstandings are, from this perspective, equally necessary factors in an unpredictable calculation: the process of creation. The principal task of a connoisseur will lie, therefore, in his personal ability to individuate and correctly trace back the multiple sources that compose an artistic construction, within a singular osmosis of past models and present solutions. In the case of Alessandro Maggiori, his trained eye as well as his cultural expectations have inescapably contributed toward the

creation of his peculiar physiognomy, both as a connoisseur and an art collector. Guided by an uncommon capacity of observation and a way of describing images with immediacy and precision, the Count was able to provide rather plausible—if not accurate—attributions, as one is forced to conclude after having read the notes written by Maggiori on the drawings belonging to his collection or printed in his books. A master in recognizing the different styles and precisely distinguishing the visual vocabularies of various artists, but also capable of pointing out the morphological metamorphoses that may have occurred throughout the career of a certain painter, Maggiori stands out as the quintessential example of a learned, highly cultured, and well-educated eighteenth-century dilettante and critic. He was sophisticated and astonishingly up-to-date in matters of art and art historiography, as his knowledge of Lanzi's *Pictorial History of Italy* unequivocally demonstrates. Moreover one could even argue that his particular attentiveness in capturing the stylistic versatility of certain artists is the direct consequence of his intelligent assimilation of Luigi Lanzi's "radial method" of investigation: a method that would provide the orientation for the writing of Maggiori's books as well as the organization of his collection, and in addition become a model of analysis and a mode of assembling artworks that could be referred to as metonymical for its strong accent on details and fragments.

With regard to Maggiori's capacity to undertake intelligent formal analysis, some good examples are provided in his "guide" of Ancona, printed in 1824. In reference to a religious composition whose author had never been named before, Maggiori suggests that the painting is "a majestic yet early work by Cesare Dandini from Florence, pupil of Curradi and then of Passignano, whose manner is clearly expressed in the lower part of the canvas."[146] The expression "in the lower part" (*nella parte di sotto*) indicates the morphological pluralism present in this specific work. Hence the necessity, on the connoisseur's side, of conducting a penetrating examination of the painting without neglecting any detail or portion of it—for "God," as Aby Warburg would state many years later, "is in the details." The work, thus disassembled into its multiple constitutive elements, would become the center of a critically oriented and historically based analysis in which literary sources and visual evidences would play equally indispensable roles.

It is in a sense reassuring, then, to find out that at the core of Alessandro Maggiori's activities, both as an art collector and a gifted connoisseur, there is a similar constant effort to restore the authorial identity of the masters who have produced the artworks purchased or simply described by the Count in his volumes. For this reason, as a refined collector of drawings, Maggiori was accustomed to write, on the surface of almost all the sheets that entered his collection, detailed notes recording the places and dates of the various acquisitions, sometimes accompanied by interesting attributions, either *ad nominem* or in reference to a school, notes that, while not always confirmed by modern scholarship, create a promptly recognizable *marque de collection*.

Curiously, though, in spite of his aptitude for distinguishing the styles associated with the different Italian schools, the Count did seem to rely on such variegated knowledge in the making of his own collection. On the contrary, he seems to have intentionally followed a narrow horizon of choices and selected only artworks in which the great tradition of classicist Rome and naturalistic Bologna were unmistakably present. By acquiring drawings formally or iconographically associated with a programmatic feeling of Renaissance nostalgia, Alessandro Maggiori clearly connected his personal aesthetic preferences with the genealogical net of styles that ties Raphael directly to Carracci and, then, in a crescendo of intervisual reappropriations, to seventeenth- and eighteenth-century masters like Carlo Maratti and Domenico Corvi. The paradigms of an exquisitely Renaissance-oriented classicism—more than those related to antique art forms—emerges from the metaphorical walls of the Maggiori collection and forms the elegant frame of reference within which the Count has programmatically decided to assemble his favorite examples of perfection or, to use Lazzarini's own colorful expression, the *chiarissimi esempi* of art.

Significantly, such a coherent set of Renaissance-oriented parameters of perfection was the same one adopted by Lanzi and Lazzarini in their texts, as well as by Amico Ricci in his *Historical Memories*. These were the most promising group of models, the ones that would help eighteenth-century artists as well as early nineteenth-century masters restore, in a nostalgic illusion of greatness, the former grandeur of Italian painting, promoting a timeless return to the age of Raphael. Thanks to this metalinguistic project, in which past and present were intimately interlinked and time was idealistically concealed, artists were to be guided not by virtue of some tantalizing complex of inferiority, but rather by an intense expectation of being able to further develop what was believed to be a still-living tradition. With them, a tradition deeply rooted in sixteenth-century Rome and seventeenth-century Bologna could be newly resumed and timelessly considered as the potential center of a modern collective unity (*Italian* art), able to bring definitively together a myriad of mosaic-like, regional inclinations (the *schools* of art).

10. The Political Implications of Taste

As we have now seen, the collection of drawings gathered by Count Alessandro Maggiori displayed "the clearest examples" of a specific artistic tendency: the classicist "line of perfection" represented by the axis Raphael–Carracci–Maratti–Corvi, whose aesthetic premises and stylistic goals were subtly distinguishable from the more antique-centered phenomenon of Neoclassicism that was spreading, in the same years, all over Europe.[147] By the end of the eighteenth century, being able to authentically praise the immanent beauty of ancient fragments of marble had become commonplace in towns like Rome and London, whereas to esteem the decorous naturalism of seventeenth-century Bolognese masters, such as Annibale Carracci and Guido Reni, and to assert the stature of these artists as equal to Raphael's, might be received with cold perplexity, if not with opened hostility, in such cultural circles as Naples, Vienna, or Madrid.

Amid such a "new-antique" atmosphere, how should one interpret Alessandro Maggiori's decision to adopt a very strict "line of perfection" while purchasing drawings for his collection, which, at its core was to be largely represented by seventeenth- and eighteenth-century protagonists of the Roman and the Bolognese schools? In other words, in the intricate network of Italian schools, so diligently described by Lanzi and conscientiously used by Maggiori himself in his many volumes, how could one explain the latter's choice of limiting his own acquisitions to works in which the Roman and Bolognese schools were clearly featured as particularly exemplary?[148] How could one reconcile Maggiori's attention toward the various schools of Italian art while writing his books with his adoption of a highly selective criterion in the organization of his private collection, one in accordance with a view of "taste" that recalls Giovan Pietro Bellori's "idea of beauty" more than Lanzi's plurality of "schools"?

In order to answer these questions, it is necessary to examine, at least in their general lines, the specific contexts in which Maggiori purchased his drawings. As we shall see, the Count's aesthetic agenda takes on a significant ideological value when it is observed in relation to the events that took place in Italy during the years of Napoleon's rule—from the constitution of the Cisalpine Republic, in 1797, to the proclamation, first, of the Italian Republic in 1802, and then of the Kingdom of Italy from 1805 to 1814, and continuing until the period of the Restoration.[149] Thus, before we turn to the concluding part of this essay, it appears essential to investigate—however briefly—the wider cultural and political background in which the Maggiori collection arose in its superb uniqueness. Without being able to address the Count's ideological orientation in detail, owing to a substantial lack of records and consistent historical evidence, we shall attempt, nevertheless, to explore some of the possible cultural implications, beyond the questions relating to the aesthetic sphere, of his personal taste.

First of all, it is important to keep in mind the dates and places that indicate when and where the Count undertook his various purchases.[150] Significantly, the first sheet, among those currently displayed at Monte San Giusto, was acquired in the years of Maggiori's Bolognese residence and carries, more precisely, the date of 1788. Between the year of the French Revolution and 1796, Alessandro Maggiori purchased approximately forty drawings in centers such as Bologna, Modena, Ferrara, and Rome. Understandably, from 1796 to 1801—in the period between the arrival of the Napoleonic army in the peninsula and the constitution of the Italian Republic—Maggiori stopped acquiring artworks. Then, from 1802 to 1809, he resumed his "politics" of purchases with regularity, buying thirty-five new sheets. In 1809, however, his plan of systematic acquisition seems to have suffered a definitive arrest, with the exception of three drawings, one bought in Rome in 1816, and two others purchased in Pesaro and Urbino in 1817. It is possible, of course, that other drawings were purchased on different dates and in other places than the ones reported here, but no documentary evidence of that exists.

On the other hand, the list of attributions provided by Maggiori—and clearly marked on the various sheets—reveals, without a doubt, his profound predilection for artists associated with the schools of Rome and Bologna, a preference directly related to the poetics of classicism belonging to the Raphael–Carracci legacy. As a matter of fact, one is naturally led to conclude that Alessandro's program expressed his love for these classicist masters after having read, on several drawings, the names of the artists purchased by him, for they are almost exclusively connected with these two schools: "*La Sirani fece*," "*Il Bononi fece*," "*Il Batoni fece*," "*Il Maratti fece*," "*Il Sassoferrato fece*," "*Il Cantarini fece*," "*Guido Reni fece*," "*Andrea Sacchi fece*," and so on.

As mentioned above, the year 1796 marks the first interruption of Maggiori's regular purchases since the moment he initiated his collection. In the spring of that year, Napoleon Bonaparte, heading his *Armée d'Italie*, had begun his unstoppable Italian campaign, proceeding without defeats and conquering towns, villages, and whole regions, until, in 1796, the Cispadane Republic was constituted, to be further enlarged and renamed the Cisalpine Republic in 1797.[151] At first embraced with enthusiasm and hope by the local population, but afterward fought with increasing violence, in a dramatic escalation of hate against the French presence in the peninsula, the Napoleonic expedition in Italy also marked the period during which thousands of works of art were taken away from their original settings as war trophies and transferred to other cities, chiefly to Paris, where museums were purposefully remodeled or rebuilt to contain them.

A similar campaign of preemption, already undertaken by Napoleon after the invasion of Belgium and The Netherlands, respectively in 1794 and 1795, had been ideologically legitimized through the so-called *rappatriament* or "doctrine of repatriation." According to this doctrine, the masterpieces of the past were considered by French intellectuals and governors as being the "victims of exile" and were, as a result, believed to have been "unjustly hidden" in places of "political tyranny," such as the fragmentary city-states of Italy, as the art historian Édouard Pommier reports in his excellent study on eighteenth-century cases of expatriation of artworks.[152] With the populace guided by means of powerful propaganda, it became quite common among French people to believe that, as Pommier acutely argues, "despotism, corruption, and decadence have deprived these works of their significance; the [French] Revolution can restitute their lives and words, bringing them back to the homeland of liberty; they are, as [French lieutenant] J. L. Barbier says, the 'patrimony of the liberty.' It is not a spoliation, but a 'return' to their natural 'domicile.'"[153] In other words, the spoliations were justified by means of a massive ideological campaign, disseminated in the attempt to create a consensus among the population so that the violent removal of artistic treasures from the conquered lands could be smoothly presented as a "restitution" or a "return" of the masterpieces to their "most authentic homeland": that is to say, France, the only modern cradle of freedom that could guarantee, according to this discourse of legitimization, full "liberty" to the grand artworks of the past. In effect, these works

were intended to enrich the rooms of the *Musée Nationale*, renamed the *Musée Napoléon*, and finally rebaptized as the *Musée du Louvre*.[154]

The idea that artworks from the past might finally find their most "appropriate" and "reliable" location in Paris, where the revolutionary screams of *liberté, égalité, fraternité* were still echoing on the streets, became a repeated leitmotiv at that time. Thanks to this overwhelming operation of ideological persuasion, the subtraction of artworks from their original locations was no longer considered to be a "vile" plan of "expatriation," but instead a "generous" program of "restitution."

The politics of cultural reappropriation pursued by the Directory and the legitimization of the plunder by means of the "doctrine of *rappatriament*" had begun with the conquest of Belgium by the French *Armée* in 1794. That year, on September 20, the painter and lieutenant Barbier emphatically described to the members of the Convention the first convoy filled with Flemish paintings that had left Brussels and were being directed to Paris in the following words:

> The fruits of genius are a patrimony of liberty. [...] For too long, these masterpieces have been dirtied by the sight of servitude: it is among free populations [that is to say, in France] that the works of these glorious men should be kept; the cries of slavery do not deserve their glory nor should the honor of kings disturb the peace of their tombs. The immortal works left by the brushstrokes of Rubens, of van Dyck [...] are deposited today in the homeland of the Arts and of Genius, in the homeland of Liberty and sacred Equality: the French Republic.[155]

Realized by "free spirits," the masterpieces of the past should proudly return to the cradle of modern civilization, the homeland of the French Revolution: Paris. Once the removal of artworks was justified, thousands of masterpieces were taken from Brussels, Amsterdam, and later from Rome, Bologna, and many other places, including The Marches, to fill the rooms of the *Musée Nationale* in the French capital. Yet in order to stop indiscriminate trafficking in art, many treaties and agreements were signed between France and the occupied territories. At Bologna, for instance, on June 23, 1796, an armistice was signed by Pope Pius VI and Napoleon, in consequence of which it was agreed to concede to the French a hundred artworks and five hundred manuscripts then preserved at the Vatican Library, in exchange for Napoleon's agreement to not invade Rome.[156]

A few months later, however, after having heard about a new alliance sealed between the Pope and the Austrians, the general decided to break the armistice and to occupy the territories of the State of the Church. On this occasion, the regions of Romagna and especially The Marches were savagely invaded and sacked. On February 17, 1797, as a consequence of this massive attack, another important agreement was signed between Napoleon and the Pope in Tolentino, a town located only a few miles away from Fermo, where Alessandro Maggiori was born and had lived until the (uncertain) date of his departure to Rome. This agreement, known as the Treaty of Tolentino, not only conceded the Legations of Bologna, Ferrara, and Ravenna to the French, but also confirmed irrevocably the concession of the artworks previously confiscated and brought to Paris.[157] By virtue of this treaty masterpieces such as the *Laocoon*, the *Apollo Belvedere*, and the most celebrated *Transfiguration* by Raphael were transferred to the French capital, where they arrived between July 27 and 28, 1798, as represented on a print engraved by Charles-Pierre-Joseph Normand, emphatically entitled *The Triumphal Entry of Italian Monuments in Paris*.[158] The atmosphere of contagious enthusiasm among French people is well expressed by a folksong composed in that occasion:

Entrez, magnifiques trésors, dans la cité d'un peuple libre;

La Seine a remplacé le Tibre et votre Panthéon est ouvert sur les bords.

[…] Rome n'est plus dans Rome: Elle est toute à Paris.

(Come, magnificent treasures, into the city of free people;

The Seine has taken the place of the Tiber and your Pantheon is open on its banks.

[…] Rome is no longer in Rome: It is all in Paris.)[159]

It goes without saying that many initiatives were undertaken—especially among Italian intellectuals—in the attempt to avoid, or at least to control to a certain extent, the campaign of systematic removal of artworks from their original settings. A particularly important action of this kind took place in Bologna, where the members of the *Accademia Clementina* played a fundamental role in trying to protect, as far as they could, the local artistic patrimony.[160] In March 1797, in fact, right after the Treaty of Tolentino was signed, the academy had just completed an inventory of the pieces that were still preserved in churches and religious corporations of the town, selecting, classifying, and partly transferring them to a safer place, namely the Institute of Sciences, where they were kept for several months. Unfortunately, however, this pioneering example of protection for art was soon rendered ineffective by the proclamation of the Roman Republic, in February 1798. Now that the State of the Church was suppressed, Bologna was no longer subordinate to Rome, but had become part of the general map of all the republics ruled *de facto* by the French Directory. It was impossible, therefore, to avoid the subsequent transfer of a conspicuous portion of Bolognese treasures to the Parisian *Musée*.

Moreover, due to the great admiration in which seventeenth-century Bolognese masters were held in France—a phenomenon that would eventually reach, in the second half of the eighteenth century, the proportion of a collective obsession for what was referred to as *"le gran goût des Bolonais"* (the grand taste of the Bolognese)[161]—artists such as Carracci, Reni, and Domenichino were placed on the same level as Raphael. This explains why works by some of the most illustrious exponents of the Bolognese school were regarded as the chief masterpieces of the Napoleonic Museum, despite the programmatic intention of its director, Domenique Vivant-Denon, to assemble in its rooms samples from all Italian schools.[162]

The good fortune of the Bolognese masters in France, and in all the territories related or subordinated to France, would, some years later, induce the vice-regent of the recently proclaimed Kingdom of Italy, Edoardo Beauharnais—the son of Giuseppina Bonaparte—to undertake a new and devastating campaign of spoliation of artworks in Italy, especially in the regions of Romagna and The Marches.[163] Once again stolen from their original contexts, the artworks were then displayed in the newly restructured Gallery of Brera in Milan, as the city had been raised to the status of the capital of the kingdom. At first guided by Italian painter Andrea Appiani, and later by the Modenese painter and restorer Aurelio Boccolari and the Bolognese painter Giuseppe Santi, the outrageous artistic theft that followed was the cause of the immense transfer of Bolognese-made works to the rooms of the Milanese museum in the first decade of the nineteenth century.

The areas nearby Bologna, as well as the regions of Emilia-Romagna and The Marches, became in those years a hopeless theater from which, one by one, countless artworks were taken. Yet as a paradoxical consequence of these savage attacks against the local artistic patrimony, a new sensibility and a more alert consciousness of the necessity of protecting and preserving these works of art began to emerge, especially among the intellectuals living in those areas.

The emergence of such a new aesthetic and civic awareness, thanks to which artworks began to be considered as symbolic carriers of a collective identity, is notably confirmed by Alessandro Maggiori's books. At the conclusion

of his "guide" of Ancona, for example, the Count writes a moving chapter entitled "Churches: Some destroyed and others not yet reopened, whose paintings have been brought elsewhere, or whose whereabouts are currently unknown, or have perished."[164] At the very beginning of that chapter, in a brief section dedicated to the church of S. Bartholomew at Ancona, the author recalls, for example, that "the painting on the main altar, made by Girolamo Siciolante da Sermoneta, is now displayed at the Imperial Gallery of Milan."[165] Analogous notes concerning works no longer visible in town, because lost, transferred, or sadly dispersed, characterize the pages of Alessandro Maggiori's books, as well as those written by Luigi Lanzi and Giovannandrea Lazzarini.[166]

The growing sense of an "Italian patriotism"—a patriotism, it is important to emphasize, that was not yet definable in its political dimension as a national quest for unity, but was a collectively shared sentiment, one vividly felt to be a common cultural link even among more distant geographical areas of the peninsula[167]—stimulated the organization of more consciously pursued attempts to defend, protect, and conserve the artistic patrimony belonging to each one of the "defeated" regions of Italy. "On these grounds," writes the Italian scholar Antonino De Francesco, "a political line more adequately definable as national will eventually take shape and become an original political culture that could be pointed out as Italian, one in which the defense of the peninsula's artistic heritage was perceived as an element that further distinguished it from its powerful (yet encumbering) ally,"[168] the ally here being a reference to the French Republic as elevated to the rank of an empire under Napoleon's guidance.

It is ironic, then, that the massive presence of the *Armée d'Italie* and the imperialistic politics adopted by the French within the conquered territories of the peninsula seem to have played a decisive role in the gradual emergence of a feeling of unity on the side of the oppressed populations. This feeling, by no means organized as a political force during Alessandro Maggiori's time, would ultimately constitute the ground upon which a certain idea of Italianness would later be conceived, in close connection with the rich literary, artistic, and linguistic patrimony spread all over the peninsula. Of course it is true that the unity of Italy would be politically achieved and legally proclaimed only in 1861, exactly one hundred fifty years ago. However, the first appearance of this new sense of civic awareness and cultural belonging dates back to the beginning of the nineteenth century and should, accordingly, be considered in the context of a pre-unitarian organization of Italy as a state.

In this progressive process of cultural self-determination, as well as in the quest for a "national identity," a chronological coincidence that appears particularly worth noting occurred. In it one can see a link between Alessandro Maggiori's decision to resume his purchasing of drawings, in 1801—after a long pause almost certainly caused by the chaotic situation of Italian social and political life—and the publication, in that same year, of an incisive article written by Vincenzo Cuoco—one of the most politically engaged Italian intellectuals of the time— in the journal *Redattore Cisalpino*. As Cuoco claims:

> [W]hile all nations are founding museums, we are selling the masterpieces that used to be the ornament of our galleries for vile prices. Above all, the last decade of the [eighteenth] century has been fatal to the artistic monuments of Italy. Never before has the attempt to preserve the remaining artworks become so central an issue for the government as in our day. We shall never return to the production of new masterpieces without savoring those that we still possess, and we shall never be able to savor them without adequately protecting such a patrimony.[169]

What emerges quite clearly in this paragraph is that the great artworks of the past were considered indispensable examples that could further stimulate and reinforce the creativity of the masters of the present times. As the reader may recall, such a pedagogical function was also one of the basic tenets in the organization

of the Maggiori collection, in which the works from the past—the *chiarissimi esempi*—were believed to illuminate the road leading to the creation of work by eighteenth-century and even early nineteenth-century artists, through a sympathetic reappropriation of Renaissance modes and models of representation. After the traumatic losses suffered by the Italian artistic heritage, largely due to the Napoleonic wars and their systematic spoliations— rationalized, as we have seen, by means of the ambiguous politics of *rappatriament*—the exemplary and didactic nature of the masterpieces still located in the peninsula began to be regarded with a new consciousness, and as a consequence such works were jealously preserved, regardless of whether they were monumental altarpieces or small-scale drawings, as in the Maggiori collection. In other words, the educational value attached to the art of the past was from that point forward directly linked to safeguarding their condition effectively. Accordingly, the key word became *proteggere*, to protect.[170]

Moreover, in 1802, the same year the Italian Republic was proclaimed, in a series of political tactics and decisions conducted by Napoleon Bonaparte, the State of the Church promulgated the earliest and most farsighted plan for preservation of the national patrimony written to that date: this was the so-called *Chirografo*, sealed by Pope Pius VII.[171] As the insightful Italian art historian Andrea Emiliani has written, "The primacy in the emanation of the old laws of preservation [...] is due to the pontifical government that had recognized in Rome the spiritual value of a *traditio*" as early as in the fifteenth century.[172] One should not be surprised, therefore, if it would later be none other than the Holy Seat that would sign, at the beginning of the nineteenth century, a document that represented a turning point in the history of conservation of the fine arts: the 1802 *Chirografo*. Thanks to this pontifical proclamation, in which a meticulous plan of protections and safeguards was established in the form of specific laws, duties, and penalties, the status of artworks—both documents and monuments—was notably raised. In addition, behind the formulation of the *Chirografo* one can unmistakably assume the presence of the sculptor, antiquarian, and theoretician Antonio Canova, who had been nominated Knight in that same year, and, more importantly for the sake of our discourse, "General Inspector of the Antiquities and Fine Arts" of Rome, taking on a charge that in the sixteenth century had been carried out by such outstanding masters as Bramante and Raphael.[173]

The 1802 *Chirografo* reaffirms a number of important premises from previously established plans on the safeguarding of artworks, such as the one signed by Pope Clemens XII in 1733, which was mostly concerned, however, with the protection of ancient statues and fragments.[174] In the new *Chirografo*, the value of the artworks from the past—now framed more broadly to include works ranging from paintings to statues, and from manuscripts to printed volumes—was peremptorily related to their being a "safe norm of study to those who devote themselves to the exercise of these noble arts,"[175] according to a notion of *exempla* not dissimilar from those described by Vincenzo Cuoco in the article mentioned above and earlier suggested by Giannandrea Lazzarini through the expression "most clear examples." Thanks to the *Chirografo* of Pius VII, as Andrea Emiliani shrewdly observes, the arts were "borne out by the spontaneous identification found between history and the present, which appears as the fruit of a very engaged neoclassical culture," and were therefore considered, from that moment on, as "nutriment to the arts themselves" and "samples and guides able to stimulate those who shall practice them."[176] All this being so, they should be carefully preserved and transmitted to future generations, for they are, in the pope's own words, "*quasi i veri Prototipi, ed esemplari del Bello*," that is to say, "almost the true Prototypes and Examples of Beauty."

In such a historical context, the collection of drawings assembled by Alessandro Maggiori, with its very specific aesthetic directives and its classicist-oriented taste, could be interpreted as an early attempt to promote an appropriate safeguarding of artworks belonging to two significant artistic schools, namely, the Roman and the

Bolognese, considered to be exemplary of the most authentic Italian tradition. It is rather tempting, therefore, to read the programmatic gathering of artworks conducted by Count Maggiori as a private reply directed against the violent removals perpetrated by the French after the invasion of Rome, Bologna, and The Marches. On the other hand, from an ideological point of view, Count Alessandro Maggiori appears always to be on the pope's side, as documented by several of his letters,[177] and, as a citizen born in one of the zones most systematically attacked by the *Armée d'Italie* and deprived of many of its masterpieces, it seems reasonable to believe that his collection may have also assumed—at least to a certain extent—an implicitly "political" connotation, along and in strict accordance with its well-defined aesthetic agenda as a "portable" academy of art created for the sake of those artists and connoisseurs who wanted to further enhance their manual as well as critical skills by studying, copying, and assimilating the lessons conveyed by works of art from the past. In other words, one could suggest that, among the many implications of the Maggiori collection, there is also a very early attempt to preserve, as attentively and carefully as possible, precious traces of the past grandeur of Italian art, and to reunite, within the protective walls of a private collection, works in which one could still feel the stature of Raphael, Carracci, and Maratti, that is to say, the true achievement of the great forerunners of an incomparably rich tradition: the Renaissance-oriented poetics of Italian classicism. Having been shaped on a transhistorical dimension, this sort of classicism could safely guide eighteenth-century masters toward a promising future, in spite of, or even in response to, the systematic thefts perpetrated by the French. From this perspective, and thanks to a new, self-conscious reappropriation of the country's own past, a path toward the future could then be opened.

11. Amico Ricci and a Discourse in Praise of a Selective Emulation

In the 1802 *Chirografo*, artworks of the past were regarded as worth preserving both for their intrinsic value as "nutriment for the arts" and as objects that presented themselves as "true Prototypes and Examples of Beauty." In the case of Alessandro Maggiori's collection of drawings, the "safe norm" and the "true Prototypes and Examples of Beauty" are emblematically represented by the greatest exponents of the Roman and Bolognese classicist schools, such as Raphael, Barocci, Domenichino, and, of course, the "grand Carracci," Annibale. Furthermore, Maggiori's admiration for the seventeenth-century masters as well as their Roman predecessors is also a noticeable element in the pages written by his friend, intellectual heir, and first biographer, Amico Ricci from Macerata. In the *Historical Memories of the Arts and the Artists of Ancona*, which as we have noted earlier was printed in 1834, the year of Maggiori's death, Ricci emphasizes the paradigmatic character of seventeenth-century Bolognese masters, and establishes a close connection between them and the development of the arts in eighteenth-century Italy, with particular attention to the specific case of The Marches, an in-between land simultaneously oriented toward Rome and Bologna. In a paragraph that refers to the "rebirth" of the visual arts in the territories of The Marches, after the "medieval clash," Ricci writes:

> It was thanks not so much to the support of the princes as to the power of private minds that the school opened by the Carracci in Bologna had grown stronger day after day, thus increasing Italian honor. Young people coming from different areas went there to learn and, after returning to their homelands, they were ready to establish a new taste and a new manner of painting. The provinces of The Marches were not behind the times and wanted to diffuse a method that was attracting everybody's attention in those days. [...] Thus young people from these provinces went to Bologna in order to find useful instruction.[178]

Clearly, in Ricci's pages too, the Carracci are presented as the "fathers" of modern art. However, the most striking part of this statement lies in the fact that, according to the author, the "useful instructions" that could help contemporary artists to further develop the "new taste" inaugurated by the Carracci were to be carried out not only by seventeenth-century followers but also by eighteenth-century masters still working at The Marches in accordance with this "new manner of painting," which is to say, in an exquisitely Carraccesque style. In other words, the legacy of the Bolognese masters was sensibly felt to be "useful" for the inspiration of artists who were Ricci's contemporaries. As Alessandro Maggiori had, Amico Ricci too acts as an indefatigable supporter of those aesthetic values inherent in the Raphael–Carracci line, and at the same time promotes the idea of a Timeless Renaissance, or the idea of engaging in a "Renaissance Revival" among early nineteenth-century painters, patrons, and art collectors. Ricci firmly believed, in fact, that if contemporary artists ceased to take lessons from the Carracci's parables, their art would miserably decline and fail, an outcome that had already been seen in the case of late sixteenth-century Mannerism. According to Ricci, "decadence" of this kind was precisely what had befallen the work of Francesco Mancini, a painter from The Marches who had formerly been Domenico Corvi's master in Rome. Not hesitating to use quite caustic expressions, Ricci describes Mancini's career as a stylistic failure on the grounds that he did not always follow the stylistic idiom so boldly inaugurated by his seventeenth-century Bolognese predecessors:

> Trained within the school of [Carlo] Cignani, Francesco Mancini, [who was] born in Sant'Angelo in Vado [in The Marches], went to Rome where, instead of following the precepts learned from his master, he has rather preferred to cultivate the style that was then flourishing at the capital, substituting for the strong, precise, and imaginative manner of the Bolognese school, the fainting, the defeated, the pathetic.[179]

For artists like Mancini, Ricci affirms, not following the classicist tradition meant one would fall irremediably into mediocrity. The legacy provided by the Bolognese school thus emerges as an aesthetic paradigm still valid in the eighteenth century, especially if one wanted to arrest the potential decadence of one's art. The pinnacle of artistic perfection, so closely associated with Raphael's grace and the selective naturalism of the Carracci, and which had defined the language of "grand taste" in seventeenth-century Europe, was still able, in Ricci's opinion, to expand the souls of eighteenth-century artists who were truly eager to listen to its promising lessons. In a period in which the concept of artistic heritage was about to become a social value, as well as being seen as the symbolic point of convergence of larger collective forces, masters such as Raphael (whose *Transfiguration* had, plainly by design, been chosen to be brought to Paris in one of the earliest convoys that left Rome in 1798), Annibale Carracci (whose works too were brought from Bologna to the rooms of the *Musée Nationale*), and Domenichino, as well as other Bolognese and Roman artists, had become objects of a new cultural idolatry, marking the beginning of a process that would soon consider them as the icons of a shared tradition that could be intimately felt as typically Italian.

In Ricci's view—in which one can easily notice the echoes of Maggiori's opinions, for the Count is remembered by Ricci himself as his "intellectual mentor"—the selective emulation of Raphael as well as a meditative study of the Bolognese masters of the *Seicento* became the true principles that could orient anyone who was striving to reach the highest horizons of good taste. This seems to have been the case with Giovan Battista Salvi, better known as Sassoferrato, by virtue of the name of his hometown at The Marches (fig. 34),[180] a master who had promptly embraced the principles of a gracious classicism and thus reached excellent results in his paintings. Trained under Domenichino, as documented by both Lanzi and Ricci, Sassoferrato then moved to Rome,

where he immediately began studying the manner of the best artists in town, for, he believed, and as Ricci explicitly states, "that virtue progresses only by means of emulation."[181] Following this paradigm, he paid careful attention to "diligent meditation upon the prototypes of beauty,"[182] an expression that significantly recalls the words of Pope Pius VII in the 1802 *Chirografo* ("the true Prototypes and Examples of Beauty"). Raphael, not surprisingly, "became his very favorite model," and Sassoferrato "was able to incarnate the spirit of the Great Master in such a way that, by translating him, as one may say, he has further elevated the master's forms and concepts."[183]

Figure 34. Sassoferrato, *Madonna with Child* Galleria Borghese, Rome

Sassoferrato's studies of Raphael were undertaken in a respectful yet active mode and not simply by means of mechanical repetition. In fact, the images painted by the seventeenth-century artist may be considered as among the most suggestive *interpretations* ever done after Raphael's originals. Rather than appearing as pale and passive replicas, his works can instead be seen as intelligently planned reappropriations. Even in the making of copies, Sassoferrato could fully manifest his personal artistic *ingenium*, as Ricci strongly asserts:

> The copy that he has made of [Raphael's] Deposition of the Christ, displayed at the church of S. Peter in Perugia [*sic*], forces me to pronounce a statement that, unless my eyes did not deceive me, someone could find too audacious. If an attentive and exquisite connoisseur looks at the original, he shall find out that the characters who are holding the dead Redeemer are expressed with excessive force and that their muscles appear too evident. There is no doubt that Sanzio had preferred these forms because they seemed more appropriate to express the different movements of the soul; but Il Salvi, far more discreetly, has concluded that the perfection in art lies in the union of the most correct expression with the most beautiful forms.[184]

Ricci was right in fearing that such a statement might have sounded "too audacious" to an eighteenth-century audience's ears for, in his comparison between Raphael and Sassoferrato, it is the latter, instead of the former, who receives the highest praise. Unexpectedly, the figures painted by Sassoferrato are considered by the nineteenth-century author to be more accomplished and refined than the ones made by Raphael himself! Ricci is firmly convinced that the example offered by Sassoferrato, with its highly selective parameters of emulation and its promising example of a judicious method of reappropriation, could provide an excellent model for eighteenth-century artists.

It is also interesting to note that, in Ricci's pages, Sassoferrato's name is significantly related to the art collection formed by Count Alessandro Maggiori. In a paragraph in which the author refers to a drawing representing S. Michele in the act of trampling on the dragon, the artwork is recorded and minutely described as one of the drawings "jealously preserved in the collection of the Count Alessandro Maggiori from Fermo, and it confirms that our painter [i.e., Sassoferrato] is very competent in the correct representation of human forms,

for the Archangel is rendered with an appropriate nobility of character, which is not altered by the action he is engaged in."[185] The drawing, purchased by Maggiori in Rome in 1803, shows Sassoferrato's gracious, Bolognese-like mode of sweetening the expression of the saint who, in spite of the dramatic dynamism of his battle with the monster, appears as "appropriately" and "beautifully" rendered as the figures depicted in the "copy" of Raphael's *Deposition*, in which the sharply defined forms painted by the Renaissance master were intentionally softened by his seventeenth-century interpreter.

Furthermore, with regard to the lively eighteenth-century phenomenon of collecting Sassoferrato's works, Ricci states that "his drawings [...] were preserved as most precious objects in the collections of art lovers."[186] In the case of the Maggiori collection, the author recalls that the Count possessed not only the remarkable drawing mentioned above, but also "a beautiful portrait of a woman from Frascati painted by Salvi, which was preserved in the house of the Count Alessandro Maggiori in Fermo."[187]

As a master particularly outstanding in the rendering of sweet physiognomies and delicate, idealized figures—Neo-Raphaelesque in his limpid style and Neo-Carraccesque in his most decorous respect for natural forms—Sassoferrato was chosen by Ricci as a perfect example of a seventeenth-century artist who was able to keep alive the Roman–Bolognese classicist legacy, thus offering a system of reappropriation that could disclose the road of creation ideally to be pursued by eighteenth-century artists. It is not surprising, then, to find that Sassoferrato's stylistic similarity to Domenichino is promptly remarked by the author. In a rather revealing paragraph, Sassoferrato's representation of S. Domenico, discussed by earlier connoisseurs in comparison with the manner of Correggio and Carlo Dolci, is forthrightly described by Ricci in terms of its exquisitely Bolognese matrix, Domenichino. As the author claims, "From Correggio, Salvi has studied chiaroscuro and has learned a lot by seeing his works. In the making of his heads, however, he does not imitate either Correggio nor Dolci, but rather Domenichino."[188] Sassoferrato's adoption of Domenichino as a model, instead of Dolci, reemerges in many of his widely known depictions of Mary. In another paragraph, filled with an intense and minute description of details, Ricci further stresses the connections between the Bolognese masters and, in particular, between Domenichino and Sassoferrato:

> His [Sassoferrato's] brushstrokes are full and his colors are as vague as [those of] his model [namely, Domenichino], from whom he has borrowed that large [way of depicting the] contour of the eyes, thanks to which the physiognomies assume a decisive, magnificent character; a character that nobody knew how to represent better than Domenichino and to emulate better than Salvi.[189]

Not all spectators and connoisseurs seemed to be equally fond of Sassoferrato's meta-mimetic abilities. In fact his extraordinary capacity to emulate the models of the past provoked contemptuous reactions and even harsh criticism among eighteenth- and early nineteenth-century audiences. Yet in spite of this general perplexity, Sassoferrato appears, before the enthusiastic eyes of the nineteenth-century author, as one of the most interesting masters of the Timeless Renaissance so eagerly researched by the Italian classicist tradition. His superlative value as an artist stands, therefore, as an irrefutable "truth" for Ricci,

> a truth that denies the unbalanced judgment of a certain Anglican lady about this painter. In a diary printed in London [...] in 1826 [...] she expresses herself in this way: *Sassoferrato is a great portrait-maker of Madonnas, but he copies from Guido here, from Carlo Dolci there, and copies them in a weak way; his brushstrokes fail because they are weak and insipid.*

In this statement—Ricci bitterly concludes—our master is not adequately recognized for the quality of merit and praise that he really deserves.[190]

After recalling the "unbalanced judgment" of the "Anglican lady," Ricci writes a most unexpected sentence in defense of Sassoferrato's working methods, stressing his artistic achievements and further asserting the validity of making images in strict consonance with models of the past, especially with respect to borrowing from Raphael- and Carracci-related examples. In a strenuous defense of what may be called an "emulative process of creation" or a "system of aesthetic reappropriation," in which the immanent value of the past is believed to be further reinforced through its new adoption in the present, Ricci argues:

> If Sassoferrato has usually rendered on his canvases the image of the Virgin in different poses, preferring to focus on simple and humble attitudes instead of [depicting] composed and elevated [subjects], this is due to his [habit of] following his own religious and tranquil genius. Who could consider, then, such a choice as a lack of talent, when he knew so vividly how to express the character of the virtue that adorns his figures? [...] He has reached what should be called the MORALITY OF PAINTING, whose importance was kept well in mind by the ancient [artists], who used to define this art [of painting] as *the representation of customs*.[191]

At first, in this sentence, Ricci seems to justify Sassoferrato's emulative procedures on the ground of an essentially moral argumentation, directly associating the artist's work with the Renaissance concept of *decorum*. In a second moment, however, Ricci takes up the threads of his own critical remarks and provides an exquisitely aesthetic explanation of why Sassoferrato's works should be highly regarded by both artists and connoisseurs. His paintings, Ricci emphatically proclaims, are superb improvements in a carefully studied and attentively preserved tradition:

> [T]he Madonnas portrayed by Sassoferrato, as well as his other simpler representations of individual heads, are most praiseworthy works for, through an air of purity and supernatural sweetness, one can immediately recognize She who was born to comfort Humankind. [...] Moreover, such an ideal was not slavishly borrowed from works made by Guido or Dolci: the former had mainly inserted his Madonnas within monumental compositions and they were of a different kind, not similar to Salvi's simple ones; [...] as for Carlo Dolci, if he was superior to Salvi with regard to the elegance of his brushstrokes, he was inferior to him in regard to the [quotient of] beauty; besides, any beauty would inevitably be inferior to the invented object, had the artist just limited himself to providing a simple imitation. Sassoferrato's fantasy was further enriched so that his personal taste for devotional images could be improved thanks to a constant contemplation of this kind of beauty. Despite his having imitated masters [of the past] in the small parts [of his paintings], he was nevertheless the inventor of their total composition.[192]

In other words, Sassoferrato's works are not pedestrian repetitions of models accurately selected from the past—a past still celebrated as exemplary—but offer, on the contrary, intelligent interpretations of forms and formulas previously established, without failing to be creative. According to Ricci, the master was able to distill a highly personal vocabulary and to compose a harmonious *whole* after borrowing *details* taken from or inspired by earlier artworks. Such a selective mode of image-making, based upon a very accurate study of particular forms elaborated by the great masters of the past in order to invent, autonomously, new compositions, presents itself as a process that, far from being a tautological reproduction, could wisely transform even the most personal manner into

a transmissible working method, thus elevating the system of reappropriation toward a quite stimulating procedure, in a sort of perennial stylistic rivalry between past and present masters.

This method of visual construction—which could be conveniently called, as we have already noted, an "emulative process of creation"—was consistently adopted by eighteenth-century Roman academies, such as Corvi's, Mengs's and Batoni's, where young artists were expected to learn, first of all, the precise rendering of anatomical details, largely borrowed from ancient statues or Renaissance drawings and prints, before facing the difficult task of depicting images from life and, finally, becoming able to create their own compositions. Details, particular aspects, and fragments were thus raised to the status of elements worth receiving aesthetic attention.[193] When interpreted as visually compelling fragments, as "most clear examples" of artistic perfection, *details* began to be accurately chosen from past artworks so that newly created *wholes* could reflect, and not simply mimic, the exemplary values of their models, establishing in this way an intriguing game of intervisual permutations. For the past *within* the present: the past *is* the present.

Every creation becomes an act of reappropriation. It follows then that art lovers, connoisseurs, and collectors alike are invited to explore the historical origins as well as the genealogical chain of morphological associations that

Figure 35. Fortunato Duranti, *Holy Family with S. John and S. Anna*
Biblioteca Comunale, Fermo, Italy

lies behind—and *within*—every image. From a historical and conceptual standpoint, such a metalinguistic approach might be related to the pioneering example of eclecticism provided by Raphael himself (see his poetics on a highly selective "idea," as described in the notorious letter addressed to Baldassare Castiglione), as well as by Annibale Carracci's polymorphism, as it was decanted by Malvasia.[194] Through the assimilation of details taken from or inspired by illustrious models, the artist can ultimately build up his own image as a whole. Significantly, such an eclecticism, elevated to the rank of a promising mode of visual construction, was adopted not only by artists contemporary with Alessandro Maggiori but also by those later living and working in areas close to where his collection of drawings was physically located.

This was the case, for instance, with the then-celebrated master Fortunato Duranti from Montefortino, the little town in the Province of Fermo where Count Maggiori was born.[195] Some of the drawings made by Duranti between 1810 and 1815, now belonging to the collection of the Biblioteca Comunale of Fermo, in fact show an analogous predisposition to follow, at the same time, the styles and working methods of different masters from the sixteenth and seventeenth centuries. Whereas some of his images unmistakably recall the visual strategies explored by Leonardo da Vinci (fig. 35), especially with regard to the subtle, atmospheric treatment of contours, other compositions instead indicate his admiration for Michelangelo's formal vocabulary, as he borrows and readjusts elements taken directly from the artist's famous *Tondo Doni*, rendering them, however, by means of a general eighteenth-century tendency to outline the figures with rather simple, delicate, yet incisive lines (fig. 36). In other works, Duranti clearly emulates Raphael's manner in such an astonishingly metamorphic way that one might have the impression that one were looking at a work created by one

Figure 36. Fortunato Duranti, *Holy Family with S. John*
Biblioteca Comunale, Fermo, Italy

Figure 37. Fortunato Duranti, *Flight into Egypt*
Biblioteca Comunale, Fermo, Italy

of his pupils, such as Polidoro da Caravaggio (fig. 37). Finally, Annibale Carracci's gracious classicism is, of course, taken into account and carefully examined, destructured, and rearranged in Fortunato Duranti's drawings.

In all these examples elaborated by nineteenth-century artists, important details or general features belonging to celebrated works oriented either classically or to Renaissance-period works were promptly assimilated and then judiciously adapted in the making of new compositions. New and yet so close to the models of the past that they could be justly described as Neo-Renaissance representations, they were also nostalgic and, for this very reason, paradoxically new. In a remarkable group of works of this kind, Duranti not only provides accurate depictions of specific, mostly religious, subjects, but also and more importantly offers eloquent *representations* of earlier *systems of representation*, thus establishing a net of metalinguistic associations among images that, separated by history, are creatively reunited thanks to the visual eclecticism of this nineteenth-century Renaissance master. Here art is a process of continual, yet critically conducted, reappropriation.

One might well expect, then, to observe that Alessandro Maggiori shared a similar veneration for the *detail*, devoting to it a place of honor in his collection of drawings. By using a criterion that could be described as "metonymic criticism"—related in a symbiotic relation to Lanzi's radial method of analysis—the Count had chosen to purchase several sheets in which only certain aspects and details were depicted: particular aspects and details that were considered worthy *as such*, regardless of their dimensions, their subjects, or their state of preservation. This explains the massive presence, in his collection, of images representing different parts of the human body, as well as fragments of draperies, clothes, and ornaments. Taken together, these drawings fully illustrate the various steps, mastery of which would potentially lead an artist to the construction of a historical composition of the type usually considered, from a classicist perspective, to be the main goal of the creative process.

In conclusion, I offer a few additional words about the collection and its historical context. Intended not only to keep alive but also to further stimulate the development of the visual arts in the territories of The Marches, through the conservation of the "most clear examples" ascribable to the Roman and the Bolognese schools, the collection of the extraordinary nucleus of drawings gathered by Count Alessandro Maggiori can now be seen, in its aesthetic as well as ideological directives, as a promising alternative to the rigid set of methods, means, and models imposed by the French academy, as we have previously argued in reference to Le Brun's methods of classifying facial expressions, and Dorigny's rules for labeling and rendering them.

After the arrival of Napoleon's *Armée* in the Italian peninsula in 1796 brought its devastating campaign of spoliation of artworks from the conquered lands, the imposition of the French system took on political implications that would eventually go far beyond the sphere of a cultural phenomenon. In the years between 1802 and 1814—when Alessandro Maggiori was buying the largest part of his collection—the political situation in Italy was evolving toward a point of no return. The gap between the concrete needs of the local populations and the decisions taken by the French State, felt increasingly to be an essentially "foreign" force, was about to become an irremediable distance. As many scholars and specialists of the Italian *Risorgimento* have argued, this growing distance would ultimately lead to the—gradual, not uniform—emergence of an unprecedented feeling, first of a cultural, and then of a political unity, one opposed to the alterity represented by the French imperialistic power. With the increasing difficulties caused by severe economic sanctions imposed on the Italian territories and the progressive tightening of conditions dictated by Paris, these two linguistic, anthropological, and cultural realities finally became irreconcilable, assuming the proportions of a fundamental political conflict.

It is in this context of profound readjustment, seen not only from social and cultural points of view, but also from an ideological perspective, that one must consider the historical significance of the collection Alessandro Maggiori created, thus interpreting its interpretation within the specific context of late eighteenth-century and early nineteenth-century Italy. If the Maggiori collection reflects, on the one hand, matters of taste and artistic sensibility that are unquestionably related to the cultural experiences and personal preferences of its owner, it also reveals, on the other, significant links with a much wider horizon of problems, such as the political overturning of pre-unitarian Italy.

Based upon an immanent paradigm of beauty—to which both the title of the exhibit, *Timeless Renaissance*, and that of chapter 1 of this essay, "Renaissance Nostalgia," relate—the Maggiori collection has coherently pursued, for approximately forty years, its original goals and ambitions, which are:

First, to bring together works respectfully yet creatively linked to venerable masters of the Roman–Bolognese classicist tradition, around whom many other artists from The Marches, such as Sassoferrato and Carlo Maratti, have orbited between the seventeenth and the eighteenth century;

Second, to assemble a set of "most clear examples" that could productively perform didactic functions not dissimilar to the ones promoted by academies such as the *Accademia Clementina* in Bologna and Domenico Corvi's private studio in Rome, thus carrying on a tradition inaugurated in Italy in the sixteenth century;

Third, to protect and preserve treasures of an artistic patrimony that began to be felt as a collective property, and as a potentially Italian *modus operandi*, as promulgated by Pope Pius VII in the 1802 *Chirografo*; and as a consequence overcoming any tantalizing—or paralyzing—regionalism;

Fourth, to offer a potential alternative to the excessively rigid canon of artistic perfection diffused by the French *Académie*, replacing it with a much more flexible horizon of methods and precepts, partly drawn from Lanzi's and Lazzarini's reflections on art, and including methods and precepts that, in spite of their visceral connection

with classicist tendencies, were nevertheless characterized by an aesthetic component that could not be taught and was distinctively pointed out as an Italian quality, namely, grace; and

Fifth, to promote the necessity of keeping artworks in their original settings, or at least in close proximity to their original cultural contexts, preserving them within the protective walls of safe collections such as the one proudly kept by Alessandro Maggiori in the villa *Il Castellano*, near Sant'Elpidio a Mare and Monte San Giusto.

These coordinates seem to have jointly guided Count Maggiori in the long process of forming his collection. More specifically with regard to his personal position in relation to Napoleon and his reactions to the French political policies, in a post-revolutionary context, it is very difficult to speak with certainty about matters that require the support of historical evidence because of the almost complete lack of documents on this subject. Primary sources, such as Maggiori's own books and letters, appear significantly silent about the ideological implications of his aesthetic agenda, and thus cannot be consulted in order to clarify his habits and the strategies of his "politics of taste."

However, one may well hypothesize, on the basis of his aristocratic origins and the ideas usually addressed in his letters, his essentially conservative position concerning the dissemination of post-revolutionary ideals and values. In fact, in a letter written on February 28, 1793, and sent from Bologna to his father, Count Annibale, Alessandro Maggiori asserts his religious as well as political beliefs, which are unmistakably rooted in the collapsing world of the *Ancien Régime*. Reaffirming, not without irony, his own placement in a hierarchically conceived society and implicitly defending his own faith—which could not have been, as a good acquaintance of Pope Pius VII and a childhood friend of Pope Leo XII,[196] anything but Catholic—he writes, referring to the social upheavals caused by the French Revolution and its diffusion in the Italian peninsula:

> If it is true, as you say, that *Portae inferi non praevalebunt* [the gates of Hell do not prevail], the very thought of their prevailing offends our faith. Therefore, without doubting God's promise, let us keep up our good mood and stop fearing more than our current situation permits us to. Who cares whether the news concerning the French is important? *Portae inferi non praevalebunt*.[197]

As history would soon demonstrate, those gates, once opened, could never be closed again. The years too continued to pass, and by the middle of the nineteenth century Count Alessandro Maggiori's aesthetic preferences—as well as his ideological convictions—would appear, in their movingly utopian and self-reflective nostalgia, with an almost disarming clarity, thus sealing the utmost expectations of an epoch and opening up, at the same time, the path for a new concept of art.

1. For biographical notes regarding Count Alessandro Maggiori and further historical remarks concerning his collection of drawings, see: Anselmi, A., "*Il carteggio storico-artistico del conte Alessandro Maggiori di Fermo,*" Nuova rivista misena X, 3 / 4 (1907); Angelucci, G., and Di Giampaolo, M., eds., *Sotto il segno di Alessandro Maggiori. Disegni dal Cinque al Settecento scelti dal Fondo Carducci–Fermo e dalla Collezione Maggiori–Monte San Giusto,* Catalogo della mostra Fermo–Monte San Giusto, 10 Luglio–10 Settembre 1992, Monte San Giusto: Carima, 1992; Di Giampaolo, M., and Angelucci, G., eds., *Disegni Marchigiani dal Cinquecento al Settecento,* Atti del Convegno "Il Disegno antico nelle Marche e dalle Marche," Monte San Giusto, May 22–23, 1992, Firenze: Edizioni Medicea, 1995; Angelucci, G., *Il Fondo Maggiori a Monte San Giusto. I disegni,* Monte San Giusto: Centro Alessandro Maggiori, 2005. From a historical point of view, the first biographical notes about Maggiori are provided by Amico Ricci; see Ricci, A., *Memorie storiche delle arti e degli artisti della Marca di Ancona,* Macerata: Alessandro Mancini, 1834, 436–37 and relative notes. See also Ricci, A. "Alessandro Maggiori," in De Tibaldo, E., *Biografia degli Italiani Illustri nelle Scienze, Lettere ed Arti,* IV, Venezia 1837, 8. A brief comment on the Maggiori collection is recently provided in Mei, M., "*Geografia del disegno nelle Marche: Le collezioni delle biblioteche,*" in Mei, M., ed., *Collectio Thesauri. Dalle Marche tesori nascosti di un collezionismo illustre,* catalogue of the exhibit, Ancona, Mole Vanvitelliana, January 15–April 30, 2005, Firenze: Edifir, 2005, 15. With regard to the dispersion of the collection and its migration to different institutions, mostly in Europe and America, see, for instance, the case of the drawings, originally belonging to the Maggiori collection and now at the Metropolitan Museum of Art in New York, as examined by Ten Eyck Gardner, A., "The History of a Collection," *Metropolitan Museum of Art Bulletin,* New Series, 5, 8 (1947): 215–20. In this article, the author mentions one note regarding the selling of the Vanderbilt collection in which the Count Alessandro Maggiori is mistakenly described as a gentleman "of Bologna."

2. Some of the drawings originally belonging to the Maggiori collection have been the object of recent attributions on the occasion of the 1992 exhibit *Sotto il segno di Alessandro Maggiori.*

3. See *Sotto il segno di Alessandro Maggiori,* 30–31. On the role played by Federico Barocci as an artist related both to Rome and to The Marches see the recent study by Lingo, S., *Federico Barocci: Allure and Devotion in Late Renaissance Painting,* New Haven, CT: Yale University Press, 2008.

4. It is worth mentioning, however, that in the inventory compiled by Di Pietro in 1925, six landscapes are recorded among the sheets formerly belonging to the Maggiori collection, two of which were tentatively attributed by the author to Guercino and one to (Annibale?) Carracci; see Di Pietro, F., "*Elenco dei disegni di antichi Maestri conservati nel Comune di Monte San Giusto e a questo lasciati in legato dal rev.do don Nicola Bollesi,*" *Rassegna Marchigiana,* IV (1925), 3: 103–08.

5. On the phenomenon of collecting drawings between the sixteenth and the eighteenth centuries see Baker, C., Elam, C., and Warwick, G., eds., *Collecting Prints and Drawings in Europe, c. 1500–1750,* Surrey, UK: Ashgate, 2003. On the general practice of collecting drawings in early modern Europe and, in particular, on the case of Padre Sebastiano Resta, see the exemplary study conducted by Warwick, G., *The Arts of Collecting: Padre Sebastiano Resta and the Market for Drawings in Early Modern Europe,* Cambridge, UK: Cambridge University Press, 2000. For further critical remarks see also Sciolla, G. C., ed., *Il Disegno. I grandi collezionisti,* Milano: Silvana Editoriale, 1992. For the development of painting in the eighteenth century in The Marches, a fundamental reference is Zampetti, P., *Pittura nelle Marche,* IV: *Dal Barocco all'Età Moderna,* Firenze: Nardini Editore-Cassa di Risparmio di Fermo, 1991. With regard to the recent scholarly attention to collections of drawings in The Marches, see Cellini, M., *Disegni della Biblioteca Comunale di Urbania. La Collezione Ubaldini. Catalogo Generale,* Regione Marche-Centro Beni Culturali, 1999.

6. From 1817 to 1832, Alessandro Maggiori published, anonymously, the following books: *Le Rime di Michelagnolo Buonarroti. Pittore, scultore, architetto e poeta fiorentino* (Roma 1817); *Le pitture sculture e architetture della città d'Ancona* (Ancona 1821); *Indicazioni ai forestieri delle pitture sculture architetture e rarità d'ogni genere che vi veggono oggi dentro la Sagrosanta Basilica di Loreto e in altri luoghi della città* (Ancona 1824); *Dialogo intorno alla vita e le opere di Sebastiano Serlio* (Ancona 1824); *Dell'itinerario d'Italia e sue più notabili curiosità d'ogni specie* (Ancona 1832); *Raccolta di proverbj e detti sentenziosi* (Ancona 1833); *Dialogo sopra la cultura del gran turco* (Ancona 1833). This list of publications is provided by Amico Ricci in the footnotes of his brief biographical remark; see Ricci, *Memorie,* 444–45. Some of Maggiori's books are directly related to the phenomenon of providing "guides" for travelers in the Italian part of the *Grand Tour.* On this topic see Trease, G., *The Grand Tour,* New Haven, CT: Yale University Press, 1991; and also Chaney, E., ed., *The Evolution of English Collecting,* New Haven, CT: Yale University Press, 2003. On the antique-centered production of souvenirs as well as artworks related to the phenomenon of the Grand Tour in Italy see the recent study of Pinelli, A., *Souvenir. L'industria dell'antico e il Grand Tour a Roma,* Roma-Bari: Editori Laterza, 2010.

7. See especially Dania, L., "*Alessandro Maggiori, critico e collezionista,*" in Di Giampaolo, M., and Angelucci, G., eds., *Disegni Marchigiani dal Cinquecento al Settecento,* Atti del Convegno "Il Disegno antico nelle Marche e dalle Marche," Monte San Giusto, May 22–23, 1992, Firenze: Edizioni Medicea, 1995, 7–18.

8. Longhi, R., *Piccola ma veridica storia della pittura italiana,* Firenze: Sansoni Editori, 1961.

9. Angelucci, *Il Fondo Maggiori,* 9.

10. Angelucci, *Il Fondo Maggiori,* 9.

11. Di Pietro, *Elenco dei disegni,* 103–08. According to a plausible hypothesis proposed by Angelucci, Di Pietro's article would have been published on the occasion of the transferring of the sheets at City Hall, as explained in Di Giampaolo and Angelucci, *Disegni Marchigiani,* 171.

12. "*I disegni del lascito di Padre Urbano Savorgnan, della Congregazione dell'Oratorio di San Filippo Neri — che nel testamento del 27 novembre 1776 sono nominati genericamente accanto a dipinti, medaglie, monete, sigilli, pietre dure, mamrmi, piatti di Urbino e altro ancora — risultano per la maggior parte inseriti in centosessantasei cornici, la più piccola delle quali conteneva una lastra d'argento incisa, ripartita in due stanze, assieme a trentadue quadretti con disegni di 'Carlo [sic] Fratta' dal chiostro di San Michele in Bosco, provenienti, questi ultimi, dal legato del dottor Jacopo Bartolomeo Beccari. Soltanto quattro disegni Savorgnan compaiono, isolati, in un'altra camera,*" in Faietti, M., *I grandi disegni italiani della Pinacoteca Nazionale di Bologna,* Milano: Silvana Editoriale 2002, 20–21.

13. Di Pietro, *Elenco dei disegni,* 106. This information is also cited in Di Giampaolo and Angelucci, *Disegni Marchigiani,* 171.

14. Di Pietro, *Elenco dei disegni,* 103. The misunderstanding concerning Maggiori's name and its transcription as "Maggini" was first noted in M. Di Giampaolo and Angelucci, *Disegni Marchigiani,* 172.

15. Angelucci, *Il Fondo Maggiori,* 10.

16. Angelucci, *Il Fondo Maggiori,* 10. According to an oral tradition, not confirmed, however, by any historical, visual, or textual evidence, the drawings belonging to the Maggiori–Bellesi collection, after having been removed, at an unknown date, from the eight frames in which they were protected, were kept, for a certain period, among the pages of books from the Biblioteca Comunale of Monte San Giusto until the day they were found, in the mid-1990s, when the whole building underwent a process of renovation.

17. On the restoration of some of the drawings from the Maggiori collection, see Bernini Pezzini, G., *Nota sul restauro dei disegni della Collezione Maggiori di Monte San Giusto;* Di Giampaolo, M., and Angelucci, G., eds., *Disegni Marchigiani dal Cinquecento al Settecento,* Atti del Convegno "Il Disegno antico nelle Marche e dalle Marche," Monte San Giusto, May 22–23, 1992, Firenze: Edizioni Medicea, 1995, 197–203. Also Angelucci underlines the importance of this systematic campaign of restoration, thanks to which two new drawings were retrieved from between glued sheets: "*In aggiunta alle perdite, la vacanza di custodia ha provocato il degrado qualitative dei fogli, che hanno subito il danneggiamento degli spigoli — generalmente amputati nello sciogliersi dei fogli — frequenti lacerazioni ai bordi, l'attenuazione dell'evidenza dei segni per l'effetto meccanico degli sfregamenti, e, a motivo del prulungato contatto con carte fortemente acide, un accentuato impoverimento della consistenza dei supporti. A tali inconvenienti ha iniziato a prestare efficace rimedio l'Istituto Nazionale per la Grafica, sotto la direzione di Michele Cordaro, il cui sollecito intervento, operato da Maria Antonietta Breccia Fratalocchi, Maria Ciacci Di Tommaso e Anna Onesti con la supervisione di Grazia Pezzini Bernini [sic]. Ha già restituito ad una condizione di miglior godimento un'apprezzabile frazione del materiale,*" G. Angelucci, *Notizie più aggiornate sul Fondo Maggiori a Monte S. Giusto,* in Di Giampaolo and Angelucci, *Disegni Marchigiani,* 172.

18. On the "theory of reception," see in particular Iser, W., *Der Akt des Lesens. Theorie ästhetischer Wirkung,* Munich: Wilhelm Fink, 1976 (trans. *The Act of Reading: A Theory of Aesthetic Response,*

Baltimore: Johns Hopkins University, 1978); and Jauss, H. R., *Toward an Aesthetic of Reception*, Minneapolis: University of Minnesota Press, 1982.

19. On Amico Ricci see Ambrosini Massari, A. M., ed., *Dotti amici: Amico Ricci e las nascita della storia dell'arte nelle Marche*, Ancona: Il lavoro editoriale, 2007. Giulio Angelucci mentions Ricci's epistolary at the Biblioteca Comunale Mozzi–Borgetti at Macerata in Di Giampaolo and Angelucci, *Disegni Marchigiani*, 16.

20. *"Fisso nel propostomi sistema di non parlare dei viventi, chi mai imaginato [sic] avrebbe, che in queste carte più col pianto, che coll'inchiostro segnar dovessi il nome di Te, che fosti tertimonio de' presenti miei studj, e ne formasti gran parte? Ancor mi ragionano alla mente quelle tue letterarie corrispondenze ripiene di tante belle dottrine, di cui mi arricchiva lo spirito, e de' più teneri sensi di leale amicizia, che m'inebriavano il cuore. Alessandro Maggiori fu nell'età nostra uno di que' pochi uomini, che nell'ozio pacifico d'una vita ritirata e tranquilla coltivò le civili virtù, coltivò Minerva, e le Muse,"* in Ricci, *Memorie*, 436.

21. Ricci, *Memorie*, 444.

22. Dania, *Alessandro Maggiori*, 7. For further information regarding the Maggiori family, see Mecchi, F. E., *Vita del giovane conte Lorenzo Maggiori patrizio fermano*, Fermo: 1876; and Rongoni, G., *Di sole in sole a Porto San Giorgio tra 700 e 800*, Fermo: Andrea Livi, 1993, 39–45, 68–71.

23. Maggiori's interest in the written sources of art history is well documented by his systematic quotation of important texts of art literature in his books, from the "guides" of Ancona and Loreto to his most ambitious *Itinerario*, in which he mentions Vasari, Bellori, Zanotti, Lanzi, Lazzarini, and many other writers. As important as his articulated knowledge of these books is his meditated use of them in a series of philologically oriented and historically based cross-examinations. Significantly, such a methodological attentiveness is shared by his contemporary, Luigi Lanzi, whose *Storia Pittorica* has provided an important point of reference for Alessandro Maggiori, especially with regard to interpretive matters. Referring to Sebastiano Resta's peculiar method of expertise, for instance, Lanzi writes: *"È degno che si legga tutto il raziocinio che questo valente scrittore fa nella sua quinta lettera, e si osservi con qual finezza di critica sviluppi un nodo per la storia della pittura sì interessante,"* in Lanzi, L., *Storia Pittorica della Italia dal Risorgimento delle Belle Arti fin presso al fine del XVIII secolo*, Bassano: Giuseppe Remondini e Figli, 1809 (M. Capucci, ed., Firenze: Sansoni Editore, 1968, I, 273).

24. A most important source for our knowledge of the years that Maggiori spent in Bologna is his epistolary, still unpublished, preserved at the Biblioteca dell'Archiginnasi, as Dania first pointed out: *"Una importante testimonianza sugli anni trascorsi nella città felsinea, sui suoi incontri, sui suoi interessi, è costituita da un carteggio di duecentoquaranta lettere scritte al padre dal 1781 al 1796, conservate presso la Biblioteca dell'Archiginnasio,"* in Dania, *Alessandro Maggiori*, 7–8. I am currently working on a critical edition of Alessandro Maggiori's letters preserved at the Archiginnasio, thanks to the generous support of the Center for Religion, Law, and Democracy at Willamette University.

25. A first, partial, listing of the drawings originally belonging to the Maggiori collection and currently divided among different American as well as European museums has been provided by Dania, *Alessandro Maggiori*, 11–14. A specific reference to drawings made by protagonists of the Venetian School, such as Titian and Veronese, is made in note 21 of Dania's essay. Further remarks about the current whereabouts of drawings purchased by Maggiori are also offered by Susinno, S., *"'Accademie' romane nella collezione braidense: primato di Domenico Corvi nel disegno dal Nudo,"* in Curzi, V., and Lo Bianco, A., eds., *Domenico Corvi*, catalogue of the exhibit, Viterbo, Museo della Rocca Albornoz, December 12, 1998–February 28, 1999, Roma: Viviani Arte, 1998, 172–89, but especially 180 and 188.

26. On Corvi, see Curzi and Lo Bianco, *Domenico Corvi*, 22.

27. Dania, *Alessandro Maggiori*, 8. No copy of this novel, either manuscript or printed, has yet been found.

28. About the monumental altar painted by Lorenzo Lotto at Monte San Giusto, see Giordano, A., *Il capolavoro di Lotto in Monte San Giusto e il Vescovo Bonafede*, Roma: Accademia Nazionale dei Lincei, 1999.

29. Most significantly, as we have already remarked, these books were published anonymously. It is only thanks to Amico Ricci's biographical note that one can attribute them to Alessandro Maggiori with certainty. In this regard see Ricci, *Memorie*, 444–45. For the complete list of volumes written by Count Maggiori see note 6. A relevant historical fact that one should mention is the massive presence of the French army in the territories of Ancona and Loreto around 1797, the same years in which Alessandro Maggiori was collecting drawings for his collection. With regard to the presence of the French army in the territories of The Marches and, in particular, in areas very close to Fermo, where the Count was living at the time, see the pertinent study by Millar, E. A., *Napoleon in Italian Literature. 1796–1821*, Rome: Edizioni di Storia e Letteratura, 1977. For instance, in a paragraph referring to the Italian writer Vincenzo Monti's initial admiration for Napoleon, Millar remarks: "Monti ungraciously took the opportunity to criticize the Church for her concern with earthly matters and welcomed Bonaparte as the one who would reform it for the good of the world. From one point of view, no excuse can be found for this particular sonnet: Monti was still in receipt of a salary from the Papal Court at the time of its writing and he could not possibly have been ignorant of the ruthless occupation by the French of Papal territory – notably Ancona and Loreto," in Millar, *Napoleon in Italian Literature*, 20.

30. *"Contento di essere benemerito verso i suoi e gli estranei, non volle per modestia comparirlo, amando di restare innominato: ma ora forma parte venerabile ed arcana dell'eternità, vada pur'egli contento di questa sua virtù; io lo svelerò senza riguardo,"* in Ricci, *Memorie*, 437.

31. Curzi, V., *"Committenti, intermediari e collezionisti: fortuna di Domenico Corvi e sistemi di diffusione delle sue opere fuori Roma,"* in Curzi, V., and Lo Bianco, A., eds., *Domenico Corvi*, catalogue of the exhibit, Viterbo, Museo della Rocca Albornoz, December 12, 1998–February 28, 1999, Roma: Viviani Arte, 1998, 35–49.

32. Dania, *Alessandro Maggiori*, 8.

33. On the relationship between Domenico Corvi and Francesco Mancini, see Rudolph, S., *"Le committenze romane di Domenico Corvi,"* in Curzi, V., and Lo Bianco, A., eds., *Domenico Corvi*, catalogue of the exhibit, Viterbo, Museo della Rocca Albornoz, December 12, 1998–February 28, 1999, Roma: Viviani Arte, 1998, 18–33.

34. Rudolph, *Le committenze romane*, 20.

35. Rudolph, *Le committenze romane*, 20. See also Curzi, *Committenti, intermediari e collezionisti*, especially p. 35.

36. Lazzarini, G., *Opere*, Pesaro: Niccolò Gavelli, 1806. The book is quoted, for instance, in Alessandro Maggiori's *Le Pitture sculture e architetture della città d'Ancona*, 46. It is possible to ascertain that Count Maggiori knew Lazzarini very well, both as an artist and a theoretician of art. In fact, in the above mentioned "guide" of Ancona, in a paragraph in which the paintings displayed at the Church of St. Augustine are described, the author comments: *"Il quadro colle Sante Martiri sul penultim'altare a sinistra, andando verso la porta, è amorosa e diligente fatica del Can.[onico] Andrea Lazzarini, erudito pittore e architetto Pescarese,"* Maggiori, *Le Pitture*, 3.

37. On the relationship between Corvi and Lazzarini, see Curzi, *Committenti, intermediari e collezionisti*, 35.

38. *"Negli anni Settanta e Ottanta un giovane poteva scegliere tra una dozzina almeno di scuole, da quelle famose di Batoni, di Mengs e di Corvi, per citare i maestri più autorevoli, a quelle di Tommaso Conca e Stefano Tofanelli,"* in Susinno, *"Accademie" romane*, 174.

39. On Carlo Maratti and, in particular, on his drawings, see Westin, J. K., and Westin, R. H., *Carlo Maratti and His Contemporaries: Figurative Drawings from the Roman Baroque*, Minnetonka, MN: Olympic Marketing Corp, 1988. See also Rudolph, S., *"Disegni di Maratti a souvenir di sue opere nelle Marche,"* in Di Giampaolo, M., and Angelucci, G., eds., *Disegni Marchigiani dal Cinquecento al Settecento*, Atti del Convegno "Il Disegno antico nelle Marche e dalle Marche," Monte San Giusto, May 22–23, 1992, Firenze: Edizioni Medicea, 1995, 131–43.

40. On Mengs see especially Roettgen, S., ed., *Mengs. La scoperta del Neoclassico*, catalogue of the exhibit, Padova, Palazzo Zabarella, March 3–June 11, 2001, Venezia: Marsilio, 2001; and also Roettgen, S., *Anton Raphael Mengs. 1728–1779. Das malerisch und zeichnerische Werk*, München: Himer, 1999.

41. On Winckelmann, see Potts, A., *Flesh and the Ideal: Winckelmann and the Origins of Art History*, New Haven, CT: Yale University Press, 1994. It is interesting, however, to observe the centrality of Raphael in Winckelmann's pages, especially in the *Gedanken ueber die Nachahmung der griechischen Werke in der Malerei und Bildhauerkunst* (1755). For a critical edition of this fundamental book for the aesthetics of the Neoclassicism see Winckelmann, J. J., *Reflections on the Imitation of Greek Works in Painting and Sculpture*, English trans. by E. Heyer and R. C. Norton, La Salle, IL: Open Court, 1987. In a paragraph referring to Raphael's profound link to the ancient Greek masters, Winckelmann claims that "he sent young artists to Greece in order to sketch for him the relics of antiquity," in Winckelmann, *Reflections*, 5. Furthermore, by borrowing an interpretive hypothesis elaborated by Giovan Pietro Bellori, in his *Lives*, Winckelmann establishes a close connection between the selective poetics of ancient Greek masters and Raphael's "idea": "The frequent opportunities to observe nature prompted Greek artists to go still further. They began to form certain general ideas of the beauty of individual parts of the body as well as of the whole—ideas which were to rise above nature itself; their model was an ideal nature originating in the mind alone.

Thus Raphael did conceive Galatea," and, Winckelmann concludes eloquently, "as we can see in his letter to Count Baldassare Castiglione: 'Since beauty is so rare among women, I avail myself of an ideal image,'" in Winckelmann, *Reflections*, 15.

42. Curzi, *Committenti, intermediari e collezionisti*, 35.

43. On the Capitol Academy see Cipriani, A., "L'Accademia di San Luca dai concorsi dei giovani ai concorsi Clementini," in Boschloo, A. W. A., ed., *Academies of Art: Between Renaissance and Romanticism*, Leids Kunsthistorisch Jaarboek V–VI (1986–1987), Leiden: 's-Gravenhage, 1989, 61–76, particularly p. 73.

44. "Nell'età di anni 15 si trasferì a Roma a studiare la pittura sotto la direzione di Francesco Mancini. Sotto la disciplina di un tale maestro si applicò con assiduità a fare le sue osservazioni sopra l'antico, e il naturale, né tralasciò le opere di Raffaello e quelle dei più valorosi artefici di questa professione. È divenuto pertanto in breve tempo bravo Disegnatore, Compositore e Prospettivista," in Curzi and Lo Bianco, *Domenico Corvi*, 35. Orlandi's text, mentioned above, is entitled *Supplemento alla serie dei trecento elogi e ritratti degli uomini I più illustri in pittura, scultura e architettura o sia Abecedario Pittorico dall'origine delle Belle Arti a tutto l'anno MDCCLXXV*, Firenze 1776.

45. With regard to Corvi's anatomical drawings at Brera, see Susinno, S., "Le accademie di Domenico Corvi," in Curzi, V., and Lo Bianco, A., eds., *Domenico Corvi*, catalogue of the exhibit, Viterbo, Museo della Rocca Albornoz, December 12, 1998–February 28, 1999, Roma: Viviani Arte, 1998, 198–217. See also, in the same catalogue, F. Valli, "Modelli romani all'Accademia di Brera," in V. Curzi and A. Lo Bianco, eds., *Domenico Corvi*, 190–97.

46. MacDonald, M. F., *British Artists at the Accademia del Nudo in Rome*, in Boschloo, A. W. A., ed., *Academies of Art: Between Renaissance and Romanticism*, Leids Kunsthistorisch Jaarboek V–VI (1986–1987), Leiden: 's-Gravenhage, 1989, 77–94.

47. On Mengs's and Canova's teaching methods at the Capitol Academy of the nude see the insightful remarks of MacDonald, *British Artists*, 80.

48. On Corvi's *Self-portrait* at Gli Uffizi, as well as other versions of the self-portrait made by the Viterbese master, see the critical entries in Curzi and Lo Bianco, *Domenico Corvi*, 146–51.

49. On Mengs's and Batoni's *Self-portraits* for the same commissioner see Curzi and Lo Bianco, *Domenico Corvi*, 146.

50. On the pedagogical implications of Dürer's *Unterweysung der Messung* see the classical study of Panofsky, E., *The Life and Art of Albrecht Dürer*, Princeton, NJ: Princeton University Press, 1955. For its adoption in eighteenth-century contexts see, in particular, the emblematic case of Nicholas Dorigny in Ralph, B., *The School of Raphael. The Student's Guide to Expression in Historical Painting. Illustrated by Examples Engraved by Duchange, and Others, Under the Inspection of Sir Nicholas Dorigny, from His Own Drawings after the Most Celebrated Heads in the Cartoon at the King's Palace to which are now added the Outlines of Each Head […] Described and Explained by Benjamin Ralph*, London, 1759 (reprint, Richardson, T., ed., Lexington, 2010, 234).

51. Bellori, G. P., *Le vite de' pittori scultori et architetti moderni*, Roma: Mascardi, 1672 (English trans., *The Lives of the Modern Painters, Sculptors, and Architects: A New Translation and Critical Edition*, eds. A. Sedgwick Wohl, H. Wohl, and T. Montanari,

Cambridge, UK: Cambridge University Press, 2009). On Bellori see *L'ideale del bello. Viaggio per Roma nel Seicento con Giovan Pietro Bellori*, catalogue of the exhibit, Rome, Palazzo delle Esposizioni, March 29–June 26, 2000, Roma: Edizioni De Luca, 2000; and also Raben, H., "Bellori's Art: The Taste and Distaste of a Seventeenth-Century Art Critic in Rome," *Simiolus*, 32, 2 / 3 (2006): 126–46.

52. "Era veramente pittor dotto, e da paragonarsi con pochi in notoria, in prospettiva, in disegno, che appreso dal mancini suo educatore ha mantenuto sempre qualche idea del gusto carraccesco," in Curzi and Lo Bianco, *Domenico Corvi*, 180.

53. For the notion of "imagined community," see Anderson, B., *Imagined Communities: Reflections on the Origin and Spread of Nationalism*, London: Verso Books, 1991.

54. On Vasari and the Florentine *Accademia del Disegno*, see Barman, K.-E., *The Fiorentine Accademia del Disegno: Liberal Education and the Renaissance Artist*; Boschloo, A. W. A., ed., *Academies of Art: Between Renaissance and Romanticism*, Leids Kunsthistorisch Jaarboek V–VI (1986–1987), Leiden: 's-Gravenhage, 1989, 14–32.

55. On the role played by dissection and anatomic studies in early modern Europe see the rigorous study of Carlino, A., *Books of the Body: Anatomical Ritual and Renaissance Learning*, Chicago: University of Chicago Press, 1999.

56. With regard to Agostino Veneziano's print, see Roman, C. E., "Academic Ideals of Art Education," in *Children of Mercury: The Education of Artists in the Sixteenth and Seventeenth Centuries*, catalogue of the exhibit, Bell Gallery (Brown University), March 2–30, 1984, Providence, RI: Brown University, 1984, 81–95.

57. See Roman, *Academic Ideals*, especially 84–87.

58. On the pedagogical compilations written and illustrated by Allori and Danti see Amornpichetkul, C., "Seventeenth-Century Italian Drawing Books: Their Origin and Development," in *Children of Mercury: The Education of Artists in the Sixteenth and Seventeenth Centuries*, catalogue of the exhibit, Bell Gallery (Brown University), March 2–30, 1984, Providence, RI: Brown University, 1984, 108–18.

59. On Vasari's magnificent *Libro dei disegni*, see Ragghianti Collobi, L., ed., *Il libro de' disegni del Vasari*, Firenze: Vallecchi, 1974. See also the pioneering article by Panofsky, P., "The First Page of Giorgio Vasari's 'Libro': A Study on the Gothic Style in the Judgment of the Italian Renaissance," in E. Panofsky, *Meaning in the Visual Arts*, New York: Doubleday, 1955, 205–20.

60. On Bellori's collection of drawings see Prosperi Valenti Rodinò, S., *Il disegno per Bellori, L'ideale del bello. Viaggio per Roma nel Seicento con Giovan Pietro Bellori*, catalogue of the exhibit, Rome, Palazzo delle Esposizioni, March 29–June 26, 2000, Roma: Edizioni De Luca, 2000, I, 131–39; and also Sciolla, G. C., ed., *Il Disegno. I Grandi Collezionisti*, Milano: Silvana Editoriale, 1992, 41–44.

61. On the Carracci Academy in Bologna, see Dempsey, C., "The Carracci Academy," in Boschloo, A. W. A., ed., *Academies of Art: Between Renaissance and Romanticism*, Leids Kunsthistorisch Jaarboek V–VI (1986–1987), Leiden: 's-Gravenhage, 1989, 33–43.

62. More particularly with regard to Agostino Carracci's pedagogical methods, see Amornpichetkul, *Seventeenth-Century Italian Drawing Books*, 113–15.

60. Amornpichetkul, *Seventeenth-Century Italian Drawing Books*, 113.

61. Amornpichetkul, *Seventeenth-Century Italian Drawing Books*, 113–14.

62. Amornpichetkul, *Seventeenth-Century Italian Drawing Books*, 111.

63. Amornpichetkul, *Seventeenth-Century Italian Drawing Books*, 111. Significantly, the text by Odoardo Fialetti, *Il vero modo et ordine per dissegnar tutte le parti et membra del corpo humano*, first published in Venice in 1608, was translated into English and printed in 1660 by A. Brown with the title *The whole art of drawing, painting, limning and etching*.

64. Amornpichetkul, *Seventeenth-Century Italian Drawing Books*, 11.

65. Amornpichetkul, *Seventeenth-Century Italian Drawing Books*, 111. On Mitelli's academic and "para-academic" drawings, see Hemphill, R., "Comic Drawings by Pietro de' Rossi Etched by Giuseppe Maria Mitelli," *Master Drawings*, 34, 3 (1996), 279–91.

66. The series designed by Carlo Cesio is preserved at the Calcografia Nazionale of Rome. On Carlo Cesio in relation to Annibale Carracci's works at the Farnese Gallery, see the article by Daly Davis, M., "Giovan Pietro Bellori and the *Nota delli musei, librerie, galerie, et ornamenti di statue e pitture ne' palazzi, nelle case, e ne' giardini di Roma (1664)*: Modern libraries and ancient painting in Seicento Rome, *Zeitschrift für Kunstgeschichte*, 68, 2 (2005), 191–233.

67. For an excellent English translation of Bellori's biography of Carlo Maratti," see Bellori, G. P., *Le vite de' pittori scultori et architetti moderni*. Roma: Mascardi, 1672 (English trans., *The Lives of the Modern Painters, Sculptors, and Architects: A New Translation and Critical Edition*, eds. A. Sedgwick Wohl, H. Wohl, and T. Montanari, Cambridge, UK: Cambridge University Press, 2009, 395–440).

68. See Roman, *Academic Ideals*, in particular 92–95.

69. Roman, *Academic Ideals*, in particular p. 92. On Bellori's life of Maratti see note 67.

70. "Havendo il Papa saputo, che il celebre pittore Carlo Maratti come già invecchiato avesse venduto per cinque mila scudi a un Inglese il suo studio di pittura, lo fece chiamare e gli disse, che non voleva che uscissero di Roma simili studii e raccolte di cose rare, a fine che vi fiorisca, e scusatosi il Maratti con dire di havere già ricevuto mille scudi per caparra, soggiunse il Papa che per il medemo prezzo lo voleva lui, per lo che detto Inglese strepita, freme et arrota li denti," in Prosperi Valenti Rodinò, S., "Clement XI collezionista di disegni," in Cucco, G., ed., *Papa Albani e le arti a Urbino e a Roma. 1700–1721*, catalogue of the exhibit, Urbino, Palazzo del Collegio, June 29–September 30, 2001, Venezia: Marsilio, 2001, 41.

71. On Vasari's *Libro de' disegni*, see note 55. For the drawings commissioned and collected by Cassiano Dal Pozzo see Ryan, H., *Cassiano Dal Pozzo's Paperback Museum: Drawings from the Royal Collection*, Edinburgh: National Galleries of Scotland, 1997. For Padre Resta see more recently Warwick, G., "Connoisseurship and the Collection of Drawings in Italy c. 1700: the Case of Padre Sebastiano Resta," in Baker, C., Elam, C., and Warwick, G., eds., *Collecting Prints and Drawings in Europe c. 1500–1750*, Surrey, UK: Ashgate, 2003, 141–53.

72. "In quelli disegni riposi principalmente tutto il resto del mio esemplare di mani piedi braccia eccetera. Misi anche alcune figure ritratte a lapis oscuro, e due mani, e una testa [dise]gnate tutte e tre le cose a lapis nero in carta scura, e lumeggiate a gessetto. Fralle mani due del Palma sono

ritratte da un suo esemplare assai antico. [...] Fra piedi i due di Guido, e gli altri due del Milanese sono stati ricavati da due disegni d'entrambi, che m'acquistai sin dal primo. Gli altri del Gran Caracci [sic] sono stati ricopiati da un antico esemplare dell'autore medesimo, inciso, e molto raro al [pr]esente. Le due ultime mani poi ritratte in carta cilestra, e lumeggiate con gesso, sono [se?] ritratte da me, da un esemplare di mani, e pie' raggruppato attempo attempo, dall'acquisto d'alcuni schizzi e disegni, che di maestri mi sono venuti alle mani. La prima figura e' del Rolli. Il colore del Caccioli, e Canusti. La [...] ultima di Ludovico [Carracci]. Le figure poi disegnate a lapis oscuro la prima rappresentanti un filosofo lo ricavata da un bel disegno, che ho meco del Contarini, alias Simon da Pesaro scolaro di Guido Reno, suo bravo allievo, ed in progresso ribelle. La seconda ho copiata da un esemplare inciso dal Mattioli, il quale ricavò il Vecchione dal gran Guercino," Bologna: Biblioteca dell'Archiginnasio, Collezione Autografi, XL, c. 10803.

73. Woolf, S., A History of Italy, 1700–1860: The Social Constraints of Political Change, London: Methuen, 1979, especially the chapters "The Offensive Against the Church," 112–19, and "The Papal States: The Impotence of Reformism," 144–46.

74. On the history of the Bolognese Accademia Clementina, see Boschloo, A. W. A., "L'Accademia Clementina e la fama dei Carracci," in Boschloo, A. W. A., ed., Academies of Art: Between Renaissance and Romanticism, Leids Kunsthistorisch Jaarboek V–VI (1986–1987), Leiden: 's-Gravenhage, 1989, 105–17, and also the catalogue of the exhibit L'arte del Settecento Emiliano. La pittura. L'Accademia Clementina, catalogue of the exhibit, Bologna, Palazzo del Podestà e di Re Enzo, September 8–November 25, 1979, Bologna: Edizioni Alfa, 1979. For the drawings belonging to the Bolognese school and the organization of the local Academy see Faietti, M., I grandi disegni italiani della Pinacoteca Nazionale di Bologna, Milano: Silvana Editoriale 2002.

75. Zanotti, G., Storia dell'Accademia Clementina di Bologna aggregata all'Instituto delle Scienze e dell'Arti, Bologna: Lelio della Volpe, 1739 (reprint, Bologna: Arnaldo Forni Editore, 1977).

76. Malvasia, C. C., Felsina pittrice. Vite dei pittori bolognesi, Bologna: Domenico Brabieri, 1678 (ed. M. Brascaglia, Bologna: Alfa, 1971).

77. "[I] Carracci vengono chiamati in causa con estrema regolarià in orazioni simili negli anni precedenti e successivi al 1800, come se fossero gli artisti in cui i giovani dovevano specchiarsi," in Boschloo, L'Accademia Clementina, 105.

78. "Era chiaro che dall'arte del passato proveniva un effetto decisamente stimolante. Più tardi questa situazione in effetti nel corso del diciottesimo secolo subì dei cambiamenti; al posto di un fertile orientamento verso il passato, subentrò la preoccupazione del passato che ci rimise in vitalità essendo vissuto quasi come un obbligo," in Boschloo, L'Accademia Clementina, 110.

79. On the ideological implications of the term "rappatriament," see Édouard Pommier's excellent essays in the volume Più antichi della luna. Studi su J. J. Winckelmann e A. Ch. Quatremère de Quincy, Bologna: Minerva Edizioni, 2000, in particular the chapter "La Rivoluzione e il destino delle opere d'arte," 227–82. Further historical remarks on this topic can be found in Balzani, R., ed., L'arte contesa nell'età di Napoleone, Pio VII e Canova, catalogue of the exhibit, Cesena, Biblioteca Malatestiana, March 14–July 26, 2009, Milano: Silvana Editoriale, 2009.

80. "Il mio punto di vista è appunto che l'Accademia Clementina, per reazione alla mancanza di rispetto per la vecchia scuola bolognese e la sua concreta manomissione soprattutto nel periodo del barocchetto, si concentrò così esclusivamente sulla conservazione della grande arte pittorica del passato e sui principi che ne formavano i fondamenti, che si chiuse agli accadimenti artistici del suo tempo," in Boschloo, L'Accademia Clementina, 111.

81. Emiliani, A., "Il territorio e opere d'arte nel XVIII secolo. Il ruolo dei grandi musei," in Balzani, R., ed., L'arte contesa nell'età di Napoleone, Pio VII e Canova, catalogue of the exhibit, Cesena, Biblioteca Malatestiana, March 14–July 26, 2009, Milano: Silvana Editoriale, 2009, 17–23.

82. With regard to Alessandro Maggiori as a dilettante painter, Luigi Dania states: "Sulla sua attività pittorica, ancora da studiare, permane il quadro che rappresenta l'Immacolata Concezione presso la Sacrestia della chiesa di S. Zenone di Fermo. Alcuni paesaggio, e studi, in collezioni private di Macerata," in Dania, Alessandro Maggiori, 14.

83. Referring to Maggiori's epistolary now at the Biblioteca dell'Archiginnasio in Bologna, the Italian scholar Giulio Angelucci writes: "Si tratta del fitto carteggio intrattenuto dal giovane Alessandro con il padre negli anni in cui egli, dopo essersi addottorato in giurisprudenza, prolungava il soggiorno petroniano, difendendo dalla scettica diffidenza dei familiari la bontà dei progressi negli studi artistici, ai quail si era dato, e la convinzione d'un proprio destino di pittore. È questo il contesto biografico nel quale si addensano gli acquisti bolognesi dei fogli attualmente a Monte S. Giusto [...] sicché la Collezione stessa risulta discendere da quella medesima congiuntà amatoriale," in Angelucci, G., Il segno di Alessandro Maggiori, in Angelucci, G., and Di Giampaolo, M., eds., Sotto il segno di Alessandro Maggiori. Disegni dal Cinque al Settecento scelti dal Fondo Carducci–Fermo e dalla Collezione Maggiori–Monte San Giusto, Catalogo della mostra Fermo–Monte San Giusto, 10 Luglio–10 Settembre 1992, Monte San Giusto: Carima, 1992, 13–16.

84. About the diffusion of the "Greek ideal" in seventeenth-century art, see Lingo, E., "The Greek Manner and a Christian 'Canon': François Duquesnoy's 'Santa Susanna,'" The Art Bulletin, 84, 1 (2002): 65–93.

85. On the French Academy, see Schoneveld-Van Stoltz, H. F., "Some Notes on the History of the Académie Royale de Peinture et de Sculpture in the Second Half of the Eighteenth Century," in Boschloo, A. W. A., ed., Academies of Art: Between Renaissance and Romanticism, Leids Kunsthistorisch Jaarboek V–VI (1986–1987), Leiden: 's-Gravenhage, 1989, 216–28. With regard to the response of Italian artists and intellectuals on French-related institutions of art, see Olmstead Tonelli, L., "Academic Practice in Sixteenth and Seventeenth Centuries," in Children of Mercury: The Education of Artists in the Sixteenth and Seventeenth Centuries, catalogue of the exhibit, Bell Gallery (Brown University), March 2–30, 1984, Providence, RI: Brown University, 1984, 96–107. The anonymous biographer of Giannandrea Lazzarini, who introduced the 1806 edition of his Opere, eloquently recalls an episode in which the Italian master had worked together with a French colleague, reaching, however, quite different results: "Conservo però appresso di me 24 piccoli ovati, metà del Lazzarini, metà di M. Menglard pittore di qualche nome, specialmente per le Marine. Erano giovani ambedue in Roma, ed amici. Il Lazzarini celiava sempre col Menglard, e gli diceva, che li Francesi difficilmente riuscivano nel dipingere figure, nelle quail non si conoscesse la Madama, e il Monsieur. Mons. Fantuzzi propose loro di farne prova in questi piccoli Ovati, fatti della S. Scrittura. Il Menglard fece ogni sforzo, ma

in quelli di Lazzarini sembra vedere le pitture di Rafaele nelle Loggie Vaticane," in Lazzarini, Opere, 39. The Italian roots of grace are defended by Lazzarini in another eloquent page, in which he praises the works of Nicolas Poussin, "Italianized" as Niccolò Pussino: "Egli sebben Francese di nascita, Italiano però per tutto ciò, che ha consecrato all'immortalità il suo Nome, dall'Italia, e specialmente da Roma, trasportò nella Francia, in quei sett'anni, ne' quail chiamato dal suo Rè vi si trattenne, l'Arte della Pittura, di cui ella era presso che digiuna: e siccome questa parte dell'espressiva degli affetti, in che egli valeva oltremodo, fece nella gentil Nazion Francese quell colpo di maraviglia, che dovea fare, nella Scuola di Francia, ch'egli fondò, l'espressione è stata sempre da indi in poi con gran diligenza ricercata, e studiata: anzi i Francesi Scrittori, che i loro dipinte opere hanno descritte, ed esaltate, sembra che di niun'altra cosa tanto si vantino, quanto del saper ben esprimere le passioni. A noi Italiani però è cosa naturale, che piacciano più l'espressione del gran Pussino, che per essersi allevato in Italia le ha sapute vestire alla foggia Italiana, di quelle de' suoi Francesi discepoli, che coll'impeto proprio della natìa loro indole hanno talora nella espressiva passati I segni della moderazione," in Lazzarini, Opere, 269–70.

86. On the impalpable qualities of grace, Lazzarini suggests: "m'era prefisso di ragionarvi intorno ad un'altra dote, senza di cui il disegno perde tutto il suo pregio; e questa è la grazia. Siccome ella è una cosa, che si può gustar bensì, ma non intendere, così è impossibile stabilire in che cosa ella consista. Pure dirò, che allora questa sembra in una figura maggiormente rilucere, quando alla più bella, e perfetta di lei Simmetria si aggiunga la più bella mossa e la più pura semplicità in ogni cosa," in Lazzarini, Opere, 104. By contrast, in reference to the concept of grace in Raphael, Lanzi writes, "Un'altra qualità, ed è la grazia, ha posseduta Raffaello eminentemente; dono questo, che in certo modo la bellezza condisce e la fa più bella. Apelle, che ne fu dotato sovranamente fra gli antichi, n'era così vano che perciò preferivasi a ogni altro artefice. Raffaello lo emulò fra' moderni; e ne sortì il cognome di nuovo Apelle. Potrà aggiugnersi qualche cosa alle forme de' suoi fanciulli e degli altri corpi delicati che rappresentò; ma nulla può aggiugnersi alla lor grazia: se portasi alquanto più oltre, degenera, come avvenne talor al Parmigianino, in affettazione. Le sue Madonne incantano, osserva Mengs, non perché abbiano lineamenti sì perfetti come la Venere medicea e la tanto lodata figlia di Niobe; ma perché il pittore in quelle sembianze e in quell sorriso fa visibili la modesia, l'amor del Figlio, il candor dell'animo, in una parola la grazia. Né solo la diffonde ne' volti, ma ne sparge le positure, i gesti, le mosse, le pieghe de' vestiti, con una disinvoltura che può conoscersi, non può emularsi. La stessa facilità con cui opera è parte di questa grazia: ella cessa ove comincia la fatica e lo studio," in Lanzi, Storia Pittorica, I, 306. Also the eighteenth-century art theoretician Francesco Milizia interprets the qualities of grace separately from those of "beauty": "La grazia non è che la stessa bellezza più delicata, più soave, più amabile. Ella proviene dalla facilità, dalla pieghevolezza, e dalla varietà de' movimenti, e dal apssaggio naturale e agevole di un movimento all'altro. Che grazia ne' fanciulli per quelle loro mosse semplici, franche, snelle! La loro ingenuità, la compiacenza, la curiosità innocente, la semplicità, il fastidio, le querele, e fin le loro lagrime sono suscettibili di grazie," in Milizia, F., Dell'Arte di vedere nelle Belle Arti del Disegno secondo i principi di Sulzer e di Mengs, Venezia: Giambattista Pasquali, 1781 (reprint, Bologna: Arnaldo Forni Editore, 1983, 50–51).

87. On the history and the philosophical premises of the Académie Royale, see Goldstein, C., "The Platonic Beginnings of the Academy of Painting and Sculpture in Paris," in Boschloo,

A. W. A., ed., *Academies of Art: Between Renaissance and Romanticism*, Leids Kunsthistorisch Jaarboek V–VI (1986–1987), Leiden: 's-Gravenhage, 1989, 186–202.

88. "*L'Accademia di San Luca è l'accademia romana carica della gloria della sua storia e insieme della storia della Roma classica e pontificia. È una tra le più antiche accademie e forse è la più internazionale. Tra i suoi membri annovera i nomi degli artisti più famosi del recente passato e tutte le schiere dei loro allievi o prosecutori più o meno corretti, la onorano per trarne luce riflessa. Il papato ben comprende la funzione che questa immagine, questa fama, può svolgere a favore di una prevalenza della cultura romana sul terreno europeo e a più riprese profonde energie e mezzi per suscitare interesse ed attenzione intorno ai concorsi accademici,*" in Cipriani, *L'Accademia di San Luca*, 69.

89. About the "artistic homologation" of the French Academy see Bryson, N., *Tradition and Desire: From David to Delacroix*, Cambridge, UK: Cambridge University Press, 1984.

90. On this important topic see the study of Montagu, J., *The Expression of the Passions: The Origin and Influence of Charles Le Brun*, New Haven, CT: Yale University Press, 1994.

91. Olmstead Tonelli, *Academic Practice*, 103. See Lazzarini's comments at note 85.

92. Olmstead Tonelli, *Academic Practice*, 101.

93. Olmstead Tonelli, *Academic Practice*, 100.

94. Olmstead Tonelli, *Academic Practice*, 100.

95. Regarding the physiognomic illustrations provided by Nicholas Dorigny after Raphael see the recent reprint of his plates in Ralph, B., *The School of Raphael. The Student's Guide to Expression in Historical Painting. Illustrated by Examples Engraved by Duchange, and Others, Under the Inspection of Sir Nicholas Dorigny, from His Own Drawings after the Most Celebrated Heads in the Cartoon at the King's Palace to which are now added the Outlines of Each Head* [...] *Described and Explained by Benjamin Ralph*, London, 1759 (reprint, Richardson, T., ed., Lexington, 2010).

96. On Lazzarini, see Calegari, G., *Disegni inediti di Giannandrea Lazzarini. I taccuini ritrovati*, Pesaro: Banca Popolare Pescarese, 1989. About this precious block-note by Lazzarini and its connections with Roman artistic circles, Italian scholar Grazia Calegari states: "*I taccuini del Lazzarini sono poi il diario di come andassero le cose, dove accadessero i discorsi e le preferenze, i dissensi, di questi signori che rappresentavano – nella Roma del Winckelmann e del Mengs – il gusto delle Legazioni pontificie. Frequentazioni nel museo di Atanasio Kircher, o divagazioni à la quête d'Isis, appunti sui Camini di Piranesi o sulla Mascarade del Petitot, insieme al ricorrente ossequio al genio di Raffaello, probabilmente fanno meglio comprendere anche quale fosse il ruolo produttivo e di supporto alle arti che si chiedeva alla recente nascita della Biblioteca e dei Musei Oliveriani nel 1756* [where the letters exchanged between Corvi and Lazzarini are still preserved]," in Calegari, *Disegni*, 11.

97. On the relationship between Corvi and Lazzarini see the accurate reconstruction provided by Curzi, *Committenti, intermediari e collezionisti*, especially 35 and 46.

98. On Lazzarini, see note 36.

99. "*Riguardo al disegno pochi difetti si trovano nelle Opere del Lazzarino. Egli conosceva, che questo era la base, e fondamento della Pittura, e vi si esercitò sempre, né voleva, che li suoi scolari maneggiassero li colori, se non dopo essersi esercitati nel disegno più anni,*" in Lazzarini, *Opere*, xxv.

100. "*Egli è tutto sul gusto di Rafaele,*" in Lazzarini, *Opere*, xxvi. On the eighteenth-century phenomenon of "veneration" of Raphael, see Baiardi, A. C.,

Guardian of the Myth: Accademia Raffaello–Urbino, catalogue of the exhibit, New York, Italian Cultural Institute, June 8–July 5, 2007, Urbino: L'Accademia Raffaello di Urbino, 2007. On the fortune of Raphael in France, see Pommier, É., *Raffaello e il Classicismo francese del XVII secolo*, Urbino: Accademia Raffaello, 2004; and also Rosenberg, M., *Raphael and France: The Artist as Paradigm and Symbol*, Philadelphia: Pennsylvania University Press, 1995.

101. "*Non può idearsi fisionomia* [sic] *più bella e graziosa di questa Santa. Ella è una bellezza greca.* [...] *La figura è decisamente Rafaellesca,*" in Lazzarini, *Opere*, xxxvi–xxvii.

102. "*Dipinse anche nella mostra di un Orologio a torre il Padre Eterno, che crea il Sole, e la luna. L'idea è Raffaellesca e felicemente eseguita, ed esiste presso li eredi del fu Conte Pietro Rasponi di Ravenna,*" in Lazzarini, *Opere*, xxxi.

103. "*Un'altra delle insigni pitture del Lazzarini è la copia del famoso quadro di Rafaele rappresentante la S. Famiglia, che esisteva in Pesaro appresso ad un'altra Famiglia Olivieri. Tutti gl'intelligenti la decisero similissima all'originale, e più compita del medesimo,*" in Lazzarini, *Opere*, xxviii.

104. "*Niuno più di lui conobbe la Storia de' Pittori, e de' loro pregj, e la varietà delle diverse scuole, e ne rendeva esattissimo conto, senza che però ne precipitase il giudizio, sul quale fu riservatissimo, e cauto,*" in Lazzarini, *Opere*, xxxiii.

105. "*Ma il Lazzarini non fu solamente buon Pittore, ed Architetto, e forse il Principe degli intelligenti nella Pittura, ed Architettura, ma fu un formale letterato, e ciò che è ancor di più, rese queste belle Arti una scienza letteraria. Ciò dimostrano evidentemente le sue Dissertazioni sulla Pittura nelle quali vi sono idee nuove, e principj ragionati, ed uno stile fluido, espressivo, ed anche elegante,*" in Lazzarini, *Opere*, xli.

106. "*Da questo vizio di manierare il vero fu quasi rovinata la Pittura dopo la mancanza della scuola di Raffaello* [...] *sinché vennero al mondo i non mai abbastanza lodati Caracci, che sbandite queste false maniere, la Pittura ristorarono, e nella primiera dignità riposero,*" in Lazzarini, *Opere*, 10. About the Carraccis' contributions to the rebirth of the arts, Lazzarini writes in another paragraph: "*Successero finalmente gl'immortali Caracci, i quali facendo sostegno alla cadente Pittura, nell'eccelso suo seggio primiero sempre più gloriosa, e più bella la riposero. Allora, fondata da essi la grande, e numerosa Scuola Bolognese, e trasportatala ancora in gran parte nella fu Metropoli del Mondo a ripiantarvi la già rovinata Scuola Romana, siccome tutte le più maravigliose perfezioni dell'arte tornarono a far pompa,*" in Lazzarini, *Opere*, 168.

107. "*Piacessi però al Cielo, che anche ai giorni nostri, per diverse cagioni, che non istarò a rammemorare, non fosse di nuovo una sì bell'arte da simil male infettata, e che la voglia di vedere la pompa dei bei colori, e il soverchio fracasso dei gran contrapposti, non tirasse ormai tutto il Mondo a compiacersi della di lei rovina! Sarebbe desiderabile, che qualche grande Ingegno sorgesse che ripigliando le virtù già smarrite di un Rafaello, di un Tiziano, di un Correggio, dei Caracci, e di altri simili, un'altra fiata ripulitala dal fuco, e dalla falsità, la sua semplice, pura, e naturale bellezza le restituisse,*" in Lazzarini, *Opere*, 10–11.

108. "*L'immortal Rafaello venuto al Mondo per essere il primo e più perfetto esemplare in ogni parte della Pittura,*" in Lazzarini, *Opere*, 27.

109. "[...] *con indicibile diligenza, e finitezza dal grande Annibale Caracci, uno dei primi Maestri dell'arte,*" in Lazzarini, *Opere*, 34.

110. "*Ma osservate le tante altre eccellenti Pitture nelle Chiese nostre, e del Guercino da Cento, e di Paolo Veronese, del Cignani, del nostro Berrettoni, del Sordo, di Pomerancio, del Savoldo, del Palma, del Mola, del Zuccheri in altro*

luogo, del nostro Niccolò da Pesaro, di Simon Cantarini, che fa tanto onore alla Patria nostra, e ch'è uno de' più leggiadri, e più fondati ingegni, che abbiano professata quest'arte; e di tanti altri rari Autori, che colle loro opere hanno la Patria nostra adornata, voi vedrete in esse di questo Precetto, di cui parlo, i chiarissimi esempi," in Lazzarini, *Opere*, 66. With respect to Cantarini, see Bellini, P., ed., *L'opera incisa di Simone Cantarini*, Pesaro: Comune di Pesaro–Assessorato alla Cultura, 1980.

111. "*Anche in questa prerogativa della Pittura (giacché niuna gliene manca) il gran Rafaello è stato il primo lume, ed esempio,*" in Lazzarini, *Opere*, 43.

112. "*E di fatto i grandi uomini hanno saputo scrivere nella faccia, e negli atti delle figure ciò che dicono, ciò che amano, ciò che temono, ciò che sentono, e per sino ciò che fingono,*" in Lazzarini, *Opere*, 34.

113. "*La ragione, per cui l'occhio dello Spettatore non si appaga nel Quadro di quella difettosa uniformità, ed uguaglianza al contrasto opposta, come in certe altre cose, che non sono Pittura, sembra, ch'egli ami, credo, ch'esser possa, perché essendo d'intrinseca essenza di quest'Arte l'imitar la Natura, convien, che serbi quello stesso tenore, ch'ell'ha, di esser varia, e accidentale in ogni suo aspetto,*" in Lazzarini, *Opere*, 62.

114. "*Da ciò nasce, che a coloro, che gustano la vera bellezza delle cose, piace piuttosto quella certa negligenza, la quale è format suo modello della Natura, che quell'affettata aggiustatezza a lei contraria,*" in Lazzarini, *Opere*, 63.

115. "*Ma niuno creda per questo, che il Dissegno, quasi un mero mecanismo consistente in tirar linee, e stendere chiaroscuro, sia opera di una forza d'ingegno men sublime, e vivace di quella, che il rimanente di quest'arte inspira, e dirigge,*" in Lazzarini, *Opere*, 79.

116. "*I più bei lumi di varie altre Facoltà, i quali o per libero dono del Cielo naturalmente posseduti, o per via laboriosa con diligente studio acquistati, debbono la mente coll'eccellente Pittore necessariamente fornire, affinché egli non con una sola material pratica, ma col fondamento della ragione sappia dissegnare,*" in Lazzarini, *Opere*, 79–80.

117. "*Così è opera del Disegno il dare a ciascheduna cosa, che si dipinge, la sua forma, e figura. Questo con due cose si ottiene, cioè col contorno, e col chiaroscuro,*" in Lazzarini, *Opere*, 81.

118. "*La perfezione di questa parte* [i. e., the "disegno"], *quando dall'Artefice sia ben trattata, spicca in qualunque oggetto, ch'egli ci rappresenta, ma in modo particolare nel Corpo Umano, il quale essendo la più bella di tutte le visibili cose, è perciò anche la più difficile ad imitarsi,*" in Lazzarini, *Opere*, 87.

119. "*La machina di esso è di così varia figura nelle sue parti, e queste stesse parti così mutabili nei loro movimenti, così differenti nella loro varia veduta, così facili ad alterarsi per le diverse passioni dell'animo, che ogni mossa, ogni aspetto, ogni espressione imprime in esse un'infinità di accidenti, ognun de' quali uno studio apposta ricerca,*" in Lazzarini, *Opere*, 87.

120. "*A persuadersi di quanta diligenza ponesse Rafaello nella notomia delle figure, che dipingeva, basterebbe osservare alcuni Studj, a penna Originali, del Quadro della Sepoltura di Cristo, che il divino Pittore fece per Madonna Atalanta Baglioni, ed ora forma uno de' principali ornamenti della insigne Galleria Borghese in Roma. Vedesi in uno di questi la Vergine svenuta appoggiata da tre donne, una delle quail la sostiene sotto le braccia, stando in piedi dietro di Lei, ed in un altro disegno la figura della Vergine, e quella della Donna, che la sostiene, non però vestite come nell'altro disegno, ma segnati semplicemente, e con soma maestrìa i soli contorni delle Ossa,*" in Lazzarini, *Opere*, 90–91.

121. In reference to the concept of "school," Lanzi asserts: "*Il Vasari non fece divisione di scuole. Monsignor Agucchi fu de' primi a compartire la pittura italiana in lombarda, veneta, Toscana e romana. Egli pure fra' primi*

74

usò a norma degli antichi la voce scuole; e nominò la romana," in Lanzi, *Storia Pittorica*, I, 259.

122. On Lanzi see the excellent survey written by Bologna, F., *La coscienza storica dell'arte d'Italia*, Milano: Garzanti, 1992, chapter VI, "*Dalle scuole seicentesche al sistema di scuole di Luigi Lanzi*," especially 151–58.

123. On Domenichino's letter to Angeloni in connection with the emerging concept of "schools" of art, see De Mambro Santos, R., *Arcadie del Vero. Arte e teoria nella Roma del Seicento*, Rome: Apeiron, 2001.

124. With regard to the definition of "system of schools" in reference to Lanzi's innovative method of investigation see Bologna, *La coscienza storica*, 153–54.

125. "*Oltre le maniere de' capiscuola, ne sorsero in lei* [that is to say, in Italy] *infinite altre temperate di questa e di quella, e talvolta miste a tanto di originalità che non è facile ridurle ad una o ad un'altra schiera. Oltreché i pittori stessi han molte volte seguito in diversi tempi o in diverse opere stile sì vario, che se ieri appartennero a' seguaci di Tiziano, oggi meglio stanno fra quegli di Raffaello o del Correggio. Non si può dunque imitare i naturalisti, che, distinte per atto di esempio le piante in più o in meno classi, secondo i vari sistemi di Tournefort o di Linneo, a ciascuna classe facilmente riducono qualsiasi pianta che vegeti in ogni luogo, aggiungendo a ciascun nome note precise, caratteristiche e permanenti. Conviene, a fare una piena istoria di pittura, trovar modo di allegarvi ogni stile per vario che sia da tutti gli altri; né a ciò ho saputo eleggere miglior partito che tessere separatamente la storia di ogni scuola. Ne ho preso esempio da Winckelmann, ottimo artefice della storia antica del disegno*," in Bologna, *La coscienza storica*, 154.

126. As Ferdinando Bologna convincingly argues: "*Nell'ottica del rapporto e delle relazioni, le «scuole» divengono per Lanzi situazioni aperte, dove il ruolo individuante spetta alle unità culturali reali, capaci di efficacia formativa, fondate sull'elaborazione e la trasmissione della cultura*," in Bologna, *La coscienza storica*, 156.

127. "*Un'altra notizia di questa epoca mi porge il ch.*[iarissimo] *sig.*[nore] *abate Morcelli* (De Stylo Inscript. Latin., 476). *Racconta che presso il sig. Annibale Maggiori nobile fermano vide una Madonna che in ambe le mani toglieva di sopra al divin Bambino, giacente in culla e da sonno compreso, un sottilissimo velo, e v'era presso San Giuseppe che di quel beato spettacolo pascea gli occhi, nel cui bastone lo scrittore stesso scoprì e lesse una iscrizione appostavi in lettere oltre modo minute: «R. S. V. A. a. XVII. P. Raphael Sanctius Urbinas an. Aetatis 17 pinxit»*," in Lanzi, *Storia Pittorica*, I, 286.

128. "*Così la pittura in non molti anni giunse ad un segno che né prima toccato avea, né di poi ha tocco, se non procurando d'imitare que' primi, o di riunire in un'opera i pregi che divisi veggonsi nelle loro*," in Lanzi, *Storia Pittorica*, I, 283.

129. "*Raffaello avea formato il suo sistema; e cercava solo esempi che gliene moltiplicasser le idee e gliene agevolassero l'esercizio*," in Lanzi, *Storia Pittorica*, I, 289.

130. According to Lanzi, Raphael in fact "*coltivò ancora la notomia, la storia, la poesia. Ma il suo studio maggiore in Roma furono gli esemplari greci, che misero il colmo al suo sapere*," in Lanzi, *Storia Pittorica*, I, 291.

131. "*Eccolo dunque in Roma e nel Vaticano in un tempo ed in circostanze da renderlo il primo pittore che fosse al mondo*," in Lanzi, *Storia Pittorica*, I, 291.

132. "*Il disegno di Raffaello, veduto in quelle carte che ora nobilitano i gabinetti, e scevre di colore presentano puro e schietto, per così dire, il ritratto della immaginativa di lui, quale offre precisione di contorni! qual grazia! qual nettezza! qual diligenza! qual possesso!*" in Lanzi, *Storia Pittorica*, I, 303.

133. "*Da questi lieti principi ebbe stabilimento la scuola che noi chiamiamo romano dal luogo più che dalla nazione, come notai. Anzi come il popolo di quella città è un misto di molte lingue e di molte genti, fra le quali i nipoti di Romolo sono i meno; così la scuola pittorica è stata popolata e supplita sempre da' forestieri, ch'ella ha accolti e riuniti a' suoi, e considerati nella sua accademia di San Luca non altamente che se nati fossero in Roma, o godessero l'antico jus de' Quiriti. Quindi derivarono le tante maniere e svariatissime che vedremo nel decorso. Alcuni, come il Caravaggio, nulla profittarono de' marmi e degli altri soccorsi propri del luogo; e questi furono nella scuola romana, non già della scuola. Altri adottaron le massime de' discepoli di Raffaello; e il metodo loro è stato ordinariamente studiar molto in lui e ne' marmi antichi; e dalla imitazione di quello, e specialmente di questi, risulta, se io non erro, il generale carattere, e, per dir così, l'accento proprio della scuola romana*," in Lanzi, *Storia Pittorica*, I, 311.

134. "*Roma non vedeva già da alcuni anni se non due estremi nella pittura. Il Caravaggio e i seguaci eran pretti naturalisti; l'Arpino e i suoi erano pretti ideali. Annibale insegnò il modo d'imitar la natura sempre nobilitandola colla Idea, e di sollevare la idea verificandola sempre con la natura*," in Lanzi, *Storia Pittorica*, I, 348.

135. The sentence is quoted by Bologna: "*scriver la storia dei Carracci e de' loro seguaci è quasi scriver la storia pittorica di tutta Italia da due secoli in qua*," in Bologna, *La coscienza storica*, 157.

136. "*Veniamo a' Carracci ed alla loro scuola. Prima che giungesse Annibale in Roma aveva già formato uno stile ove non restava alcuna cosa a desiderare, sennon un gusto maggiore dell'antico disegno. Lo aggiunse Annibale agli altri suoi pregi quando venne a Roma: e i discepoli che lo seguitarono, e dopo la sua morte continuarono a operare in quella città, si discernono specialmente per questo carattere da quegli che si rimasero in Bologna sotto la disciplina di Lodovico suo cugino. Essi fecero similmente degli allievi in Roma: niuno, eccetto il Sacchi, così vicino di merito al suo maestro, com'essi erano stati ad Annibale; niuno scopritore e principe di qualche nuovo stile, com'essi erano riusciti; ma tali nondimeno che miser freno a' manieristi e a' caravaggeschi, e ricondussero i seguaci della scuola romana ad un miglior metodo*," in Lanzi, *Storia Pittorica*, I, 362.

137. "*Non segno i confini di questa scuola con quei dello stato ecclesiastico; perché vi comprenderei Bologna e Ferrara e la Romagna, i cui pittori ho riserbati ad altro tomo. Qui considero con la capitale solamente le provincie a lei più vicine, il Lazio, la Sabina, il Patrimonio, l'Umbria, il Piceno, lo stato d'Urbino* [namely the most important areas currently belonging to the region of Le Marche], *i cui pittori furono per la maggior parte educati in Roma, o da maestri almeno di là venuti*," in Lanzi, *Storia Pittorica*, I, 261.

138. See notes 121 and 123.

139. "*Non meno bella di questa S. Palazi è un'altra tavola del medesimo artefice (ma dell'ultima maniera) posseduta dai Signori Conti Camerata, nella cui galleria tiene forse il primo luogo*," in Maggiori, *Le Pitture*, 74–75.

140. "*Dopo aver Gio.*[vanni] *Battista* [Caccianiga] *studiato in Bologna andò a viver in Roma, dove a poco a poco mutò in parte la sua maniera, accostandosi a quella del Maratti*," in Maggiori, *Le Pitture*, 71. One should not confuse Giovan Battista Caccianiga with the Milanese master Francesco Caccianiga, who had also worked in Ancona and was, therefore, mentioned by Maggiori. In the Church of the Cappuccini, for instance, Alessandro Maggiori suggests that "*Il S. Felice col Bambino fra le braccia sembra di Francesco Caccianiga Milanese, allievo in Bologna del cavalier Marcantonio Franceschini*," in Maggiori, *Le Pitture*, 6. Significantly, Caccianiga is remembered by Maggiori as having had both a Roman as well as a Bolognese education.

141. "*L'Orlandi, scrive il Lanzi, lo chiama Giovanni, e Giovanni Peruzzini io lessi nel libro Pitture di Bologna dell'Ascoso Accademico Gelato ed in altri posteriori. Alcuni sono però o quali dicono essere stato Giovanni fratello di Domenico, e altri affermano in contrario avervi un Peruzzini solo e con quest'ultimo nome. Saranno però d'una mano istessa tutte le opere che vanno sotto nome del Cav.*[alier] *Peruzzini? Alcune certo se n'incontrano che, mentre danno a veder qualche cosa della maniera delle prime, sembrano di pennello oltremodo inferiore e diverso: e ciò medesimo par che confermi il dubbio che i Peruzzini sieno, per lo meno, stati due. Una Memoria Pesarese ricondurrebbe anzi a credere che, non che altro, fossero stati tre, leggendosi ivi che Domenico ebbe un figliuolo il quale viveva e operava in Roma circa del mille secento ottanta; e a costui nemmeno potrebbero aggiudicarsi l'opere inferiori dette di sopra, quando sia vero che operava… con fama di buono, e risoluto pittore come similmente si legge nella Memoria sopraindicata*," in Maggiori, *Le Pitture*, 42–43.

142. Becci, A. *Catalogo delle pitture che si conservano nelle chiese di Pesaro. Si aggiunge la Dissertazione sopra l'Arte della Pittura del sig. Canonico Gio. Andrea Lazzarini*, Pesaro: Gavelli, 1783.

143. "*La tavola della S. Teresa sul primo altare alla manca, quando con uno strale è traffitta da un Angelo, è fattura del Peruzzini; non senza imitazione dello stile Baroccesco*," in Maggiori, *Le Pitture*, 7. In a footnote regarding this painting, Maggiori makes it clear that such a stylistic interpretation—and the connection between Peruzzini's manner and Barocci's working methods—had been proposed earlier by Luigi Lanzi in his *Storia Pittorica*.

144. "*La tavola dell'altar maggiori con S. Andrea Apostolo sembra del Peruzzini*," in Maggiori, *Le Pitture*, 22. Referring to a painting in the Church of S. Francesco ad Alto, Maggiori is not sure whether it had been made by Peruzzini and, consequently, states: "*Il quadro del prim'altare alla destra è forse del Peruzzini*," in Maggiori, *Le Pitture*, 14.

145. "*Il S. Luca nella tavolina posta al corno dell'epistola, dentro il presbiterio, tiene in parte il modo di Simone e in parte dei Carracci; ma è del Cavalier Domenico Peruzzini d'Ancona, allievo, come affermano, di Gio.*[vanni] *Paolo Pandolci Pesarese*," in Maggiori, *Le Pitture*, 2. In a different paragraph, in which Maggiori examines another painting by Peruzzini, he again underlines the stylistic connections between the artist from Ancona and the Carracci: "*La Vergine che stando a sedere sulle nuvole fra Santa Maria Maddalena e S. Caterina, stende il ritratto di S. Domenico a S. Raimondo Nonnato, è quadro nel terz'altare assai Carraccesco del Peruzzini*," in Maggiori, *Le Pitture*, 12.

146. "*La tavola di S. Carlo e altri Santi sull'altare che segue è grandiosa e facile operazione di Cesare Dandini da Firenze, allievo prima del Curradi, e quindi del Passignano, di cui apparisce il modo singolarmente nella parte di sotto*," in Maggiori, *Le Pitture*, 24–25.

147. For a more Italian–French centered approach to Neoclassicism see Pinelli, A., *Il Neoclassicismo nell'arte del Settecento*, Rome: Carocci Editore, 2005. For a different interpretation of eighteenth-century facts of art and culture, in relation to a wider background of historical as well as economic factors, see Craske, M., *Art in Europe: 1700–1830*, New York: Oxford University Press, 1997. For further information regarding eighteenth-century aesthetic debates and the redefinition of the concept of art, see Mattick, Jr., P., ed., *Eighteenth-century Aesthetics and the Reconstruction of Art*, Cambridge, UK: Cambridge

University Press, 1993 (2nd ed. 2008).

148. With the only exception being a group of drawings ascribable to Venetian masters and currently preserved at Palazzo Rosso in Genoa. In fact, in a footnote concerning the collection of drawings at Palazzo Rosso, Luigi Dania recalls his correspondence with the Italian scholar Pietro Boccardo and says: "*Pietro Boccardo* [...] *con lettera 23 dicembre 1994, ci ha reso noto: 'Questi 117 fogli sono stati inventariati nel 1942 per la maggior parte come disegni di "Scuola veneziana" o di "Scuola romana", ma quando Maggiori li acquistò li reputava di autori ben noti di quelle scuole. Non so dirle a chi si debba l'abbandono delle attribuzioni altisonanti — Tiziano, Veronese, Palma il giovane, per esempio — in favore di quelle generiche che le ho dato*,'" in Dania, *Alessandro Maggiori*, 16, footnote 21.

149. See Woolf, *History of Italy*, especially Part 3, "Revolution and Moderation," 153–226, and also Part 4, "The Search for Independence," 227–92. About the Napoleonic period in Italian history and culture, see Millar, E. A., *Napoleon in Italian Literature: 1796–1821*, Rome: Edizioni di Storia e Letteratura, 1977; see also Pillepich, A., *Napoléon et les Italiens*, Paris: Nouveau Monde Editions, 2003; and Capra, C., Della Peruta, F., and Mazzocca, F., eds., *Napoleone e la Repubblica Italiana (1802–1805)*, catalogue of the exhibit, Milan, Rotonda di Via Besana, November 11, 2002–February 28, 2003, Milano: Skira, 2002. From a more micro-historical level, interesting readings on the social, cultural, and political situation of The Marches under Napoleon include Cicconi, R., *1799: L'insorgenza antifrancese e il Sacco di Macerata*, Atti del convegno di studi, Macerata, Università di Macerata, May 20, 1999, Macerata: Comune di Macerata, 2001, as well as Capponi, R., *Morrovalle napoleonica. Amministrazione e coscrizione (1808–1814)*, Morrovalle: Amministrazione Comunale di Morrovalle, 2004.

150. A list of dates and places of the drawings purchased by Maggiori is provided by Dania, *Alessandro Maggiori*, 11–14.

151. On this topic see the brief yet precise essay by De Francesco, A., *La politica dell'*Armée d'Italie; and Balzani, R., ed., *L'arte contesa nell'età di Napoleone, Pio VII e Canova*, catalogue of the exhibit, Cesena, Biblioteca Malatestiana, March 14–July 26, 2009, Milano: Silvana Editoriale, 2009, 33–38.

152. Pommier, *Più antichi della luna*, 244. See also Pinelli, A., "Storia dell'arte e cultura della tutela. Le *Lettres à Miranda di Quatremère de Quincy*," in *Ricerche di Storia dell'arte*, 8 (1975–1976), 43–62; and Luke, Y., "*The Politics of Partecipation: Quatremère de Quincy and the Theory of 'concours public' in Revolutionary France, 1791–1795*," in *The Oxford Art Journal*, X, 1987, 1: 15–43. On the ideological basis of the politics of the *rappatriament* see Rizzoli, F., "Geografia e cronologia delle requisizioni d'opere d'arte in Italia dal 1796 al 1799," in Balzani, R., ed., *L'arte contesa nell'età di Napoleone, Pio VII e Canova*, catalogue of the exhibit, Cesena, Biblioteca Malatestiana, March 14–July 26, 2009, Milano: Silvana Editoriale, 2009, 43–46.

153. Pommier, *Più antichi della luna*, 244.

154. On the organization of the *Musée Napoléon*, see Siegel, J., "Owning Art after Napoleon: Destiny or Destination at the Birth of the Museum," *PMLA*, 125, 1 (2010): 142–51.

155. Pommier, *Più antichi della luna*, 244.

156. Costanzi, C., *Le vie di fuga: principali percorsi nelle dispersioni delle opere d'arte dalle Marche*, in Costanzi, C., ed., *Le Marche disperse. Repertorio di opere d'arte*

dalle Marche al mondo, Milan: Silvana Editoriale, 2005, 21–35.

157. On the "Treaty of Tolentino" see Emiliani, *Il territorio e opere d'arte nel XVIII secolo*, 17–23. See also *Ideologie e patrimonio storico-culturale nell'età rivoluzionaria e napoleonica. A proposito del trattato di Tolentino*, Atti del convegno, Tolentino, September 18–21, 1999, Roma, 2000.

158. On the triumphal arrival of Italian masterpieces in Paris and specifically with regard to Normand's print, see the critical entry written by Federica Rizzoli in Balzani, *L'arte contesa*, 153. With regard to the powerful effect exercised by Raphael's *Transfiguration* in Paris see note 100 and, in particular, Rosenberg, *Raphael and France*, especially 147–64.

159. Quoted in De Francesco, *La politica dell'*Armée d'Italie, 35.

160. According to Federica Rizzoli, "*particolarmente interessante il caso di Bologna per il ruolo svolto dall'Accademia Clementina nell'opera di tutela, già nel periodo della Repubblica cispadana*," in Rizzoli, *Geografia e cronologia*, especially p. 45. On this topic see also Emiliani, *Il territorio*, 21–22.

161. Emiliani, *Il territorio*, 21.

162. On Vivant-Denon cultural politics and aesthetic policies see Dupuy, M.-A., ed., *Dominique-Vivant Denon: L'œil de Napoléon*, Paris: Réunion des Musées Nationaux, 1999.

163. On the campaign undertaken by Beauharnais, see Emiliani, *Il territorio*, 22.

164. "*Chiese, alcune demolite, ed alter non peranche riaperte, le cui tavole o passarono altrove, o s'ignora dove siano, o sono perite*," in Maggiori, *Le Pitture*, 28.

165. "*La tavola dell'altar maggiore, la qual tavola fu di Girolamo Spicciolante da Sermoneta, si trova ora nella galleria Imperial di Milano*," in Maggiori, *Le Pitture*, 28.

166. An important allusion to the unstoppable spoliation of artworks conducted by the French Army, beyond the boundaries of The Marches, can be found in the pages of Amico Ricci, in which the author refers to the eighteenth-century painter Filippo Locatelli and, in particular, to his copies after Correggio: "*Circospetto, e freddo imitatore della natura non dava alle sue opere il carattere d'originlità, ma tutte le conduceva senza affettazione, e maniera, e con una verità di colorito, che in questa singolarmente si distinse presso i suoi, e li stranieri ancora. Ond'è che l'Imperatore Napoleone, il quale per arricchire la sua Parigi di monumenti artistici con più d'onestà sostituiva ai migliori dipinti ne' muri, si servì della mano del nostro artefice, per ritrarre I famigerati dipinti d'Antonio Allegri da Coreggio, esistenti in una delle camere del monastero di San Paolo, giò dottamente descritti dal Padre Ireneo Affò*," in Ricci, *Memorie*, 434.

167. On the distinction between a collectively shared cultural heritage and a more politically oriented patriotism, see Banti, A. M., *Il Risorgimento italiano*, Bari, Editori Laterza, 2004, especially pp. 11–16.

168. "*Su questo terreno avrebbe preso forma una linea politica propriamente nazionale, destinata a tradursi in una cultura politica originale e propriamente italiana, dove la stessa difesa del patrimonio culturale della penisola diveniva uno strumento per differenziarla dal possente (ed ingombrante) liberatore e alleato*," in De Francesco, *La politica dell'*Armée d'Italie, 37.

169. "*L'Italia produsse una volta Vinci, Michelangiolo, Raffaello, Tiziano, Veronese* [...] *era già qualche secolo da che non ne produceva più. Si contentavano i loro discendenti della gloria minore di sapere almeno apprezzare e conservare quei capi d'opera che più non sapevano produrre. Ma mentre tutte le altre nazioni si formano de' musei, che*

prima non avevano, noi vendevamo per vil presso i capi d'opera che adornavano i nostri. L'ultimo decennio del secolo è stato soprattutto fatale ai monumenti delle arti in Italia. Non mai tanto necessaria è stata l'attenzione del Governo per conservare quelli che ancora ci avanzano, quanto in questo momento. Non ritorneremo giammai a produr de' nuovi capi d'opera, se non gustando quelli che abbiamo, e non potremo mai gustarli se non li sapremo conservar," in De Francesco, *La politica dell'*Armée d'Italie, 37. With regard to Vincenzo Cuoco and the anti-French reaction of many Italian intellectuals of the time, scholar Eileen Anne Millar holds that "all these writings were the result of intelligent observation of a revolution which failed, and history has shown that through them an apparently negative turn of events created the mentality of national feeling which was to develop during the next fifty years until it reached its definite goal of unity and independence," in Millar, *Napoleon in Italian Literature*, 44.

170. On this important topic see Emiliani, A., *Leggi, bandi e provvedimenti per la tutela dei beni artistici e culturali negli antichi stati italiani. 1571–1860*, Bologna: Nuova Alfa Editoriale, 1996.

171. See Emiliani, *Leggi, bandi e provvedimenti*, 86–95. On the ideological as well as practical implications of the *Chirografo*, see also Balzani, R., "Nel crogiolo del patrimonio: come le opere d'arte cambiarono statuto," in Balzani, R., ed., *L'arte contesa nell'età di Napoleone, Pio VII e Canova*, catalogue of the exhibit, Cesena, Biblioteca Malatestiana, March 14–July 26, 2009, Milano: Silvana Editoriale, 2009, 24–27.

172. "*Naturalmente, il primato storico nella emanazione di queste antiche leggi di tutela, sia per esaustività di enumerazione, sia per volontà finalistica, spetta a quel governo pontificio che in Roma riconosce per tempo il valore spirituale di una 'traditio' che volge in impero dei cristiani l'antico impero dei gentili*," Emiliani, *Leggi, bandi e provvedimenti*, 7.

173. On Canova, see Johns, C. M. S., *Antonio Canova and the Politics of Patronage in Revolutionary and Napoleonic Europe*, Berkeley: University of California Press, 1998.

174. On the 1733 document, see Emiliani, *Leggi, bandi e provvedimenti*, 72–75.

175. Given the importance of the 1802 *Chirografo* within our critical discourse, it is worth quoting its opening paragraphs: "*Mentre la Santità di Nostro Signore Papa Pio VII estende le sue Paterne cure a tutti gli oggetti delle Arti produttrici, e di manifattura, per aumentare con i loro prodotti la opulenza, e la prosperità dei suoi amatissimi Sudditi, non perde di vista un altro ramo d'industria, che quasi proprio, e particolare di questa Popolazione, e di questo suolo non che concorre, e gareggia con quelli, ma supera l'attività e la influenza non meno nel promuovere i vantaggi, che nell'accrescere di decoro, e la celebrità di questa Metropoli, ed anche dello Stato. Riconoscendo la Santità Sua nelle produzioni di Belle Arti, che nate nella Grecia hanno da tanti secoli trasportato, e fissato il loro proprio, e quasi unico domicilio in Roma, uno dei pregi più singolari, che distingue da tutte le altre questa Città, ed insieme una delle più utili, e più interessanti occupazioni dei suoi Sudditi, e di tutti quelli, che vi concorrono, ha rivolti efficacemente i suoi pensieri a procurare, che i Monumenti, e le belle opere dell'Antichità, che servono di alimento alle Arti stesse, e di esemplare, e di guida, e di eccitamento a quelli, che le professano, si conservino quasi i veri Prototipi, ed esemplari del Bello, religiosamente per ornamento, e per istruzione pubblica, e si aumentino ancora con il discoprimento di altre rarità, che in qualche parte compensino le perdite di quelle, che le vicende dei tempi ci hanno involate*," in Emiliani, *Leggi, bandi e provvedimenti*, 86.

176. Emiliani, *Leggi, bandi e provvedimenti*, 86.

177. The profound and enduring connection that Alessandro Maggiori displayed with eminent protagonists of the Roman Catholic Church throughout his life is eloquently documented, for example, in the dedication of his "guide" of the Basilica of Loreto (*Indicazioni al forestiere delle pitture sculture architetture e rarità d'ogni genere che vi veggono oggi dentro la Sagrosanta Basilica di Loreto e in altri luoghi della città*, Ancona: Sartorj, 1824) to Monsignor Stefano Bellini, bishop of Loreto and Recanati, who may have had, according to the words used in these pages, a strong interest in the visual arts: "*E che, mentre con ogni ingegno a ricercarne attendete l'antica e più vera istoria, oltre ogni dir vi dimostriate curante, che ciò onde esso è celebre eziandio nelle scuole del Disegno, sia diligentemente tenuto e conservato.*"

178. "*Non per favore de' Principi, ma da sola potenza di private ingegni cresceva ogni dì più in istima, e considerazione la scuola, che aperta dai Carracci in Bologna ridondava ad onore italiano. Da ogni dove concorrevano Giovani ad istruirsi, e reduci alle loro patrie, un nuovo gusto, una nuova maniera di dipingere vi stabilivano. La provincia della Marca andò sempre di pari passo colle altre d'Italia, e non fu seconda neppure questa volta a volere che anch'in essa si stabilisse un metodo, che chiamava a quei giorni l'attenzione, e la compiacenza degli Uomini colti, e degli amici dell'onore del proprio paese; perciò anche da detta provincia partirono dei Giovani per Bologna a fine di procacciarsi utili istruzioni,*" in Ricci, *Memorie*, 264.

179. "*Uscito di fresco dalla scuola del Cignani andava a Roma Francesco Mancini da Sant'Angelo in Vado, e piuttoschè seguire i precetti già appresi dal Maestro, ponevasi invece a coltivare anch'esso lo stile, che allora vigeva nella capitale, sostituendo a forte, al risoluto, all'imaginativo della scuola Bolognese, il languido, il leccato, il patetico,*" in Ricci, *Memorie*, 415.

180. On Sassoferrato, see Pulini, M., ed., *Il Sassoferrato. Un preraffaellita tra i puristi del Seicento*, catalogue of the exhibit, Cesena, Galleria Comunale d'Arte, May 15–October 25, 2009, Milano: Medusa Edizioni, 2009. On Sassoferrato, Lanzi comments: "*Carraccesco, ma non si sa di quale scuola, fu Giambattista Salvi detto dalla patria Il Sassoferrato, di cui facemmo menzione parlando di Carlo Dolci e delle sue immagini sì devote. Questi lo supera nella bellezza delle Madonne, ma nella finezza del pennello è vinto dal Dolci. Il gusto è dissimile, avendolo formato il Salvi su di altri esemplari. Studiò prima in patria sotto Tarquinio suo padre, poi in Roma, indi in Napoli; non si sa precisamente sotto quali maestri, sennonché nelle sue memorie manoscritte lessi un Domenico. La età degli studi del Salvi a maraviglia combina col tempo in cui Domenichino operava in Napoli, e il modo di dipingere lo fa conoscere addetto a quel maestro, ma non a lui solo. Restano ancora presso i suoi eredi molte copie di valentissimi artefici ch'egli fece per proprio studio: ve ne osservai dell'Albano, di Guido, del Barocci, di Raffaello, ridotte in picciole proporzioni, e lavorate, come suol dirsi, col fiato,*" in Lanzi, *Storia Pittorica*, I, 369.

181. "*Conobbe il Salvi che la virtù non progredisce, che col mezzo della emulazione, e che ad ottenere tale vantaggio era di necessità stabilirsi ove vi fosse mezzo di vivissima gara,*" in Ricci, *Memorie*, 251. The conviction that "virtue progresses only by means of emulation" is well represented also by the case of another artist, Cesare Mariani, who was born in The Marches and had worked, in the middle of the nineteenth century, for Pope Pius IX in the remodeling of the pictorial decoration of several churches in Rome, in which he had quite programmatically adopted compositional as well as stylistic solutions notably borrowed from

Michelangelo, Raphael, and Annibale Carracci. On this interesting case of reappropriation, and again following the chronological sequence of Ricci and Maggiori, see De Mambro Santos, R., *Santa Lucia del Gonfalone*, Roma: Istituto Nazionale di Studi Romani-F.lli Palombi, 2001.

182. "*Il Salvi al contrario né concepì l'utilità, e rivolse le sue fatiche alla più costante, e diligente meditazione dei prototipi del bello,*" in Ricci, *Memorie*, 252.

183. "*Raffaele fu il suo modello prediletto, e talmente s'immedesimò nello spirito di questo grande Artista, che traducendolo né innalzò, sarei per dire, le forme, e i concetti,*" in Ricci, *Memorie*, 252.

184. "*La copia che fece della deposizione di Croce, e la quale vedesi nella Chiesa di San Pietro di Perugina, potrebbe, se il mio occhio non s'inganna, avvalorare la proposizione, che forse ad alcuno sembrerà ardita. Se si considera l'originale vi scoprirà un conoscitore minuto, e delicato in quei, che sostengono l'estinto Redentore, dei lineamenti espressi con troppa forza, ed i muscoli alquanto risentiti. Non v'ha dubbio che il Sanzio preferì queste forme, poiché le stimò più adatte ad esprimere i diversi commovimenti dell'anima; ma il Salvi mostrandosi più moderato conchiuse, che la perfezione dell'arte consiste nell'unire la più giusta espressione alle forme più belle,*" in Ricci, *Memorie*, 252.

185. "*Un suo disegno con un San Michele, che calpesta il Dragone, gelosamente veniva custodito dal Conte Alessandro Maggiori di Fermo, il quale conferma il nostro pittore studiosissimo nel bene ordinare le forme umane, vedendovisi nell'Arcangelo una conveniente nobiltà d carattere, senza che sia alterata dall'azione, a cui attende,*" in Ricci, *Memorie*, 256–57.

186. "*Ma per tacere dei disegni, i quali si conservano come oggetti preziosissimi nelle raccolte degli amatori, converrebbe più lungamente estendersi, annoverando le tante sue Madonne, che oggi si hanno nelle principali Gallerie d'Europa, e che ai tempi del pittore si compravano a caro prezzo, per collocarsi sopra i genuflessorj dei Sovrani, e dei ricchi Signori,*" in Ricci, *Memorie*, 257.

187. "*È a ricordarsi un bel ritratto d'una Villica Frascatana dipinto dal Salvi, che rimaneva presso il C.[onte] Alessandro Maggiori di Fermo. Vi è disegno, forza di colore, ed un'espressione che incanta,*" in Ricci, *Memorie*, 264.

188. "*Dal Correggio studiò il Salvi il chiaroscuro, ed in vedere le opere sue ebbe moltissimo ad apprendervi. Nel tingere le sue teste non imita né l'uno, ne l'altro di questi pittori: ma piuttosto al Domenichino s'avvicina,*" in Ricci, *Memorie*, 254.

189. "*Il suo pennello è pieno, ed il suo colorito è vago come quello del modello, da cui il derivò; traendo dal medesimo anche quel largo contorno degli occhi, che tanto vale ad imprimere nelle fisionomie un carattere deciso, e grandioso, che niuno più del Domenichino seppe raggiungere, ne meglio del Salvi imitare,*" in Ricci, *Memorie*, 254.

190. "*Verità ch'esclude il mal pesato giudizio, che di questo pittore volle dare un'anglicana viaggiatrice. Questa in un diario stampato in Londra pel Colbam l'anno 1826 […]: così s'espreme – Sassoferrato è un gran ritrattista di Madonne, ma va copiando ora Guido, ora Carlo Dolci, e copia debolmente; il suo pennello fallisce per debbolezza, ed insipidità – avvisandosi così di far decadere il nostro artefice da quel grado di merito e di lode, in cui è collocato,*" in Ricci, *Memorie*, 254.

191. "*Se il Salvi rese soggetto ordinario delle sue tele l'imagine della Vergine diversamente atteggiata, e preferì gli argomenti semplici e dimessi ai composti ed elevati, in ciò non fece, che ubbidire al suo genio religioso dolce e tranquillo. Ma chi vorrà attribuirgli questo a mancamento, quando sa esprimere così vivamente il carattere delle virtù, che adornano il bujbetto, che al trpimo vederlo ravvisasi per tale? avrà egli anzi ottenuto appieno quello, che chiamasi MORALE DELLA PITTURA, della cui importanza tanto erano convinti gli antichi, che definivano quest'arte la rappresentant dei costumi,*" in Ricci, *Memorie*, 254.

192. "*Le Madonne pertanto effigiate dal Sassoferrato, e quelle più semplici singolarmente, che racchiudono la testa, saranno sempre opere pregevolissime; perocchè alla sol'aria di purità e dolcezza sopranaturale si ravvisa subito colei, che fu assunta a conforto dell'uman genere […] Ne certamente questo ideale egli servilmente ritrasse dalle opere di Guido, o del Dolci; poiché quanto al primo le di lui Madonne formano per lo più parte delle sue grandi opere di composizione, e mostrano un genere diverso dalle semplici del nostro Salvi, ne possono somministrare soggetto a confronto; quanto a Carlo D9olci, se questi fu superiore al Salvi nella finezza del pennello, gli fu inferiore nella bellezza, e questa bellezza sarebbe sempre inferiore all'oggetto inventato, se l'artista ad una semplice imitazione ristretto si fosse. Si arricchì adunque la fantasia del Sassoferrato, e il di lui gusto per le devote imagini si rese squisito con la costante contemplazione di questo genere di bellezza, e quantunque fosse imitatore de' suoi Maestri in quanto alle parti, fu però inventore nel tutto insieme,*" in Ricci, *Memorie*, 255.

193. On the aesthetic and historical significance of "details" see study by Arasse, D., *Le détail: pou une histoire rapprochée de la peinture*, Paris: Flammarion, 1997.

194. On Raphael's concept of "idea," see the study by Minnich, N. H., "Raphael's Portrait *Leo X with Cardinals Giulio de' Medici and Luigi de' Rossi*: A Religious Interpretation," *Renaissance Quarterly*, 56, 4 (2003): 1005–52; and also Williamson, E., "The Concept of Grace in the Work of Raphael and Castiglione," *Italica*, 24, 4 (1947): 316–24. In regard to the notion of "eclecticism" in relation to Annibale Carracci, see the seminal study by Mahon, D., "Eclecticism and the Carracci: Further Reflections on the Validity of a Label," *Journal of the Warburg and Courtauld Institutes*, 16, 3 / 4 (1953): 303–41.

195. On Fortunato Duranti, see Eitner, L., and Dania, L., *Fortunato Duranti, 1787–1863*, Stanford, CA: Department of Art and Architecture, Stanford University, 1966; Patani, O., ed., *Le referenze visuali di Fortunato Duranti*, Milano: Stanza del Borgo, 1985; De Vecchi, P., and Blasio, S., eds., *La Pinacoteca Duranti di Montefortino*, Azzano San Paolo: Bolis, 2003.

196. For further information regarding the pontificate of Leo XII, see Leoni, F., ed., *Il Pontificato di Leone XII: Annibale della Genga*, Urbino: Edizioni QuattroVenti, 1992.

197. This letter is cited in Angelucci and Di Giampaolo, *Sotto il segno di Alessandro Maggiori*, 16.

77

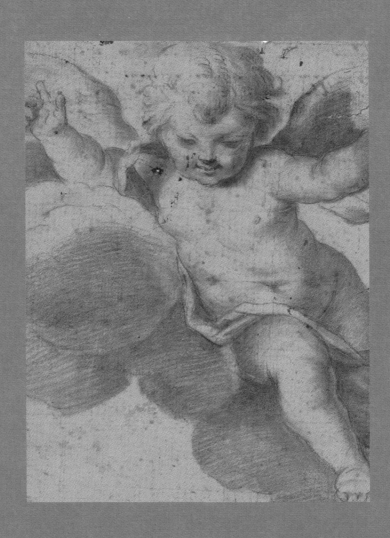

Anonymous artist, *Flying angel* (detail), red chalk on ivory-colored paper
7 x 10.25 in., Fondo Alessandro Maggiori, Biblioteca Comunale, Monte San Giusto, Italy

CATALOGUE

Italian Drawings from the Alessandro Maggiori Collection

I. FEMALE HEADS

1.

Anonymous artist (Roman School, 18th century)
***Head and shoulders of a woman after Raphael's** Transfiguration*
Red chalk on ivory-colored paper
15.5 x 11.75 in.
Fondo Alessandro Maggiori, Biblioteca Comunale, Monte San Giusto, Italy

Inscriptions: on the verso, "Copia della F[...]hioni nel quadro del [...] di Raffaele" (Copy of F[...]hioni in the painting of [...] by Raphael); "Alessandro Maggiori comprò in Roma nel 1803" (Alessandro Maggiori bought it in Rome in 1803).
Bibliography: Di Pietro, *Elenco*, p. 106; Angelucci, *Notizie*, pp. 174–79.

2.

Anonymous artist (Roman School, 18th century)
Head of a young woman with hair in plaits
Red chalk on light brown paper
11 x 9 in.
Fondo Alessandro Maggiori, Biblioteca Comunale, Monte San Giusto, Italy

Inscription: on the verso, "Appartiene ad Alessandro Maggiori il quale lo comprò in Roma correndo l'anno 1806" (It belongs to Alessandro Maggiori, whom bought it in Rome in the year 1806).
Bibliography: Di Pietro, *Elenco*, p. 103; Angelucci, *Notizie*, pp. 174–79.

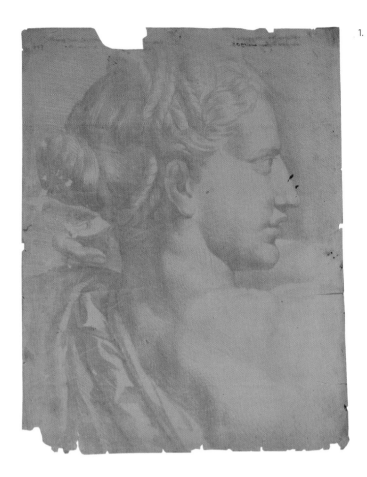

1.

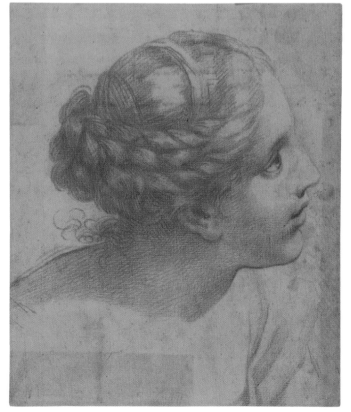

2.

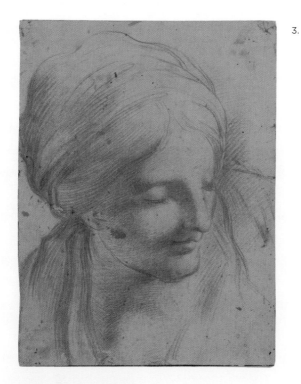

3.

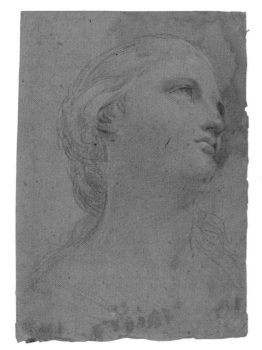

4a.

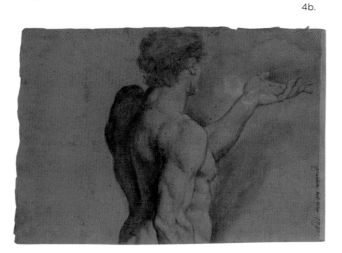

4b.

3.
Anonymous artist
Head of a woman with closed eyes
Red chalk on ivory-colored paper
10 x 7.5 in.
Fondo Alessandro Maggiori, Biblioteca
Comunale, Monte San Giusto, Italy

Inscription: on the verso, "Io Aless.
Maggiori acquistai in Roma il dì 7 di
Luglio del 1809" (I, Aless. Maggiori
purchased it in Rome on July 7, 1809).
Bibliography: Di Pietro, *Elenco*, p. 103;
Angelucci, *Notizie*, pp. 174–79.

4a. – 4b.
Anton Raphael Mengs (born Aussig,
Germany, 1728–died Rome, 1770)
Head of young woman (recto), ***Study
of a standing naked man seen from
the rear with outstretched hand***
(verso)
Black chalk, slightly heightened with
white, on light brown paper
11.25 x 7.75 in.
Fondo Alessandro Maggiori, Biblioteca
Comunale, Monte San Giusto, Italy

Inscription: on the verso, "Ricavata dal
vivo 1790" (Made from life 1790).
Bibliography: Di Pietro, *Elenco*, p.
105; Roettgen, *Anton Raphael Mengs*,
p. 387; Roettgen, *Mengs*, p. 340;
Angelucci, *Notizie*, pp. 174–79.

5.
Anonymous artist
Profile of a woman
Black charcoal on light brown paper
8.75 x 7.25 in.
Fondo Alessandro Maggiori, Biblioteca
Comunale, Monte San Giusto, Italy

Inscription: on the verso, "Io Aless.
Maggiori acquistai in Bologna
correndo l'anno 1808" (I Aless.
Maggiori purchased it in Bologna
during the year 1808).
Bibliography: Di Pietro, *Elenco*, p. 105;
Angelucci, *Notizie*, pp. 174–79.

6.
Andrea Mainardi, called Il Chiaveghino
(born Cremona, 1550–died Cremona,
1621)
***Head of a young woman in profile to
the left***
Black chalk, with red chalk, on white
paper
3.5 x 3.25 in.
Fondo Alessandro Maggiori, Biblioteca
Comunale, Monte San Giusto, Italy

Inscriptions: on the verso, "Federico
Barocci" and "Io Aless. Maggiori
comprai in Urbino l'anno 1817" (I Aless
Maggiori bought it at Urbino in the
year 1817).
Bibliography: Di Pietro, *Elenco*, p. 108;
Angelucci, *Sotto il segno*, pp. 34–35;
Angelucci, *Notizie*, pp. 174–79.

5

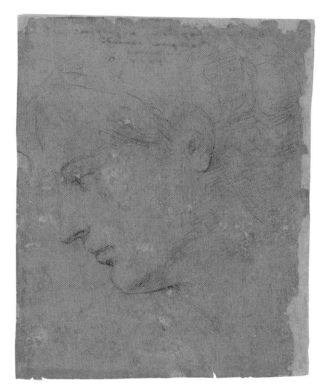

6

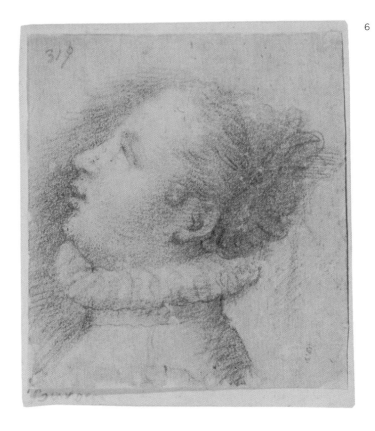

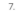

7.

7.
After Antonio Campi (born Cremona, 1524–died Cremona, 1587)
Portrait of Princess Anna of Austria
Pen and brown ink, with light brown wash, on oval light brown paper
5.75 x 4.5 in.
Fondo Alessandro Maggiori, Biblioteca Comunale, Monte San Giusto, Italy

Inscriptions: on the frame of the drawing, "ANNA MAXIMILIANI II ROM. IMP. F. PHILIPPI HISP. REG. UX. IIII"; on the verso, "Si vede questo ritratto nella storia di Cremona, e fu intagliato da Agostino" (One can find this portrait in the history of Cremona, engraved by Agostino); "Appartiene ad Alessandro Maggiori il quale lo comprò in Roma nel 1805" (It belongs to Alessandro Maggiori who bought it in Rome in 1805).
Bibliography: Di Pietro, *Elenco*, p. 104; Angelucci, *Sotto il segno*, pp. 32–33; Angelucci, *Notizie*, pp. 174–79.

2. MALE HEADS

8.
Attributed to Bartolomeo Passerotti (born Bologna, 1529–died Bologna, 1592)
Head of a man with hat
Pen and brown ink on light brown paper
3.5 x 3 in.
Fondo Alessandro Maggiori, Biblioteca Comunale, Monte San Giusto, Italy

Inscriptions: on the recto, "B. Passerotti"; on the verso, "[C]elebre Pittor Bolognese" (Famous Bolognese Painter); "Ales. Maggiori omprò in Bologna l'anno 1791" (Ales. Maggiori bought it in Bologna in the year 1791).
Bibliography: Di Pietro, *Elenco*, p. 108; Angelucci, *Notizie*, pp. 174–79.

8.

9.
Attributed to School of Guido Reni
(born Bologna, 1575–died Bologna,
1642)
Portrait of an old man
Red chalk on ivory-colored paper
6.25 x 4.5 in.
Fondo Alessandro Maggiori, Biblioteca
Comunale, Monte San Giusto, Italy

Inscriptions: on the recto, "Scuola di
Reni" (School of Reni); on the verso
"Scuola di Reni" and "Ales. Maggiori
comprò in Bologna l'anno 1789" (Ales.
Maggiori bought it in Bologna in the
year 1789).
Bibliography: Di Pietro, *Elenco*, p. 108;
Angelucci, *Notizie*, pp. 174–79.

10.
Attributed to Giuseppe Cesari, called
Il Cavalier D'Arpino (born Rome, 1568–
died Rome, 1640)
Head of a bearded man with bandage
Black and red chalk on white paper
5.25 x 4.25 in.
Fondo Alessandro Maggiori, Biblioteca
Comunale, Monte San Giusto, Italy

Inscriptions: on the recto, "Il Cav.
Cesari D'Arpin[..]" (The Knight Cesari
D'Arpin[...]); on the verso, "Appartiene
ad Ales. Maggiori il quale lo comprò
in Roma nel 1806" (It belongs to Ales.
Maggiori who bought it in Rome in
1806).
Bibliography: Di Pietro, *Elenco*, p. 107;
Angelucci, *Notizie*, pp. 174–79.

9.

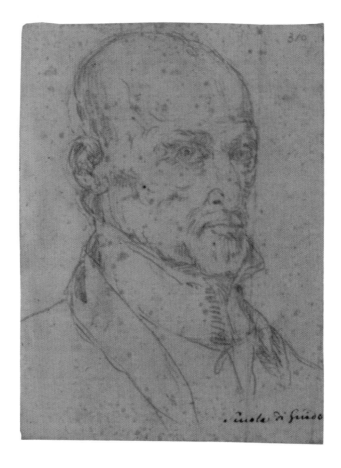

10.

11.

11.
Anonymous artist
Head of a man
Black charcoal over black and red chalk, on ivory-colored paper
11.25 x 7.75 in.
Fondo Alessandro Maggiori, Biblioteca Comunale, Monte San Giusto, Italy

Inscription: "Appartiene ad Alessandro Maggiori il quale lo comprò in Bologna il giorno 31 maggio del 1794" (It belongs to Alessandro Maggiori, whom bought it in Bologna in May 31, 1794).
Bibliography: Di Pietro, *Elenco*, p. 104; Angelucci, *Notizie*, pp. 174–79.

12.
Anonymous artist
Portrait of Sylvius Piccolominus
Black chalk on white paper
10 x 8 in.
Fondo Alessandro Maggiori, Biblioteca Comunale, Monte San Giusto, Italy

Inscriptions: on the recto, "Ritratto di Silv. Piccolomini" (Portrait of Silvio Piccolomini); on the verso, "Sylvius Piccolominus"; "A. Maggiori acquistò in Roma, correndo l'anno 1794" (A. Maggiori purchased in Rome during the year 1794).
Bibliography: Di Pietro, *Elenco*, p. 104; Angelucci, *Notizie*, pp. 174–79.

12.

13.
Carlo Bononi (born Ferrara, 1569–died Ferrara, 1632)
Head of a young man
Black charcoal on grey paper
9.25 x 7.25 in.
Fondo Alessandro Maggiori, Biblioteca Comunale, Monte San Giusto, Italy

Inscriptions: on the recto, "Il Bononi fece" (Bononi made it); on the verso, "16 Marzo 1791"; "Fu scolaro del Bascarolo, e dipinse asai [*sic*] bene sul gusto caracesco" (was a pupil of Bascarolo and painted quite well in the carraccesque taste); "Io A. Maggiori acquistai in Ferrara nel 1791" (I, A. Maggiori, purchased it in Ferrara in 1791).
Bibliography: Di Pietro, *Elenco*, p. 103; Angelucci, *Sotto il segno*, pp. 54–55; Angelucci, *Notizie*, pp. 174–79.

14.
Andrea Sacchi (born Nettuno, 1599–died Rome, 1661)
Head of an old man in profile to the right
Black charcoal over black chalk, on light brown paper
5.5 x 5 in.
Fondo Alessandro Maggiori, Biblioteca Comunale, Monte San Giusto, Italy

Inscription: on the verso, "Io A. Maggiori acquistai in Bologna nel 1792" (I A. Maggiori purchased it in Bologna in 1792).
Bibliography: Di Pietro, *Elenco*, p. 107; Angelucci, *Sotto il segno*, pp. 70–71; Angelucci, *Notizie*, pp. 174–79.

13.

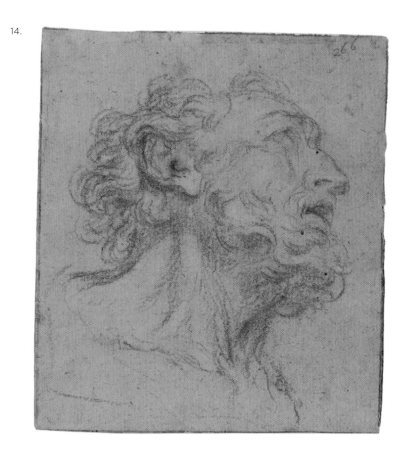

14.

15.

15.
Attributed to Giovan Francesco Gessi (born Bologna, 1588–died Bologna, 1649)
Head of an old bearded man
Black chalk with touches of brown ink, on light green paper
6 x 4.25 in.
Fondo Alessandro Maggiori, Biblioteca Comunale, Monte San Giusto, Italy

Inscriptions: on the recto, "Il Gessi fece" (Gessi made it); on the verso, "Io Aless. Maggiori acquistai in Modena nel 1790" (I Aless. Maggiori purchased it in Modena in 1790).
Bibliography: Di Pietro, *Elenco*, p. 107; Angelucci, *Notizie*, pp. 174–79.

16.
Attributed to Pier Francesco Cittadini, called Il Milanese (born Milan, 1616–died Bologna, 1681)
Head of an old man in profile to the left
Red chalk on ivory-colored paper
4 x 3.75 in.
Fondo Alessandro Maggiori, Biblioteca Comunale, Monte San Giusto, Italy

Inscriptions: on the recto, "Il Milanese"; on the verso, "Io Aless. Maggi[...] acquistai in Bologna il giorno 10 d'Ott.e del 1792" (I Aless. Maggi[...] purchased in Bologna on October 10, 1792).
Bibliography: Di Pietro, *Elenco*, p. 107; Angelucci, *Notizie*, pp. 174–79.

16.

17.
Anonymous artist
Lowering head of a man
Red chalk on ivory-colored paper
10.5 x 8.5 in.
Fondo Alessandro Maggiori, Biblioteca
Comunale, Monte San Giusto, Italy

Inscription: on the verso, "Io A.
Maggiori acquistai in Roma correndo
l'anno 1809" (I A. Maggiori purchased
it in Rome during the year 1809).
Bibliography: Di Pietro, *Elenco*, p. 104;
Angelucci, *Notizie*, pp. 174–79.

18.
Attributed to Carlo Cignani (born
Bologna, 1628–died Forlì, 1719)
Head of a boy
Red charcoal, with touches of red
chalk, on light brown paper
9.5 x 7.75 in.
Fondo Alessandro Maggiori, Biblioteca
Comunale, Monte San Giusto, Italy

Inscriptions: on the recto, "Cav. Conte
Carlo Cignani"; on the verso, "Carlo
Cignani nato a Bologna nel 1629 morto
in Forlì il 1719" (Carlo Cignani born in
Bologna in 1629, died in Forlì in 1719);
"Il Cav. Conte Carlo Cignani fece" (the
Knight Count Carlo Cignani made it);
"Io A. Maggiori acquistai in Bologna
il dì 30 de Maggio del 1792" (I A.
Maggiori purchased it in Bologna on
May 30, 1792).
Bibliography: Di Pietro, *Elenco*, p. 105;
Angelucci, *Notizie*, pp. 174–79.

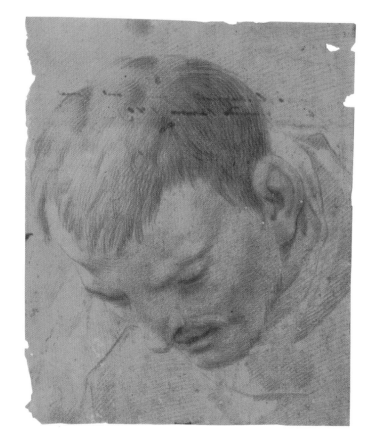

17.

18.

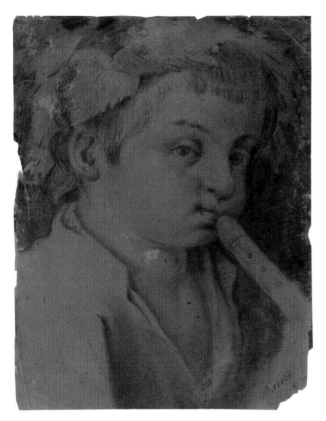

20.

19.
Attributed to Giovanni Battista Gaulli, called Il Baciccio (born Genova, 1639–died Rome, 1709)
Boy playing a flute with grape leaves around head
Black and red charcoal, with touches of black chalk, on light brown paper
10.25 x 8 in.
Fondo Alessandro Maggiori, Biblioteca Comunale, Monte San Giusto, Italy

Inscriptions: on the recto, "Bacici"; on the verso, "Ales. Maggiori comprò a Roma nel 1804" (Ales. Maggiori bought it in Rome in 1804).
Bibliography: Di Pietro, *Elenco*, p. 105; Angelucci, *Notizie*, pp. 174–79.

20.
Donato Creti (born Cremona, 1671–died Bologna, 1749)
Sheet of studies with heads
Red chalk, with touches of brown ink, on ivory-colored paper
8.5 x 7.75 in.
Fondo Alessandro Maggiori, Biblioteca Comunale, Monte San Giusto, Italy

Inscriptions: on the recto, "Donato Creti fece" (Donato Creti made it); on the verso, "Di padre bolognese nato però a Cremona si fe' pittor nella scola di Lorenzo Pasinelli" (His father was Bolognese, but he was born in Cremona where he became a painter in the school of Lorenzo Pasinelli); "Appartiene ad Aless. Maggiori il quale lo comprò in Bologna il giorno 19 Luglio dell'anno 1791" (It belongs to Aless. Maggiori who bought it in Bologna on July 19 of the year 1791).
Bibliography: Di Pietro, *Elenco*, p. 107; Angelucci, *Sotto il segno*, pp. 106–07; Angelucci, *Notizie*, pp. 174–79.

21.
Attributed to Mauro Antonio Tesi,
called Il Maurino (born Montalbano,
1730–died Bologna, 1766)
**Sheet of studies with human and
grotesque heads and two lying
figures**
Pen and brown ink on white paper
7.5 x 4.75 in.
Fondo Alessandro Maggiori, Biblioteca
Comunale, Monte San Giusto, Italy

Inscription: on the recto, "Tesi."
Bibliography: Di Pietro, *Elenco*, p. 106;
Angelucci, *Notizie*, pp. 174–79.

3. STUDIES OF CHILDREN,
PUTTI, AND ANGELS

22.
Anonymous artist
**Study of a naked child with
outstretched arms**
Red chalk, with touches of black chalk,
on blue paper
5.25 x 6.5 in.
Fondo Alessandro Maggiori, Biblioteca
Comunale, Monte San Giusto, Italy

Inscription: on the verso, "Appartiene
ad Aless. Maggiori il quale lo comprò
a Roma nel 1803" (It belongs to Aless.
Maggiori who bought it in Rome in
1803).
Bibliography: Di Pietro, *Elenco*, p. 105;
Angelucci, *Notizie*, pp. 174–79.

21.

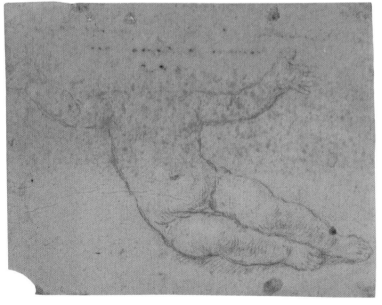

22.

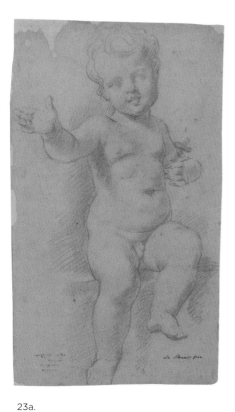

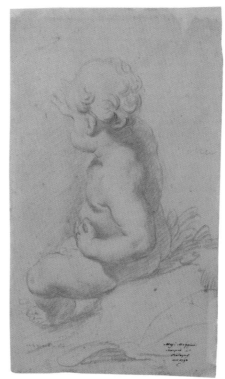

23a. 23b.

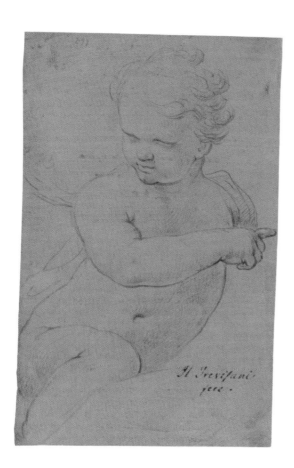

24.

23a. – 23b.
Carlo Cignani (born Bologna, 1628–died Forlì, 1719)
Baby Jesus holding a small cross (recto), **Baby Jesus seen from the rear** (verso)
Red chalk on white paper
14.5 x 8.25 in.
Fondo Alessandro Maggiori, Biblioteca Comunale, Monte San Giusto, Italy

Inscriptions: on the left lower part of the drawing is written, in brown ink, "*La Sirani fece*" (Sirani has made it); on the verso, on the right side, "Aless. Maggiori comprò a Bologna nel 1790" (Alessandro Maggiori purchased it in Bologna in 1790).
Bibliography: Di Pietro, *Elenco*, p. 103; Angelucci, *Sotto il segno*, pp. 100–01; Angelucci, *Notizie*, pp. 174–79.

24.
Attributed to Francesco Trevisani (born Capodistria, 1656–died Rome, 1746)
Putto *with a pointing hand*
Black chalk on ivory-colored paper faded light brown
10.25 x 6.5 in.
Fondo Alessandro Maggiori, Biblioteca Comunale, Monte San Giusto, Italy

Inscriptions: on the recto, "Il Trevisani fece" (Trevisani made it); on the verso, "A. Maggiori comprò in Roma l'anno 1808" (A. Maggiori bought it in Rome in the year 1808).
Bibliography: Di Pietro, *Elenco*, p. 108; Angelucci, *Notizie*, pp. 174–79.

25.
Giovanni Benedetto Castiglione, called
Il Grechetto (born Genova, 1609–died
Mantua, 1664)
**Two studies of a naked child with his
right arm raised**
Oil on dark brown paper with touches
of black ink
9.5 x 7.25 in.
Fondo Alessandro Maggiori, Biblioteca
Comunale, Monte San Giusto, Italy

Inscription: "Di Benedetto Castiglioni
detto Il Grechetto nato a Genova nel
1616, morto a Mantova nel 1670" (By
Benedetto Castiglioni, known as Il
Grechetto born in Genoa in 1616, died
in Mantua in 1670).
Bibliography: Di Pietro, *Elenco*, p. 108;
Angelucci, *Notizie*, pp. 174–79.

26.
Anonymous artist (Roman School,
beginning of 18th century)
**Two winged putti and sketch of a
head**
Black chalk, with touches of red chalk,
on ivory-colored paper faded light
brown
7.25 x 6 in.
Fondo Alessandro Maggiori, Biblioteca
Comunale, Monte San Giusto, Italy

Inscriptions: on the recto, "Il Cantarini
fece" (Catarini made it); "Aless.
Maggiori comprò in Pesaro il giorno
9 di Marzo del 1817" (Aless. Maggiori
bought it in Pesaro the day 9 of March
of 1817).
Bibliography: Di Pietro, *Elenco*, p. 108;
Angelucci, *Sotto il segno*, pp. 98–99;
Angelucci, *Notizie*, pp. 174–79.

25.

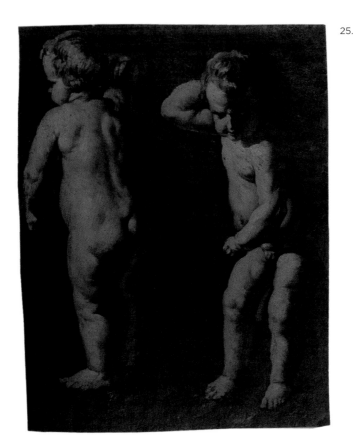

26.

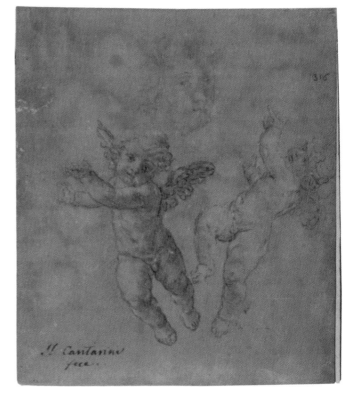

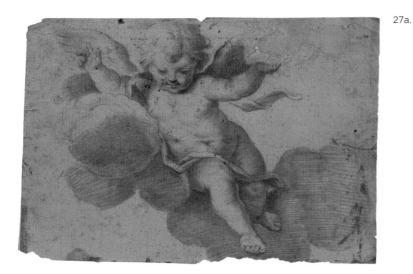

27a.

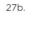

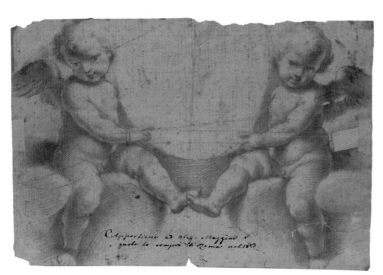

27b.

27a. – 27b.
Anonymous artist
Flying angel (recto), *Two angels holding a medallion* (verso)
Red chalk on ivory-colored paper
7 x 10.25 in.
Fondo Alessandro Maggiori, Biblioteca Comunale, Monte San Giusto, Italy

Inscription: on the verso, "Appartiene ad Aless. Maggiori il quale lo comprò in Roma nel 1803" (It belongs to Aless. Maggiori who bought it in Rome in 1803).
Bibliography: Di Pietro, *Elenco*, p. 107; Angelucci, *Notizie*, pp. 174–79.

28.
Fabrizio Boschi (born Florence, 1572–died Florence, 1642)
Study for a frieze with the coat of arms of the Pucci Family
Red chalk and red charcoal on ivory-colored paper
5 x 9.75 in.
Fondo Alessandro Maggiori, Biblioteca Comunale, Monte San Giusto, Italy

Inscription: "A. Maggiori comprò in Bologna il giorno 30 di maggio del 1792" (A. Maggiori bought it in Bologna on May 30, 1792).
Bibliography: Di Pietro, *Elenco*, p. 106; Angelucci, *Sotto il segno*, pp. 58–59; Angelucci, *Notizie*, pp. 174–79.

28.

29.
Anonymous artist
Seated boy eating beans from a bowl
Black chalk on ivory-colored paper
4.75 x 3.5 in.
Fondo Alessandro Maggiori, Biblioteca
Comunale, Monte San Giusto, Italy

Inscription: on the verso, "A. Magg[...]
R[...]a l'anno 17[9]2" (A. Magg[iori]
R[om]e year 17[9]2).
Bibliography: Di Pietro, *Elenco*, p. 108;
Angelucci, *Notizie*, pp. 174–79.

4. ANATOMICAL STUDIES —
HANDS

30.
Giacomo Cavedone (born Sassuolo,
1577–died Bologna, 1660)
Study of a hand holding a drapery
Black chalk on light brown paper
8.75 x 5.75 in.
Fondo Alessandro Maggiori, Biblioteca
Comunale, Monte San Giusto, Italy

Bibliography: Di Pietro, *Elenco*, p. 106;
Angelucci, *Notizie*, pp. 174–79.

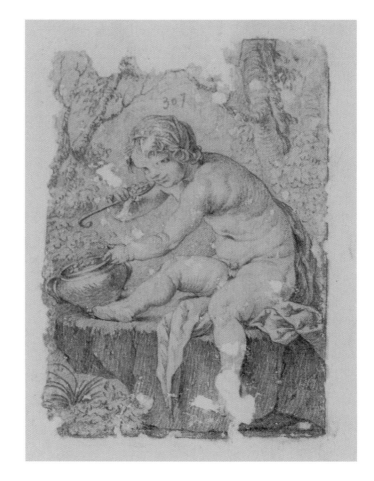

29.

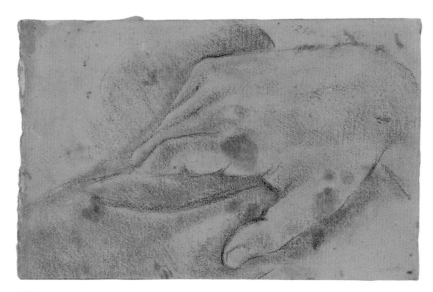

30.

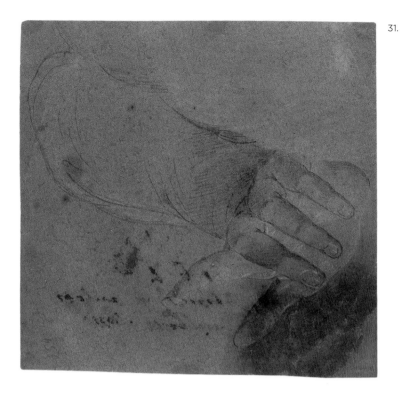

31.

31.
Carlo Bononi (born Ferrara, 1569–died Ferrara, 1632)
Study of an outstretched hand
Black chalk, black charcoal, slightly heightened with white chalk, on blue-grey paper
6.5 x 6.75 in.
Fondo Alessandro Maggiori, Biblioteca Comunale, Monte San Giusto, Italy

Inscription: on the verso, "Aless. Maggiori comprò in Bologna nel 1791" (Aless. Maggiori bought in Bologna in 1791).
Bibliography: Di Pietro, *Elenco*, p. 106; Angelucci, *Sotto il segno*, pp. 56–57; Angelucci, *Notizie*, pp. 174–79.

32.
Attributed to Elisabetta Sirani (born Bologna, 1638–died Bologna, 1665)
Study of a right arm raised and holding an apple
Red chalk on light brown paper
7.25 x 6.5 in.
Fondo Alessandro Maggiori, Biblioteca Comunale, Monte San Giusto, Italy

Inscriptions: on the recto, "La Sirani fece" (Sirani made it); on the verso, "Aless. Maggiori comprò a Bologna nel 1789" (Aless. Maggiori bought it in Bologna in 1789).
Bibliography: Di Pietro, *Elenco*, p. 104; Angelucci, *Notizie*, pp. 174–79.

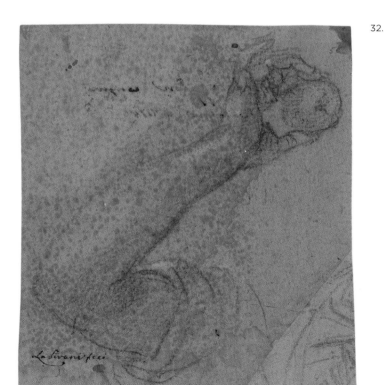

32.

5. ANATOMICAL STUDIES —
TORSOS

33.
Domenico Zampieri, called Il
Domenichino (born Bologna, 1581–died
Naples, 1641)
Figure with right arm raised (recto),
Study of drapery (verso)
Black charcoal, with touches of white
charcoal, on grey-blue paper
5.5 x 5 in.
Fondo Alessandro Maggiori, Biblioteca
Comunale, Monte San Giusto, Italy

Inscriptions: on the recto, "Bartolomeo
Cesi fece" (Bartolomeo Cesi made
it); on the verso, "Appartiene ad
Alessandro Maggiori il quale lo comprò
in Bologna nel 1789" (It belongs to
Alessandro Maggiori who bought it in
Bologna in 1789).
Bibliography: Di Pietro, *Elenco*, p. 107;
Angelucci, *Notizie*, pp. 174–79.

34.
Attributed to Lodovico Carracci (born
Bologna, 1555–died Bologna, 1619)
Seated woman looking backward
Red chalk and red charcoal on ivory-
colored paper
4 x 5 in.
Fondo Alessandro Maggiori, Biblioteca
Comunale, Monte San Giusto, Italy

Inscriptions: on the verso, "Carazza"
[*sic*], "una detta Lasciva di Lodovico"
(a certain Lascivious Woman by
Lodovico [Carracci]); "Appartiene ad
Alessandro Maggiori" (It belongs to
Alessandro Maggiori), "Bologna 19
Maggio 1796" (Bologna, May 19, 1796).
Bibliography: Di Pietro, *Elenco*, p. 108;
Angelucci, *Notizie*, pp. 174–79.

33.

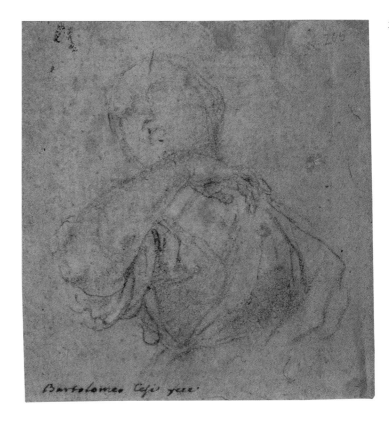

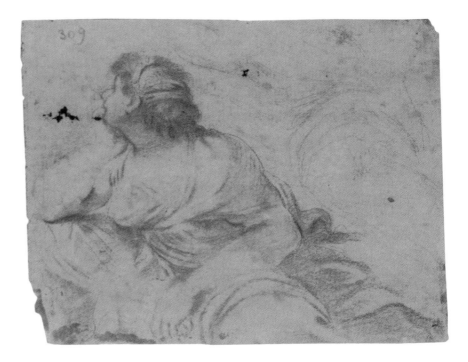

34.

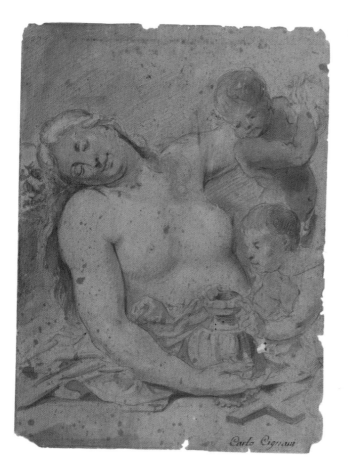

35.
Attributed to Carlo Cignani (born Bologna, 1628–died Forlì, 1719)
Half-length figure of a naked Magdalene with bowl, rosary, and cross, and surrounded by two infants
Red chalk, with touches of red charcoal, on light brown paper
10.75 x 7.75 in.
Fondo Alessandro Maggiori, Biblioteca Comunale, Monte San Giusto, Italy

Inscriptions: on the recto, "Carlo Cignani"; on the verso, "Io Aless. Maggiori comprai in Roma nel 1801" (I Aless. Maggiori bought it in Rome in 1801).
Bibliography: Di Pietro, *Elenco*, p. 107; Angelucci, *Notizie*, pp. 174–79.

36.
Anonymous artist
Dead Christ
Red chalk on light brown paper
7 x 5.25 in.
Fondo Alessandro Maggiori, Biblioteca Comunale, Monte San Giusto, Italy

Bibliography: Di Pietro, *Elenco*, p. 103; Angelucci, *Notizie*, pp. 174–79.

36.

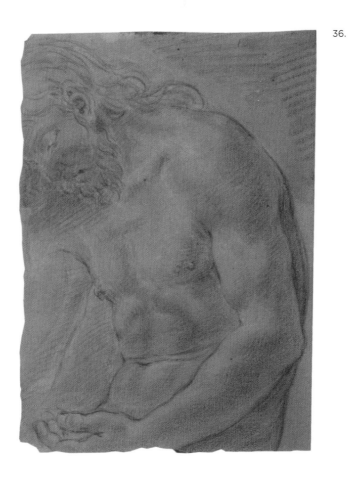

37.
Giovanni Francesco Barbieri, called
Il Guercino (born Cento, 1591–died
Bologna, 1666)
Male figure with left arm raised
Black charcoal, with touches of brown
ink, on light brown paper
7.25 x 8.75 in.
Fondo Alessandro Maggiori, Biblioteca
Comunale, Monte San Giusto, Italy

Inscriptions: on the recto, "Scuola
Bolognese" (Bolognese school); on the
verso, "Alessandro Maggiori comprò
a Bologna nel 1792" (Alessandro
Maggiori bought it in Bologna in 1792).
Bibliography: Di Pietro, *Elenco*, p. 105;
Angelucci, *Sotto il segno*, pp. 50–51;
Angelucci, *Notizie*, pp. 174–79.

38.
Anonymous artist
***Half-length naked figure looking
backward and reclining with joined
hands***
Black chalk on light brown paper
4 x 4 in.
Fondo Alessandro Maggiori, Biblioteca
Comunale, Monte San Giusto, Italy

Inscriptions: on the verso, "Questa
figura si vede dipinta nella tavola
maggiore al Suffragio del Porto di
Fermo" (This figure is painted in the
main altar of the [Church of the]
Suffragio in the Harbor of Fermo);
"Aless. Maggiori comprò in Roma nel
1806" (Aless. Maggiori bought it in
Rome in 1806).
Bibliography: Di Pietro, *Elenco*, p. 108;
Angelucci, *Notizie*, pp. 174–79.

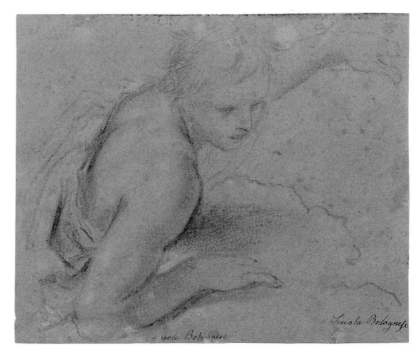

37.

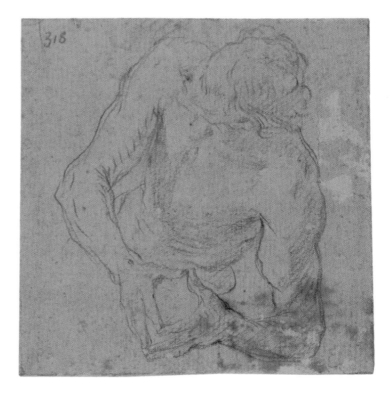

38.

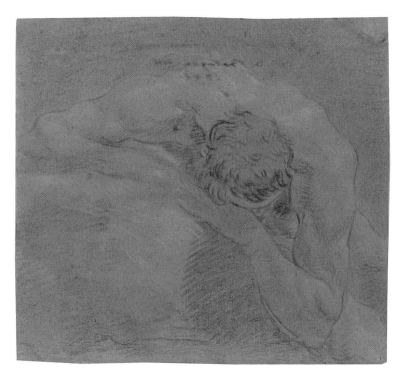

39.

40.

39.
Giuseppe Varotti (born Bologna, 1715–died Bologna, 1780)
Study of a reclining figure with lowered head
Black charcoal, slightly heightened with white charcoal, on light brown paper
7 x 7.75 in.
Fondo Alessandro Maggiori, Biblioteca Comunale, Monte San Giusto, Italy

Inscription: on the verso, "Io Aless. Maggiori comprai a Bologna nel 1791" (I Aless. Maggiori bought it in Bologna in 1791).
Bibliography: Di Pietro, *Elenco*, p. 104; Angelucci, *Sotto il segno*, pp. 104–05; Angelucci, *Notizie*, pp. 174–79.

40.
Anonymous artist
Standing naked man holding a stick
Red charcoal on ivory-colored paper faded light brown
10.5 x 7.25 in.
Fondo Alessandro Maggiori, Biblioteca Comunale, Monte San Giusto, Italy

Inscription: on the verso, "Appartiene ad Alessandro Maggiori il quale lo comprò in Roma nel 1809" (It belongs to Alessandro Maggiori who bought it in Rome in 1809).
Bibliography: Di Pietro, *Elenco*, p. 107; Angelucci, *Notizie*, pp. 174–79.

6. ANATOMICAL STUDIES — BODIES IN ACTION

41a. – 41b.
Anonymous artist
Study of a naked young man pulling
(recto), ***Study of drapery*** (verso)
Red chalk, with touches of red
charcoal, on light brown paper
8.25 x 7 in.
Fondo Alessandro Maggiori, Biblioteca
Comunale, Monte San Giusto, Italy

Inscription: on the verso, at the center
of upper part of the sheet, "Aless.
Maggiori comprò a Roma l'anno 1816"
(Aless. Maggiori bought it in Rome in
the year 1816).
Bibliography: Di Pietro, *Elenco*, p. 104;
Angelucci, *Notizie*, pp. 174–79.

42.
Anonymous artist
Standing male figure in action
Black charcoal on ivory-colored paper
7 x 4.25 in.
Fondo Alessandro Maggiori, Biblioteca
Comunale, Monte San Giusto, Italy

Inscription: on the verso, "Ales.
Maggiori comprò in Bologna nel 1794"
(Ales. Maggiori bought it in Bologna
in 1794).
Bibliography: Di Pietro, *Elenco*, p. 105;
Angelucci, *Notizie*, pp. 174–79.

41a.

41b.

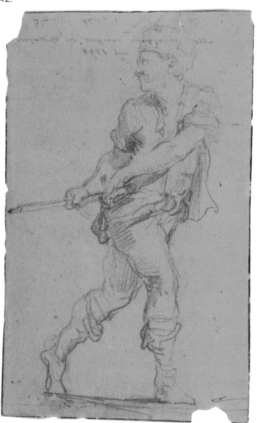

42.

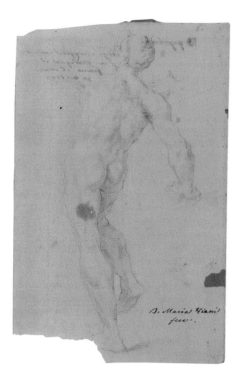

43a.　　　　　　　　　　　　43b.

43a. – 43b.
Attributed to Domenico Maria Viani (born Bologna, 1668–died Pistoia, 1711)
Study of a naked man moving (recto), **Sheet of studies with four male figures** (verso)
Black chalk on white paper
9.25 x 5.75 in.
Fondo Alessandro Maggiori, Biblioteca Comunale, Monte San Giusto, Italy

Inscriptions: on the recto, "D. Maria Viani fece" (D. Maria Viani made it); on the verso, "Ales. Maggiori comprò in Bologna il giorno 16 marzo del 1792" (Ales. Maggiori bought it in Bologna on March 16, 1792).
Bibliography: Di Pietro, *Elenco*, p. 105; Angelucci, *Notizie*, pp. 174–79.

44.
Attributed to Elisabetta Sirani (born Bologna, 1638–died Bologna, 1665)
Naked figure seen from the rear
Black charcoal on white paper
9.5 x 5.25 in.
Fondo Alessandro Maggiori, Biblioteca Comunale, Monte San Giusto, Italy

Inscriptions: on the recto, "La Sirani fece" (Sirani made it); on the verso, "Aless. Maggiori comprò a […] 1791" (Aless. Maggiori bought it in […] 1791).
Bibliography: Di Pietro, *Elenco*, p. 105; Angelucci, *Notizie*, pp. 174–79.

44.

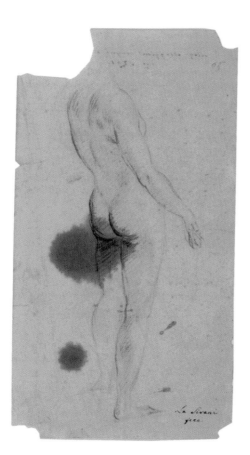

45.
Follower of Ubaldo Gandolfi (born
San Matteo della Decima, 1728–died
Ravenna, 1781) or Gaetano Gandolfi
(born San Matteo della Decima, 1734–
died Bologna, 1802)
Standing naked woman
Black charcoal on light brown paper
11.75 x 5.5 in.
Fondo Alessandro Maggiori, Biblioteca
Comunale, Monte San Giusto, Italy

Inscription: "Io Aless. Maggiori comprai
a Bologna il giorno 9 d'Ott.e del 1792"
(I Aless. Maggiori bought it in Bologna
on the 9 of October 1792).
Bibliography: Di Pietro, *Elenco*, p. 105;
Angelucci, *Sotto il segno*, pp. 112–13;
Angelucci, *Notizie*, pp. 174–79.

7. STUDIES OF DRAPERY
AND FIGURES *ALL'ANTICA*

46a. – 46 b.
Anonymous artist
*Study of two figures wearing classical
drapery* (recto),
*Study of a naked man seen from the
rear with his right leg
raised and study of a draped figure*
(verso)
Pen and brown ink on ivory-colored
paper
7.75 x 5.75 in.
Fondo Alessandro Maggiori, Biblioteca
Comunale, Monte San Giusto, Italy

Inscription: "Alessa. Maggiori comprò
in Bologna li 26 Xbre 1796" (Aless.
Maggiori bought it in Bologna on
October 26, 1796).
Bibliography: Di Pietro, *Elenco*, p. 104;
Angelucci, *Notizie*, pp. 174–79.

45.

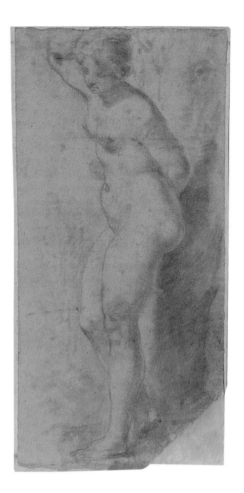

46a.

46b.

47.

47.
Attributed to Guido Reni (born
Bologna, 1575–died Bologna, 1642)
Study of drapery
Red chalk, with red charcoal, on light
brown paper
8.75 x 9.25 in.
Fondo Alessandro Maggiori, Biblioteca
Comunale, Monte San Giusto, Italy

Inscriptions: on the verso, "Guido Reni
fece" (Guido Reni made it); "Aless.
Maggiori comprò a Bologna nel 1790"
(Aless. Maggiori bought in Bologna in
1790).
Bibliography: Di Pietro, *Elenco*, p. 104;
Angelucci, *Notizie* , pp. 174–79.

48.
Attributed to Pompeo Batoni (born
Lucca, 1708–died Rome, 1787)
Study of drapery (recto), *Fragment of
architectural design* (verso)
Red charcoal and white chalk on light
brown paper faded grey
6.75 x 7.25 in.
Fondo Alessandro Maggiori, Biblioteca
Comunale, Monte San Giusto, Italy

Inscription: on the verso, "Aless.
Maggiori comprò a Roma nel 1808"
(Aless. Maggiori bought it in Rome in
1808).
Bibliography: Di Pietro, *Elenco*, p. 104;
Angelucci, *Notizie*, pp. 174–79.

48.

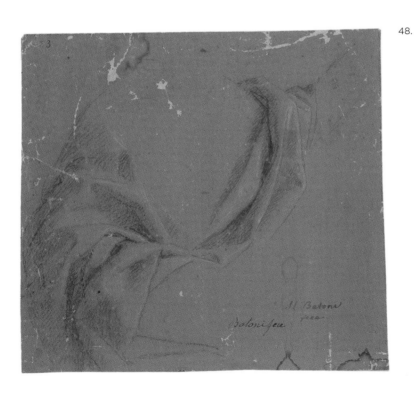

49a. – 49b.
Attributed to Elisabetta Sirani (born
Bologna, 1638–died Bologna, 1665)
**Three-quarter-length study of an
ecclesiastic** (recto), **Study of an
ecclesiastic** (verso)
Black charcoal, with touches of black
chalk, on light brown paper
6.5 x 6.25 in.
Fondo Alessandro Maggiori, Biblioteca
Comunale, Monte San Giusto, Italy

Inscriptions: on the right side, "La
Sirani fece" (Sirani made it); on the left
side of the verso, "A. Maggiori comprò
in Bologna nel 1791" (A. Maggiori
bought it in Bologna in 1791).
Bibliography: Di Pietro, *Elenco*, p. 104;
Angelucci, *Notizie*, pp. 174–79.

50a. – 50b.
Bartolomeo Cesi (born Bologna, 1556–
died Bologna, 1629)
Standing youth playing a flute (recto),
**Studies of a standing figure, a head,
and legs** (verso)
Red and white chalk on blue-grey
paper
9.25 x 7.25 in.
Fondo Alessandro Maggiori, Biblioteca
Comunale, Monte San Giusto, Italy

Inscriptions: on the recto, "B. Cesi
fece" (B. Cesi made it); "Aless.
Maggiori comprò in Bologna nel 1795"
(Aless. Maggiori bought it in Bologna
nel 1795).
Bibliography: Di Pietro, *Elenco*, p. 108;
Angelucci, *Sotto il segno*, pp. 44–45;
Angelucci, *Notizie*, pp. 174–79.

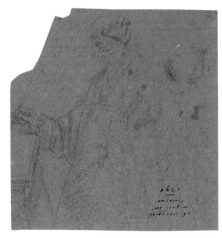

49a.

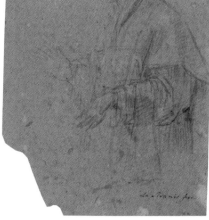

49b.

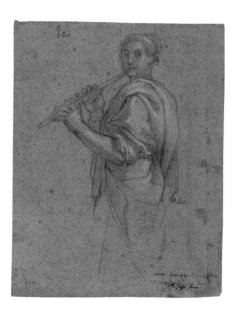

50a.

50b.

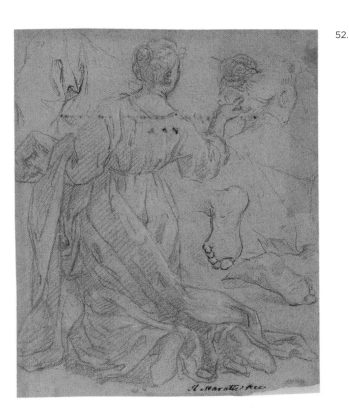

51.

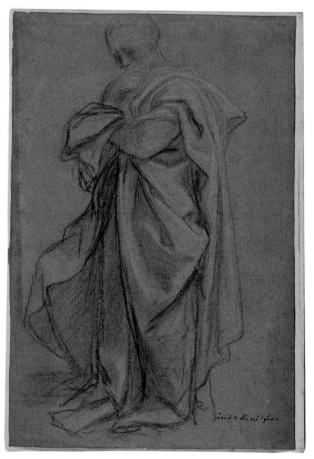

51.
Follower of Carlo Maratti (born
Camerano, 1625–died Rome, 1713)
***Standing figure wearing classical
drapery (study for a saint?)***
Black and white chalk on blue-grey
paper
12 x 7.75 in.
Fondo Alessandro Maggiori, Biblioteca
Comunale, Monte San Giusto, Italy

Inscriptions: on the recto, "Guido Reni
fece" (Guido Reni made it); on the
verso, "Io Aless. Maggiori comprai in
Bologna il giorno 30 d'aprile del 1792"
(I Aless. Maggiori bought it in Bologna
on April 30, 1792).
Bibliography: Di Pietro, *Elenco*, p. 105;
Angelucci, *Sotto il segno*, pp. 84–85;
Angelucci, *Notizie*, pp. 174–79.

52.
Follower of Carlo Maratti (born
Camerano, 1625–died Rome, 1713)
***Kneeling female figure seen from the
rear and studies of feet, a head, and
drapery***
Red and black chalk, with touches of
white chalk, on light blue paper
9.75 x 8 in.
Fondo Alessandro Maggiori, Biblioteca
Comunale, Monte San Giusto, Italy

Inscriptions: on the recto, "Il Maratti
fece" (Maratti made it); on the verso,
"A. Maggiori acquistò in Roma nel
1807" (A. Maggiori purchased it in
Rome in 1807).
Bibliography: Di Pietro, *Elenco*, p. 105;
Angelucci, *Sotto il segno*, pp. 82–83;
Angelucci, *Notizie*, pp. 174–79.

52.

53.
Antonio Cantimori, called Il Visacci
(born Urbino, 1550–died Urbino, 1620)
***Seated woman wearing classical
drapery***
Black chalk, black and red charcoal on
ivory-colored paper
11 x 7 in.
Fondo Alessandro Maggiori, Biblioteca
Comunale, Monte San Giusto, Italy

Inscription: on the verso, "Io Aless.
Maggiori comprai a Roma nel 1803" (I
Aless. Maggiori bought it in Rome in
1803).
Bibliography: Di Pietro, *Elenco*, p. 104;
Angelucci, *Sotto il segno*, pp. 64–65;
Angelucci, *Notizie*, pp. 174–79.

54.
Francesco Trevisani (born Capodistria,
1656–died Rome, 1746)
Study for a Virgin with sleeping child
Black chalk, with touches of black
charcoal, on ivory-colored paper
8.25 x 9.75 in.
Fondo Alessandro Maggiori, Biblioteca
Comunale, Monte San Giusto, Italy

Inscriptions: on the recto, "Il Trevisani
fece" (Trevisani made it); on the verso,
"Aless. Maggiori comprò in Roma
l'anno 1809" (Aless. Maggiori bought it
in Rome in the year 1809).
Bibliography: Di Pietro, *Elenco*, p. 106;
Angelucci, *Sotto il segno*, pp. 76–77;
Angelucci, *Notizie*, pp. 174–79.

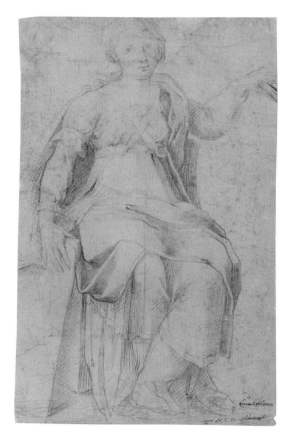

53.

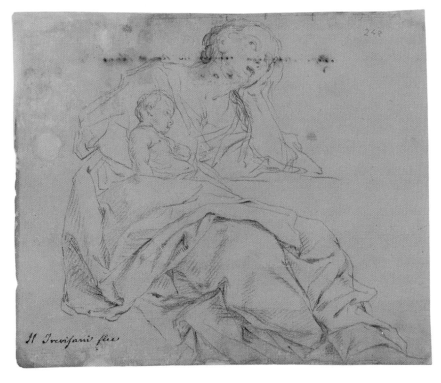

54.

55a.

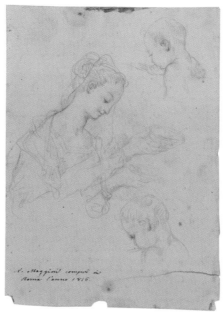

55b.

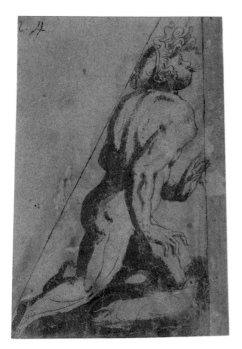

56a.

56b.

55a. – 55b.
Anonymous Artist
Studies for a woman feeding a child
(recto and verso)
Black chalk on ivory-colored paper
8.5 x 6 in.
Fondo Alessandro Maggiori, Biblioteca
Comunale, Monte San Giusto, Italy

Inscription: on the left lower side of
the verso, "A. Maggiori comprò in
Roma l'anno 1816" (A. Maggiori bought
it in Rome in the year 1816).
Bibliography: Di Pietro, *Elenco*, p. 103;
Angelucci, *Notizie*, pp. 174–79.

8. MYTHOLOGICAL THEMES

56a. – 56b.
Giorgio Vasari (born Arezzo, 1511–died
Florence, 1574)
Kneeling male nude blowing (recto),
**Seated woman holding a stick (?)
with a lion** (verso)
Pen and brown ink, with brush drawing
in brown ink, on blue-grey paper
6.5 x 4.25 in.
Fondo Alessandro Maggiori, Biblioteca
Comunale, Monte San Giusto, Italy

Inscription: on the verso, "D'Alessandro
Maggiori il quale lo comprò in [...] nel
1794" (Of Alessandro Maggiori who
bought it in [...] in 1794).
Bibliography: Di Pietro, *Elenco*, p. 106;
Angelucci, *Sotto il segno*, pp. 24–25;
Angelucci, *Notizie*, pp. 174–79.

57.
Anonymous artist (Bolognese School, beginning 18th century)
Neptune in his chariot drawn by sea-horses, accompanied by Tritons and Nereids
Black chalk on white paper
4.5 x 4.75 in.
Fondo Alessandro Maggiori, Biblioteca Comunale, Monte San Giusto, Italy

Bibliography: Di Pietro, _Elenco_, p. 107; Angelucci, _Sotto il segno_, pp. 108–09; Angelucci, _Notizie_, pp. 174–79.

58.
Antonio Consetti (born Modena, 1686–died Modena, 1766)
Zeus and Io surprised by Juno in her chariot drawn by peacocks
Red chalk, red charcoal and brush drawing in light brown ink on ivory-colored paper
11 x 8.5 in.
Fondo Alessandro Maggiori, Biblioteca Comunale, Monte San Giusto, Italy

Inscriptions: on the recto, "Andrea Sacchi fece" (Andrea Sacchi made it); on the verso, "Appartiene ad Alessandro Maggiori il quale lo comprò in Roma nel 1803" (It belongs to Alessandro Maggiori who bought it in Rome in 1803).
Bibliography: Di Pietro, _Elenco_, p. 105; Angelucci, _Sotto il segno_, pp. 102–03; Angelucci, _Notizie_, pp. 174–79.

58.

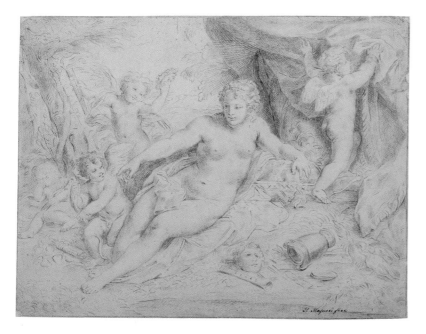

59.

60a.

60b.

59.
Anonymous artist (Roman School, beginning 18th century)
Composition with Venus on a bed surrounded by four winged putti
Black chalk, squared in black chalk, on white paper
11.75 x 15.5 in.
Fondo Alessandro Maggiori, Biblioteca Comunale, Monte San Giusto, Italy

Inscriptions: "Il Masucci fece" (Masucci made it); "Alessandro Maggiori comprò in Napoli l'anno 1807" (Alessandro Maggiori bought it in Naples in the year 1807).
Bibliography: Di Pietro, *Elenco*, p. 104; Angelucci, *Sotto il segno*, pp. 86–87; Angelucci, *Notizie*, pp. 174–79.

60a. – 60b.
Anonymous artist
Study for a composition with Venus kissing Cupid (recto), *Head of a male figure and studies of drapery* (verso)
Red chalk on ivory-colored paper
4.5 x 6 in.
Fondo Alessandro Maggiori, Biblioteca Comunale, Monte San Giusto, Italy

Inscription: on the verso, "Io Aless. Maggiori comprai a Roma nel 1816" (I Aless. Maggiori bought it in Rome in 1816).
Bibliography: Di Pietro, *Elenco*, p. 103; Angelucci, *Notizie*, pp. 174–79.

61.
Giovanni Paolo Melchiorri (born Rome,
1664–died Rome, 1745)
**Ceres with a winged putto *carrying a
sheaf of wheat***
Black chalk on white paper
10 x 8.5 in.
Fondo Alessandro Maggiori, Biblioteca
Comunale, Monte San Giusto, Italy

Inscriptions: on the recto in brown
ink, "Masucci;" on the verso, "G. P.
Melchior" in the upper part; on the
lower corner, "Masucci" and "Aless.
Maggiori comprò in Roma l'anno 1805"
(Aless. Maggiori bought it in Rome in
the year 1805).
Bibliography: Di Pietro, *Elenco*, p. 103;
Angelucci, *Sotto il segno*, pp. 78–79;
Angelucci, *Notizie*, pp. 174–79.

62.
Giovanni Paolo Melchiorri (born Rome,
1664–died Rome, 1745)
Naiad
Black chalk on white paper
6.75 x 7.5 in.
Fondo Alessandro Maggiori, Biblioteca
Comunale, Monte San Giusto, Italy

Inscriptions: on the recto, "Massucci";
on the verso, "Aless. Maggiori comprò
in Roma l'anno 1803" (Aless. Maggiori
bought it in Rome in the year 1803).
Bibliography: Di Pietro, *Elenco*, p. 105;
Angelucci, *Sotto il segno*, pp. 80–81;
Angelucci, *Notizie*, pp. 174–79.

61.

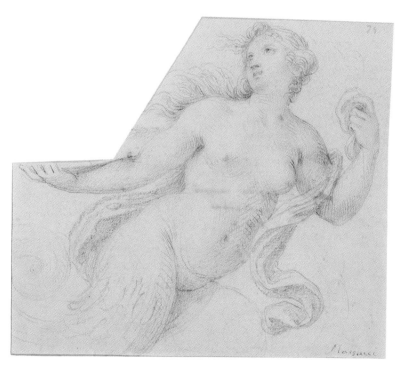

62.

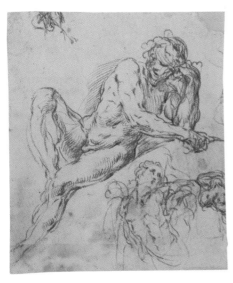

63a.

63b.

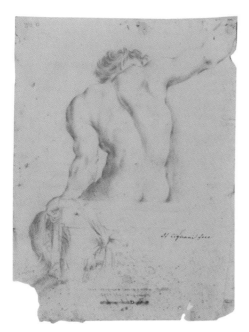

64a.

64b.

63a. – 63b.
Giulio Cesare Procaccini (born Bologna, 1574–died Milan, 1625)
Study of a reclining figure (faun?) and half-length standing figure (recto), *Studies of figures, an arm, and religious scene (Flight into Egypt?)* (verso)
Red chalk, with touches of red charcoal, on ivory-colored paper
9.25 x 7.75 in.
Fondo Alessandro Maggiori, Biblioteca Comunale, Monte San Giusto, Italy

Inscription: on the verso, at the center of the sheet but upside down, "Aless. Maggiori comprò a Roma nel 1795" (Aless. Maggiori bought it in Rome in 1795).
Bibliography: Di Pietro, *Elenco*, p. 103; Angelucci, *Sotto il segno*, pp. 36–37; Angelucci, *Notizie*, pp. 174–79.

64a. – 64b.
Attributed to Carlo Cignani (born Bologna, 1628–died Forlì, 1719)
Seated faun seen from the rear with outstretched arm (recto), *Leaping faun seen from the rear with outstretched arms* (verso)
Red chalk on ivory-colored paper
9.25 x 6.75 in.
Fondo Alessandro Maggiori, Biblioteca Comunale, Monte San Giusto, Italy

Inscriptions: on the recto, "Il Cignani fece" (Cignani made it); on the verso, "Aless. Maggiori comprò in Bologna nel 1793" (Aless. Maggiori bought it Bologna in 1793).
Bibliography: Di Pietro, *Elenco*, p. 108; Angelucci, *Notizie*, pp. 174–79.

65.
Pietro Bonaccorsi, called Perin del Vaga (born Florence, 1501–died Rome, 1547)
Two studies for spiral ornaments with figures
Pen and brown ink, over black chalk, on white paper
7.75 x 6 in.
Fondo Alessandro Maggiori, Biblioteca Comunale, Monte San Giusto, Italy

Inscription: on the central upper part of the verso, "Aless. Maggiori comprò in Roma l'anno 1805" (Aless. Maggiori bought it in Rome in the year 1805).
Bibliography: Di Pietro, *Elenco*, p. 103; Angelucci, *Sotto il segno*, pp. 20–22; Angelucci, *Notizie*, pp. 174–79.

66.
Pietro Bonaccorsi, called Perin del Vaga (born Florence, 1501–died Rome, 1547)
Study for spiral ornaments with figures and frieze
Pen and brown ink, over black chalk, on white paper
5.75 x 8.25 in.
Fondo Alessandro Maggiori, Biblioteca Comunale, Monte San Giusto, Italy

Inscription: at the center of the upper part on the verso, "Aless.o Maggiori comprò in Roma l'anno 1805" (Aless.o Maggiori bought it in the year 1805).
Bibliography: Di Pietro, *Elenco*, p. 103; Angelucci, *Sotto il segno*, pp. 20–23; Angelucci, *Notizie*, pp. 174–79.

65.

66.

67.

67.
Mauro Antonio Tesi, called Il Maurino
(born Montalbano, 1730–died Bologna,
1766)
Study for a ceiling
Pen and brown ink, with touches of
red chalk, on white paper
7.5 x 11.75 in.
Fondo Alessandro Maggiori, Biblioteca
Comunale, Monte San Giusto, Italy

Bibliography: Di Pietro, *Elenco*, p. 106;
Angelucci, *Sotto il segno*, pp. 110–11;
Angelucci, *Notizie*, pp. 174–79.

68.
Anonymous artist (Roman School, 17th
century)
Study of Mercury
Black chalk and black charcoal on grey
paper
15.5 x 11.75 in.
Fondo Alessandro Maggiori, Biblioteca
Comunale, Monte San Giusto, Italy

Bibliography: Angelucci, *Sotto il segno*,
p. 86; Angelucci, *Notizie*, pp. 174–79.

68.

9. RELIGIOUS THEMES AND COMPOSITIONS

69.
Anonymous artist (Roman School, 17th century)
Monstrance
Pen and brown ink, over black chalk, on white paper
15.5 x 11.75 in.
Fondo Alessandro Maggiori, Biblioteca Comunale, Monte San Giusto, Italy

Inscription: "[...]ssandro Maggiori comprò in Napoli l'anno 1807" (...ssandro Maggiori bought it in Naples in the year 1807).
Bibliography: Angelucci, *Sotto il segno*, p. 86; Angelucci, *Notizie*, pp. 174–79.

70a. – 70b.
Giovanni Battista Salvi, called Il Sassoferrato (born Sassoferrato, 1609–died Rome, 1685)
S. Michael fighting against the Dragon (recto), ***Head of a woman*** (verso)
Black chalk and black charcoal, squared in black chalk, on blue-grey paper
15 x 10.75 in.
Fondo Alessandro Maggiori, Biblioteca Comunale, Monte San Giusto, Italy

Inscriptions: on the recto, "Sassoferrato fece" (Sassoferrato made it); "Appartiene ad Aless. Maggiori il quale lo comprò in Roma nel 1803" (It belongs to Aless. Maggiori who bought it in Rome in 1803).
Bibliography: Ricci 1834, p. 437; Di Pietro, *Elenco*, p. 106; Angelucci, *Sotto il segno*, pp. 62–63; Angelucci, *Notizie*, pp. 174–79.

70a.

70b.

71.

71.
School of Giovanni Baglione (born Rome, ca. 1573–died Rome, 1644)
Resurrection of Christ
Pen and brown ink, red chalk with touches of black chalk, on ivory-colored paper
9.75 x 7.25 in.
Fondo Alessandro Maggiori, Biblioteca Comunale, Monte San Giusto, Italy

Inscriptions: on the recto, "Il cav, d'Arpino fece" (The knight d'Arpino made it); on the verso, "Io Aless. Maggiori comprai in Roma nel 1802" (I Aless. Maggiori bought it in Rome in 1802).
Bibliography: Di Pietro, *Elenco*, p. 107; Angelucci, *Sotto il segno*, pp. 68–69; Angelucci, *Notizie*, pp. 174–79.

72.
Andrea Pozzo (born Trento, 1642–died Vienna, Austria, 1709)
S. Ignazio of Loyola freeing a possessed person
Pen and brown ink, over black chalk, squared in black chalk, on white paper
13 x 7.75 in.
Fondo Alessandro Maggiori, Biblioteca Comunale, Monte San Giusto, Italy

Inscription: on the right side of the verso, in brown ink, "Io Aless. Maggiori comprai a Roma nel 1802" (I, Aless. Maggiori bought it in Rome in 1802).
Bibliography: Di Pietro, *Elenco*, p. 103; Angelucci, *Sotto il segno*, pp. 88–89; Angelucci, *Notizie*, pp. 174–79.

72.

10. STUDIES OF ANIMALS

73.
School of Federico Barocci (born Urbino, ca. 1528–died Urbino, 1612)
Study of a donkey
Black chalk on blue-grey paper
9 x 7 in.
Fondo Alessandro Maggiori, Biblioteca Comunale, Monte San Giusto, Italy

Bibliography: Di Pietro, *Elenco*, p. 104; Angelucci, *Sotto il segno*, pp. 30–31; Angelucci, *Notizie*, pp. 174–79.

74.
Anonymous artist
Study of an ox (recto), ***Detail of a draped female figure*** (verso)
Red chalk on ivory-colored paper
8.5 x 7.25 in.
Fondo Alessandro Maggiori, Biblioteca Comunale, Monte San Giusto, Italy

Inscription: on the verso, "Aless. Maggiori comprò a Roma nel 1803" (Aless. Maggiori bought it in Rome in 1803).
Bibliography: Di Pietro, *Elenco*, p. 105; Angelucci, *Notizie*, pp. 174–79.

73.

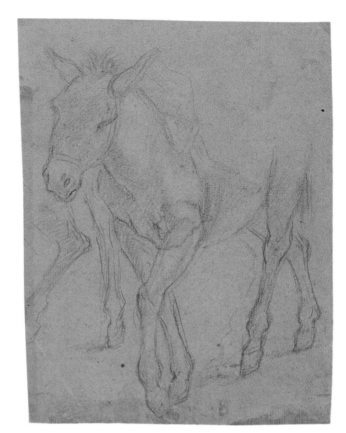

74.

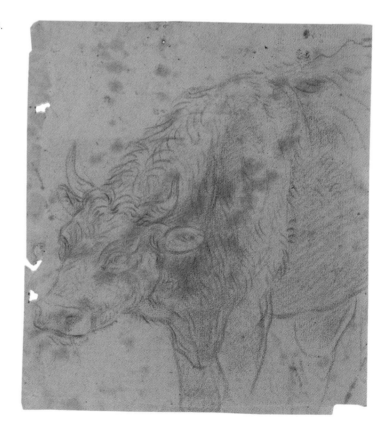

BIBLIOGRAPHY

Primary Sources

Becci, A. *Catalogo delle pitture che si conservano nelle chiese di Pesaro. Si aggiunge la Dissertazione sopra l'Arte della Pittura del sig. Canonico Gio. Andrea Lazzarini.* Pesaro: Gavelli, 1783.

Bellori, G. P. *Le vite de' pittori scultori et architetti moderni.* Roma: Mascardi, 1672 (English trans., *The Lives of the Modern Painters, Sculptors, and Architects: A New Translation and Critical Edition*, eds. A. Sedgwick Wohl, H. Wohl, and T. Montanari. Cambridge, UK: Cambridge University Press, 2009.

Lanzi, L. *Storia Pittorica della Italia dal Risorgimento delle Belle Arti fin presso al fine del XVIII secolo.* Bassano: Giuseppe Remondini e Figli, 1809 (M. Capucci, ed., Firenze: Sansoni Editore, 1968).

Lazzarini, G. *Opere.* Pesaro: Niccolò Gavelli, 1806.

Maggiori, A. *Le Rime di Michelagnolo Buonarroti. Pittore, scultore, architetto e poeta fiorentino.* Rome: 1817.

Maggiori, A. *Le pitture, sculture e architetture della città d'Ancona.* Ancona: Arcangelo Sartorj, 1821.

Maggiori, A. *Indicazioni al forestiere delle pitture sculture architetture e rarità d'ogni genere che vi veggono oggi dentro la Sagrosanta Basilica di Loreto e in altri luoghi della città.* Ancona: Sartorj, 1824.

Maggiori, A. *Dialogo intorno alla vita e le opere di Sebastiano Serlio.* Ancona: Sartorj, 1824.

Maggiori, A. *Dell'itinerario d'Italia e sue più notabili curiosità d'ogni specie.* Ancona: Arcangelo Sartorj, 1832.

Maggiori, A. *Raccolta di proverbj e detti sentenziosi.* Ancona, 1833.

Maggiori, A. *Dialogo sopra la cultura del gran turco.* Ancona, 1833.

Malvasia, C. C. *Felsina pittrice. Vite dei pittori bolognesi.* Bologna: Domenico Brabieri, 1678 (ed. M. Brascaglia, Bologna: Alfa, 1971).

Mecchi, F. E. *Vita del giovane conte Lorenzo Maggiori patrizio fermano.* Fermo: 1876.

Milizia, F. *Dell'Arte di vedere nelle Belle Arti del Disegno secondo i principi di Sulzer e di Mengs.* Venezia: Giambattista Pasquali, 1781 (reprint, Bologna: Arnaldo Forni Editore, 1983).

Zanotti, G. *Storia dell'Accademia Clementina di Bologna aggregata all'Instituto delle Scienze e dell'Arti.* Bologna: Lelio della Volpe, 1739 (reprint, Bologna: Arnaldo Forni Editore, 1977).

Ricci, A. *Memorie storiche delle arti e degli artisti della Marca di Ancona.* Macerata: Alessandro Mancini, 1834.

Ricci, A. "*Alessandro Maggiori.*" In De Tibaldo, E. *Biografia degli Italiani Illustri nelle Scienze, Lettere ed Arti*, IV. Venezia: 1837.

Ralph, B. *The School of Raphael. The Student's Guide to Expression in Historical Painting. Illustrated by Examples Engraved by Duchange, and Others, Under the Inspection of Sir Nicholas Dorigny, from His Own Drawings after the Most Celebrated Heads in the Cartoon at the King's Palace to which are now added the Outlines of Each Head [...] Described and Explained by Benjamin Ralph.* London: 1759 (reprint, Richardson, T., ed., Lexington, 2010).

Winckelmann, J. J. *Gedanken über die Nahmung der griechischen Wercke in der Mahlerey und Bildhauer-Kunst.* Dresden: 1755 (English trans., *Reflections on the Imitation of Greek Works in Painting and Sculpture*, Heyer, E. and Norton, R. C., eds. La Salle, IL: Open Court, 1987).

Maggiori's Letters

Biblioteca dell'Archiginnasio, Bologna, *Collezione Autografi*, XL, cc. 10796–11034.

Secondary Sources

Ambrosini Massari, A. M., ed. *Dotti amici: Amico Ricci e las nascita della storia dell'arte nelle Marche.* Ancona: Il lavoro editoriale, 2007.

Amornpichetkul, C. "Seventeenth-Century Italian Drawing Books: Their Origin and Development." In *Children of Mercury: The Education of Artists in the Sixteenth and Seventeenth Centuries*, 108–18. Catalogue of the exhibit, Bell Gallery (Brown University), March 2–30, 1984. Providence, RI: Brown University, 1984.

Anderson, B. *Imagined Communities: Reflections on the Origin and Spread of Nationalism.* London: Verso Books, 1991.

Angelucci, G. "*Il segno di Alessandro Maggiori.*" In G. Angelucci and M. Di Giampaolo, eds., *Sotto il segno di Alessandro Maggiori. Disegni dal Cinque al Settecento scelti dal Fondo Carducci-Fermo e dalla Collezione Maggiori-Monte San Giusto*, 13–16. Catalogo della mostra Fermo–Monte San Giusto, 10 Luglio–10 Settembre 1992. Monte San Giusto: Carima, 1992.

———. "*Notizie più aggiornate sul Fondo Maggiori a Monte San Giusto.*" In M. Di Giampaolo and G. Angelucci, eds. *Disegni Marchigiani dal Cinquecento al Settecento*, 171–81. Atti del Convegno "Il Disegno antico nelle Marche e dalle Marche," Monte San Giusto, May 22–23, 1992. Firenze: Edizioni Medicea, 1995.

———. *Il Fondo Maggiori a Monte San Giusto. I disegni.* Monte San Giusto: Centro Alessandro Maggiori, 2005.

Angelucci, G., and M. Di Giampaolo, eds. *Sotto il segno di Alessandro Maggiori. Disegni dal Cinque al Settecento scelti dal Fondo Carducci–Fermo e dalla Collezione Maggiori–Monte San Giusto.* Catalogo della mostra Fermo–Monte San Giusto, 10 Luglio–10 Settembre 1992. Monte San Giusto: Carima, 1992.

Anselmi, A. "*Il carteggio storico-artistico del conte Alessandro Maggiori di Fermo.*" *Nuova rivista misena*, X (1907), 3 / 4: 51–54.

Arasse, D. *Le détail: pour une histoire rapprochée de la peinture.* Paris: Flammarion, 1997.

Baiardi, A. C. *Guardian of the Myth: Accademia Raffaello-Urbino.* Catalogue of the exhibit, New York: Italian Cultural Institute, June 8–July 5, 2007; Urbino: L'Accademia Raffaello di Urbino, 2007.

Baker, C., C. Elam, and G. Warwick, eds. *Collecting Prints and Drawings in Europe, c. 1500–1750.* Surrey, UK: Ashgate, 2003.

Balzani, R., ed. *L'arte contesa nell'età di Napoleone, Pio VII e Canova.* Catalogue of the exhibit, Cesena, Biblioteca Malatestiana, March 14–July 26, 2009. Milano: Silvana Editoriale, 2009.

———. "*Nel crogiolo del patrimonio: come le opere d'arte cambiarono statuto.*" In R. Balzani, ed. *L'arte contesa nell'età di Napoleone, Pio VII e Canova*, 24–27. Catalogue of the exhibit, Cesena, Biblioteca Malatestiana, March 14–July 26, 2009. Milano: Silvana Editoriale, 2009.

Banti, A. M. *Il Risorgimento italiano.* Bari: Editori Laterza, 2004.

Barman, K.-E. "The Fiorentine Accademia del Disegno: Liberal Education and the Renaissance Artist." In A. W. A. Boschloo, ed., *Academies of Art: Between Renaissance and Romanticism*, 14–32. Leids Kunsthistorisch Jaarboek V–VI (1986–1987). Leiden: 's-Gravenhage, 1989.

Bean, J., and W. Griswold. *18th Century Italian Drawings in the Metropolitan Museum of Art.* New York: Harry N. Abrams, 1990.

Bellini, P., ed. *L'opera incisa di Simone Cantarini*, Pesaro: Comune di Pesaro-Assessorato alla Cultura, 1980.

Bernini Pezzini, G. "*Nota sul restauro dei disegni della Collezione Maggiori di Monte San Giusto.*" In M. Di Giampaolo and G. Angelucci, eds. *Disegni Marchigiani dal Cinquecento al Settecento*, 197–203. Atti del Convegno "Il Disegno antico nelle Marche e dalle Marche," Monte San Giusto, May 22–23, 1992. Firenze: Edizioni Medicea, 1995.

Bologna, F. *La coscienza storica dell'arte d'Italia*, Milano: Garzanti, 1992.

Boschloo, A. W. A. "*L'Accademia Clementina e la fama dei Carracci.*" In A. W. A. Boschloo, ed., *Academies of Art: Between Renaissance and Romanticism*, 105–17. Leids Kunsthistorisch Jaarboek V–VI (1986–1987). Leiden: 's-Gravenhage, 1989.

Boschloo, A. W. A., ed. *Academies of Art: Between Renaissance and Romanticism.* Leids Kunsthistorisch Jaarboek V–VI (1986–1987). Leiden: 's-Gravenhage, 1989.

Bryson, N. *Tradition and Desire: From David to Delacroix.* Cambridge, UK: Cambridge University Press, 1984.

Calegari, G. *Disegni inediti di Giannandrea Lazzarini. I taccuini ritrovati.* Pesaro: Banca Popolare Pescarese, 1989.

Capponi, R. *Morrovalle napoleonica. Amministrazione e coscrizione (1808–1814)*. Morrovalle: Amministrazione Comunale di Morrovalle, 2004.

Capra, C., F. Della Peruta, and F. Mazzocca, eds. *Napoleone e la Repubblica Italiana (1802–1805)*. Catalogue of the exhibit, Milan, Rotonda di Via Besana, November 11, 2002–February 28, 2003. Milano: Skira, 2002.

Carlino, A. *Books of the Body: Anatomical Ritual and Renaissance Learning*. Chicago: University of Chicago Press, 1999.

Cellini, M. *Disegni della Biblioteca Comunale di Urbania. La Collezione Ubaldini. Catalogo Generale*. Regione Marche-Centro Beni Culturali, 1999.

Chaney, E., ed. *The Evolution of English Collecting*. New Haven, CT: Yale University Press, 2003.

Children of Mercury: The Education of Artists in the Sixteenth and Seventeenth Centuries. Catalogue of the exhibit, Bell Gallery (Brown University), March 2–30, 1984. Providence, RI: Brown University, 1984.

Cipriani, A. "*L'Accademia di San Luca dai concorsi dei giovani ai concorsi Clementini*." In A. W. A. Boschloo, ed. *Academies of Art: Between Renaissance and Romanticism*, 61–76. Leids Kunsthistorisch Jaarboek V–VI (1986–1987). Leiden: 's-Gravenhage, 1989.

Collins, J. L. *Papacy and Politics in Eighteenth-Century Rome: Pius VI and the Arts*. Cambridge, UK: Cambridge University Press, 2004.

Costanzi, C. "*Le vie di fuga: principali percorsi nelle dispersioni delle opere d'arte dalle Marche*." In C. Costanzi, ed. *Le Marche disperse. Repertorio di opere d'arte dalle Marche al mondo*, 21–35. Milan: Silvana Editoriale, 2005.

Costanzi, C., ed. *Le Marche disperse. Repertorio di opere d'arte dalle Marche al mondo*. Milano: Silvana Editoriale, 2005.

Craske, M. *Art in Europe, 1700–1830*. New York: Oxford University Press, 1997.

Cucco, G., ed. *Papa Albani e le arti a Urbino e a Roma. 1700–1721*. Catalogue of the exhibit, Urbino, Palazzo del Collegio, June 29–September 30, 2001. Venezia: Marsilio, 2001.

Curzi, V. "*Committenti, intermediari e collezionisti: fortuna di Domenico Corvi e sistemi di diffusione delle sue opere fuori Roma*." In V. Curzi and A. Lo Bianco,eds. *Domenico Corvi*, 35–49. Catalogue of the exhibit, Viterbo, Museo della Rocca Albornoz, December 12, 1998–February 28, 1999. Roma: Viviani Arte, 1998.

Curzi, V. and A. Lo Bianco, eds. *Domenico Corvi*. Catalogue of the exhibit, Viterbo, Museo della Rocca Albornoz, December 12, 1998–February 28, 1999. Roma: Viviani Arte, 1998.

Daly Davis, M. "Giovan Pietro Bellori and the "*Nota delli musei, librerie, galerie, et ornamenti di statue e pitture ne' palazzi, nelle case, e ne' giardini di Roma*" (1664): Modern libraries and ancient painting in Seicento Rome." *Zeitschrift für Kunstgeschichte*, 68 (2) (2005): 191–233.

Dania, L. "*Alessandro Maggiori, critico e collezionista*." In M. Di Giampaolo and G. Angelucci, eds. *Disegni Marchigiani dal Cinquecento al Settecento*, 7–18. Atti del Convegno "Il Disegno antico nelle Marche e dalle Marche," Monte San Giusto, May 22–23, 1992. Firenze: Edizioni Medicea, 1995.

De Francesco, A. "*La politica dell'Armée d'Italie*." In R. Balzani, ed. *L'arte contesa nell'età di Napoleone, Pio VII e Canova*, 33–38. Catalogue of the exhibit, Cesena, Biblioteca Malatestiana, March 14-July 26, 2009. Milano: Silvana Editoriale, 2009.

De Mambro Santos, R. *Arcadie del Vero. Arte e teoria nella Roma del Seicento*. Roma: Apeiron, 2001.

———. *Santa Lucia del Gonfalone*. Roma: Istituto Nazionale di Studi Romani-F.lli Palombi, 2001.

Dempsey, C. "The Carracci Academy." In A. W. A. Boschloo, ed. *Academies of Art: Between Renaissance and Romanticism*, pp. 33–43. Leids Kunsthistorisch Jaarboek V–VI (1986–1987). Leiden: 's-Gravenhage, 1989.

De Vecchi, P., and S. Blasio, eds. *La Pinacoteca Duranti di Montefortino*. Azzano San Paolo: Bolis, 2003.

Di Giampaolo, M. and G. Angelucci, eds. *Disegni Marchigiani dal Cinquecento al Settecento*. Atti del Convegno "Il Disegno antico nelle Marche e dalle Marche," Monte San Giusto, May 22–23, 1992. Firenze: Edizioni Medicea, 1995.

Di Pietro, F. "*Elenco dei disegni di antichi Maestri conservati nel Comune di Monte San Giusto e a questo lasciati in legato dal rev.do don Nicola Bollesi*." *Rassegna Marchigiana*, IV (1925), 3: 103–08.

Dupuy, M.-A., ed. *Dominique-Vivant Denon: L'œil de Napoléon*. Paris: Réunion des Musées Nationaux, 1999.

Eitner, L., and L. Dania. *Fortunato Duranti, 1787–1863*. Stanford, CA: Department of Art and Architecture, Stanford University, 1966.

Emiliani, A. *Leggi, bandi e provvedimenti per la tutela dei beni artistici e culturali negli antichi stati italiani. 1571–1860*. Bologna: Nuova Alfa Editoriale, 1996.

———. "*Il territorio e opere d'arte nel XVIII secolo. Il ruolo dei grandi musei*." In R. Balzani, ed. *L'arte contesa nell'età di Napoleone, Pio VII e Canova*, 17–23. Catalogue of the exhibit, Cesena, Biblioteca Malatestiana, March 14-July 26, 2009. Milano: Silvana Editoriale, 2009.

Faietti, M. *I grandi disegni italiani della Pinacoteca Nazionale di Bologna*. Milano: Silvana Editoriale 2002.

Giordano, A. *Il capolavoro di Lotto in Monte San Giusto e il Vescovo Bonafede*. Roma: Accademia Nazionale dei Lincei, 1999.

Goldstein, C. "The Platonic Beginnings of the Academy of Painting and Sculpture in Paris." In A. W. A. Boschloo, ed. *Academies of Art: Between Renaissance and Romanticism*, 186–202. Leids Kunsthistorisch Jaarboek V–VI (1986–1987). Leiden: 's-Gravenhage, 1989.

Hemphill, R. "Comic Drawings by Pietro de' Rossi Etched by Giuseppe Maria Mitelli." *Master Drawings*, 34(3) (1996): 279–91.

Ideologie e patrimonio storico-culturale nell'età rivoluzionaria e napoleonica. A proposito del trattato di Tolentino. Atti del convegno, Tolentino, September 18–21, 1999, Roma, 2000.

Johns, C. M. S. *Antonio Canova and the Politics of Patronage in Revolutionary and Napoleonic Europe*. Berkeley: University of California Press, 1998.

L'arte del Settecento Emiliano. La pittura. L'Accademia Clementina. Catalogue of the exhibit, Bologna, Palazzo del Podestà e di Re Enzo, September 8–November 25, 1979. Bologna: Edizioni Alfa, 1979.

Leoni, F., ed. *Il Pontificato di Leone XII: Annibale della Genga*. Urbino: Edizioni QuattroVenti, 1992.

L'ideale del bello. Viaggio per Roma nel Seicento con Giovan Pietro Bellori. Catalogue of the exhibit, Rome, Palazzo delle Esposizioni, March 29–June 26, 2000. Roma: Edizioni De Luca, 2000.

Lingo, E. "The Greek Manner and a Christian 'Canon': François Duquesnoy's 'Santa Susanna.'" *The Art Bulletin*, 84(1) (2002): 65–93.

Lingo, S. *Federico Barocci: Allure and Devotion in Late Renaissance Painting*. New Haven, CT: Yale University Press, 2008.

Longhi, R. *Piccola ma veridica storia della pittura italiana*. Firenze: Sansoni Editori, 1961.

Luke, Y. "The Politics of Participation: Quatremère de Quincy and the Theory of 'Concours publiques' in Revolutionary France, 1791–1795." *The Oxford Art Journal*, 10(1) (1987): 15–43.

MacDonald, M. F. "British Artists at the Accademia del Nudo in Rome." In A. W. A. Boschloo, ed. *Academies of Art: Between Renaissance and Romanticism*, 77–94. Leids Kunsthistorisch Jaarboek V–VI (1986–1987). Leiden: 's-Gravenhage, 1989.

Mahon, D. "Eclecticism and the Carracci: Further Reflections on the Validity of a Label." *Journal of the Warburg and Courtauld Institutes*, 16, 3 / 4 (1953): 303–41.

Mattick, Jr., P., ed. *Eighteenth-century Aesthetics and the Reconstruction of Art*. Cambridge, UK: Cambridge University Press, 1993 (2nd ed. 2008).

Mei, M. "*Geografia del disegno nelle Marche: le collezioni delle biblioteche*." In M. Mei, ed. *Collectio Thesauri. Dalle Marche tesori nascosti di un collezionismo illustre*, 7–17. Catalogue of the exhibit, Ancona, Mole Vanvitelliana, January 15–April 30, 2005. Firenze: Edifir, 2005.

Millar, E. A. *Napoleon in Italian Literature, 1796–1821*. Roma: Edizioni di Storia e Letteratura, 1977.

1799: L'insorgenza antifrancese e il Sacco di Macerata. Atti del convegno di studi, Macerata, Università di Macerata, May 20, 1999. Macerata: Comune di Macerata, 2001.

Minnich, N. H. "Raphael's Portrait *Leo X with Cardinals Giulio de' Medici and Luigi de' Rossi*: A Religious Interpretation." *Renaissance Quarterly*, 56(4) (2003): 1005–52.

Montagu, J. *The Expression of the Passions: The Origin and Influence of Charles Le Brun*. New Haven, CT: Yale University Press, 1994.

Olmstead Tonelli, L. "Academic Practice in the Sixteenth and Seventeenth Centuries." In *Children of Mercury: The Education of Artists in the Sixteenth and Seventeenth Centuries*, 96–107. Catalogue of the exhibit, Bell Gallery (Brown University), March 2–30, 1984. Providence: Brown University, 1984.

Panofsky, E. "The First Page of Giorgio Vasari's 'Libro': A Study on the Gothic Style in the Judgment of the Italian Renaissance." In E. Panofsky, *Meaning in the Visual Arts*, ch. 5. New York: Doubleday, 1955.

———. *The Life and Art of Albrecht Dürer*. Princeton, NJ: Princeton University Press, 1955.

Patani, O., ed. *Le referenze visuali di Fortunato Duranti*. Milano: Stanza del Borgo, 1985.

Pillepich, A. *Napoléon et les Italiens*. Paris: Nouveau Monde Editions, 2003.

Pinelli, A. "Storia dell'arte e cultura della tutela. Le Lettres à Miranda di Quatremère de Quincy." *Ricerche di Storia dell'arte*, 8 (1975–1976): 43–62.

———. *Il Neoclassicismo nell'arte del Settecento*. Rome: Carocci Editore, 2005.

———. *Souvenir. L'industria dell'antico e il Grand Tour a Roma*. Roma-Bari: Editori Laterza, 2010.

Pommier, É. *Più antichi della luna. Studi su J. J. Winckelmann e A. Ch. Quatremère de Quincy*. Bologna: Minerva Edizioni, 2000.

———. *Raffaello e il Classicismo francese del XVII secolo*. Urbino: Accademia Raffaello, 2004.

Potts, A. *Flesh and the Ideal: Winckelmann and the Origins of Art History*. New Haven, CT: Yale University Press, 1994.

Prosperi Valenti Rodinò, S. *Il disegno per Bellori, L'ideale del bello. Viaggio per Roma nel Seicento con Giovan Pietro Bellori*, 131–39. Catalogue of the exhibit, Rome, Palazzo delle Esposizioni, March 29–June 26, 2000. Roma: Edizioni De Luca, 2000, I.

———. "Clement XI collezionista di disegni." In G. Cucco, ed. *Papa Albani e le arti a Urbino e a Roma. 1700–1721*, 39–44. Catalogue of the exhibit, Urbino, Palazzo del Collegio, June 29–September 30, 2001. Venezia: Marsilio, 2001.

Pulini, M., ed. *Il Sassoferrato. Un preraffaellita tra i puristi del Seicento*. Catalogue of the exhibit, Cesena, Galleria Comunale d'Arte, May 15–October 25, 2009. Milano: Medusa Edizioni, 2009.

Raben, H. "Bellori's Art: The Taste and Distaste of a Seventeenth-Century Art Critic in Rome." *Simiolus*, 32, 2 / 3 (2006): 126–46.

Ragghianti Collobi, L., ed. *Il libro de' disegni del Vasari*. Firenze: Vallecchi, 1974.

Rizzoli, F. "Geografia e cronologia delle requisizioni d'opere d'arte in Italia dal 1796 al 1799." In R. Balzani, ed. *L'arte contesa nell'età di Napoleone, Pio VII e Canova*, 43–46. Catalogue of the exhibit, Cesena, Biblioteca Malatestiana, March 14-July 26, 2009. Milano: Silvana Editoriale, 2009.

Roettgen, S. *Anton Raphael Mengs and His British Patrons*. Firenze: Scala, 1993.

———. *Anton Raphael Mengs. 1728–1779. Das malerisch und zeichnerische Werk*. München: Himer, 1999.

Roettgen, S., ed. *Mengs. La scoperta del Neoclassico*. Catalogue of the exhibit, Padova, Palazzo Zabarella, March 3–June 11, 2001. Venezia: Marsilio, 2001.

Roman, C. E. "Academic Ideals of Art Education." In *Children of Mercury: The Education of Artists in the Sixteenth and Seventeenth Centuries*, 81–95. Catalogue of the exhibit, Bell Gallery (Brown University), March 2–30, 1984. Providence, RI: Brown University, 1984.

Rongoni, G. *Di sole in sole a Porto San Giorgio tra 700 e 800*. Fermo: Andrea Livi, 1993.

Rosenberg, M. *Raphael and France: The Artist as Paradigm and Symbol*. Philadelphia: Pennsylvania University Press, 1995.

Rudolph, S. "Disegni di Maratti a souvenir di sue opere nelle Marche." In M. Di Giampaolo and G. Angelucci, eds. *Disegni Marchigiani dal Cinquecento al Settecento*, 131–43. Atti del Convegno "Il Disegno antico nelle Marche e dalle Marche," Monte San Giusto, May 22–23, 1992. Firenze: Edizioni Medicea, 1995.

———. "Le committenze romane di Domenico Corvi." In V. Curzi and A. Lo Bianco, eds. *Domenico Corvi*, 18–33. Catalogue of the exhibit, Viterbo, Museo della Rocca Albornoz, December 12, 1998–February 28, 1999. Roma: Viviani Arte, 1998.

Ryan, H. *Cassiano Dal Pozzo's Paperback Museum: Drawings from the Royal Collection*. Edinburgh: National Galleries of Scotland, 1997.

Schoneveld-Van Stoltz, H. F. "Some Notes on the History of the Académie Royale de Peinture et de Sculpture in the Second Half of the Eighteenth Century." In A. W. A. Boschloo, ed. *Academies of Art: Between Renaissance and Romanticism*, 216–28. Leids Kunsthistorisch Jaarboek V–VI (1986–1987). Leiden: 's-Gravenhage, 1989.

Sciolla, G. C., ed. *Il Disegno. I grandi collezionisti*. Milano: Silvana Editoriale, 1992.

Siegel, J. "Owning Art after Napoleon: Destiny or Destination at the Birth of the Museum." *PMLA*, 125 (1) (2010): 142–51.

Susinno, S. "Accademie' romane nella collezione braidense: primato di Domenico Corvi nel disegno dal Nudo." In V. Curzi and A. Lo Bianco, eds. *Domenico Corvi*, 172–89. Catalogue of the exhibit, Viterbo, Museo della Rocca Albornoz, December 12, 1998–February 28, 1999. Roma: Viviani Arte, 1998.

———. "Le accademie di Domenico Corvi." In V. Curzi and A. Lo Bianco, eds. *Domenico Corvi*, 198–217. Catalogue of the exhibit, Viterbo, Museo della Rocca Albornoz, December 12, 1998–February 28, 1999. Roma: Viviani Arte, 1998.

Ten Eyck Gardner, A. "The History of a Collection." *The Metropolitan Museum of Art Bulletin*, New Series, 5 (8) (1947): 215–20.

Trease, G. *The Grand Tour*. New Haven, CT: Yale University Press, 1991.

Warwick, G. *The Arts of Collecting: Padre Sebastiano Resta and the Market for Drawings in Early Modern Europe*. Cambridge, UK: Cambridge University Press, 2000.

———. "Connoisseurship and the Collection of Drawings in Italy c. 1700: the Case of Padre Sebastiano Resta." In C. Baker, C. Elam, and G. Warwick, eds. *Collecting Prints and Drawings in Europe, 1500–1750*, 141–53. Surrey, UK: Ashgate, 2003.

Westin, J. K., and R. H. Westin. *Carlo Maratti and His Contemporaries: Figurative Drawings from the Roman Baroque*. Minnetonka, MN: Olympic Marketing Corp., 1988.

William, R. *Art, Theory, and Culture in Sixteenth-Century Italy. From Techne to Metatechne*. Cambridge, UK: Cambridge University Press, 1997.

Williamson, E. "The Concept of Grace in the Work of Raphael and Castiglione." *Italica*, 24 (4) (1947): 316–24.

Woolf, S. *A History of Italy, 1700–1860: The Social Constraints of Political Change*. London: Methuen, 1979.

Zampetti, P. *Pittura nelle Marche. IV: Dal Barocco all'Età Moderna*. Firenze: Nardini Editore-Cassa di Risparmio di Fermo, 1991.